Advanced Style

# Advanced Style

## ARI SETH COHEN

FOREWORD BY MAIRA KALMAN
INTERVIEW BY DITA VON TEESE

 powerHouse Books

BROOKLYN,NY

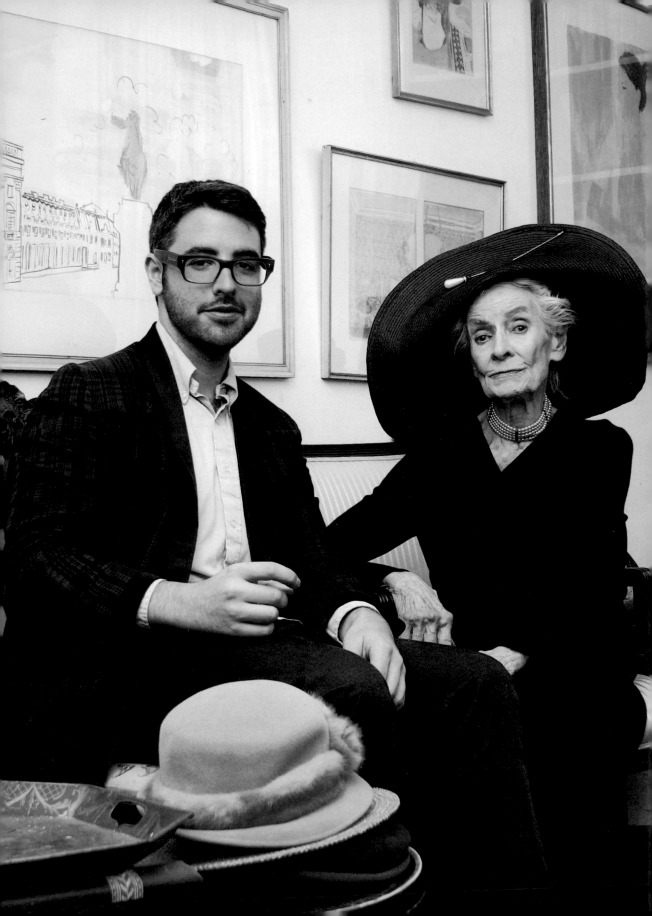

# Introduction

"I can't imagine going without a hat. The only romantic thing left in life is a hat."

—Mimi Weddell

Ever since I can remember, I have been captivated by amazing older women. My grandma, Bluma, was my best friend. We would spend hours in each other's company, watching classic films, taking trips to the library, and drawing cartoons. My tastes were largely shaped through excavations of her dresser drawers filled with dazzling vintage jewels and old photographs. I was struck by images of the elegant and glamorous past—a time when men and women wore hats and gloves and dressed up because it was the thing to do. My other grandmother, Nana Helen, embodied this manner of graceful dressing. She had an impeccable fashion sense and the confidence to match.

One of my first art projects as a child was making drawings of well-dressed grande dames; I filled more than one sketchbook with these colorful ladies. When I moved to New York as an adult, inspired by Grandma Bluma's promise that "everything creative is happening there," I saw my drawings come to life on the streets of this marvelous city. I found ladies and gentleman who still wear hats and gloves and who express a sense of style all their own. I was inspired to start a blog that would capture images of an oft-overlooked yet strikingly fashionable segment of society—one that would pay homage to my grandmothers' style and spirit.

I have never considered "old" a bad word. To be old is to be experienced, wise, and advanced. The ladies I photograph challenge stereotypical views on age and aging. They are youthful in mind and spirit and express themselves through personal style and individual creativity. The soul of *Advanced Style* is not bound to age, or even to style, but rather to the celebration of life. The fashion these women display is merely a reflection of the care and thought they put into every aspect of their lives. These photos offer proof that the secret to remaining vital in our later years is to never stop being curious, never stop creating, and never stop having fun.

**Ari Seth Cohen**
**New York City, 2011**

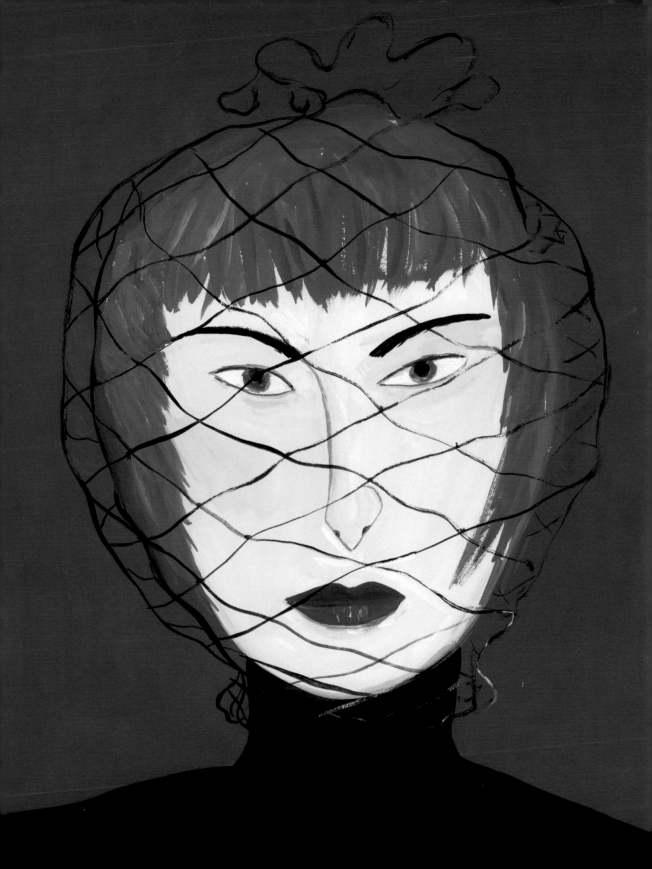

# About People Who are Older and How They Look

My piano teacher, Mrs. Danziger, well into her 80s, always wore an elegant dress, sheer stockings, and high heels. She had a braid wrapped around her head with a powder blue ribbon running through it. My mother, Sara Berman, always wore white. Sometimes a dark tie with a white coat, blouse, vest, and pants. She looked like a combination of Colette and Marlene Dietrich.

Albert Einstein sailed his boat wearing a ratty sweatshirt. Frumpy pants. His hair disheveled. He always looked incredible. Who else? Louise Bourgeois. Duke Ellington. Isak Dinesen. Picasso. Gandhi. Isadora Duncan. My neighbor Beth Levine, the shoe designer. She walked out of the elevator, at 92 years old in a pencil skirt and heels, into our lobby, the chicest person in town. So what is it about style. What makes someone beautiful, no matter what the age? No matter the wealth?

What makes you turn your head as you walk down the street and think, "There goes a great looking person"? It is easier to define when you are looking at someone young. But if someone is in their 70s or 80s or 90s, or 100s(!), it is more elusive. More challenging.

Ari Seth Cohen has done something very important. He has looked at our grand population and singled out the people that, in a way, are most invisible and have the most to offer.

We are lucky when any older person crosses our path. Our lives are enriched just by proximity. The wisdom. The spirit. The saying exactly what they think. The dispensing of advice. The courage. The humor. The crankiness. The kindness. Or the iconoclasm. All of these come from people who have lived a long life. And the fashion. Well that doesn't hurt. It might be some bobby pins in the hair and a pair of blue sneakers. Or a perfectly tailored tweed skirt and jacket. Or a splendid hat. Or none of the above. It does not need to be high fashion. But it is high humanity. So here are people that we should take note of and tip our hats to.

And we should tip our hats to Ari. Not only is he looking at what people LOOK like, he is also looking at their soul. And we are better for it.

**Maira Kalman**

The elegant and refined **Rose** believes, "If everyone is wearing it, then it's not for me." Over the past 100 years, she has developed a keen eye for fashion. For her, no outfit is complete without an eye-catching belt or elegant strand of beads. Rose's words of wisdom should be requisite reading for anyone wondering how to live life to its utmost.

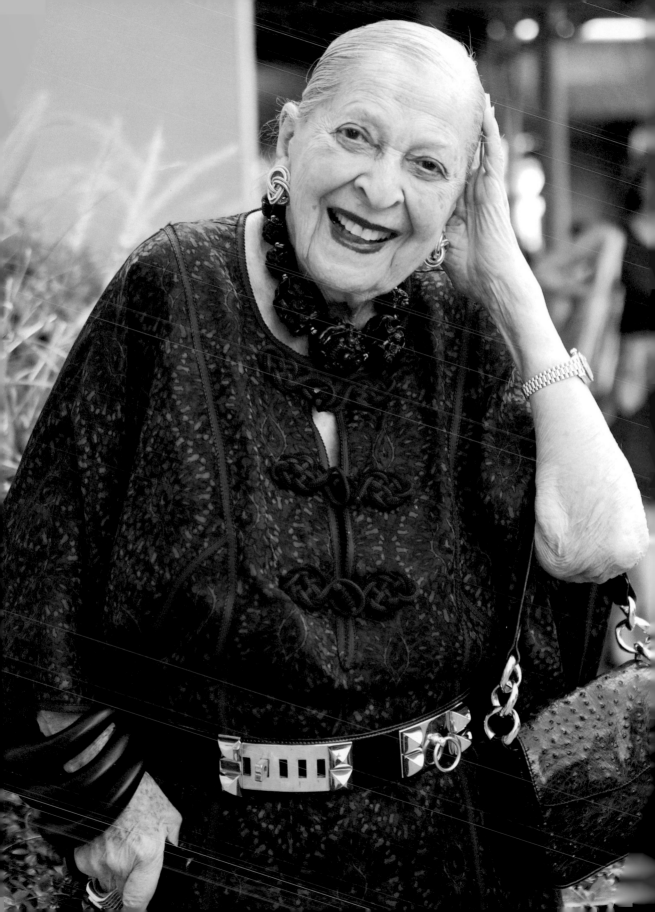

## "Be more, appear less."

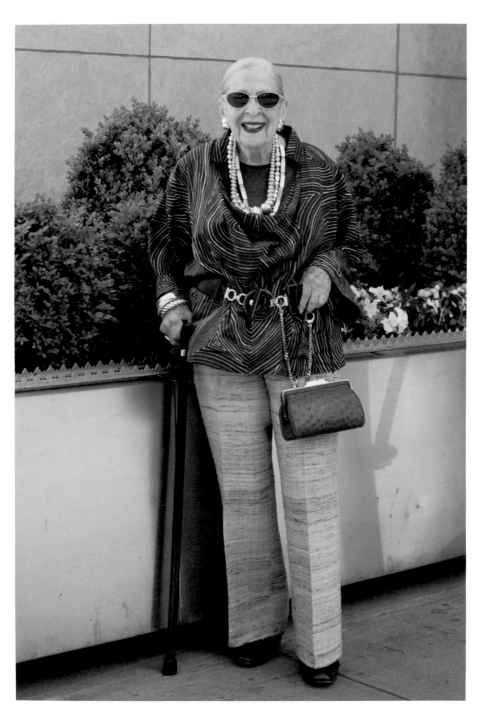

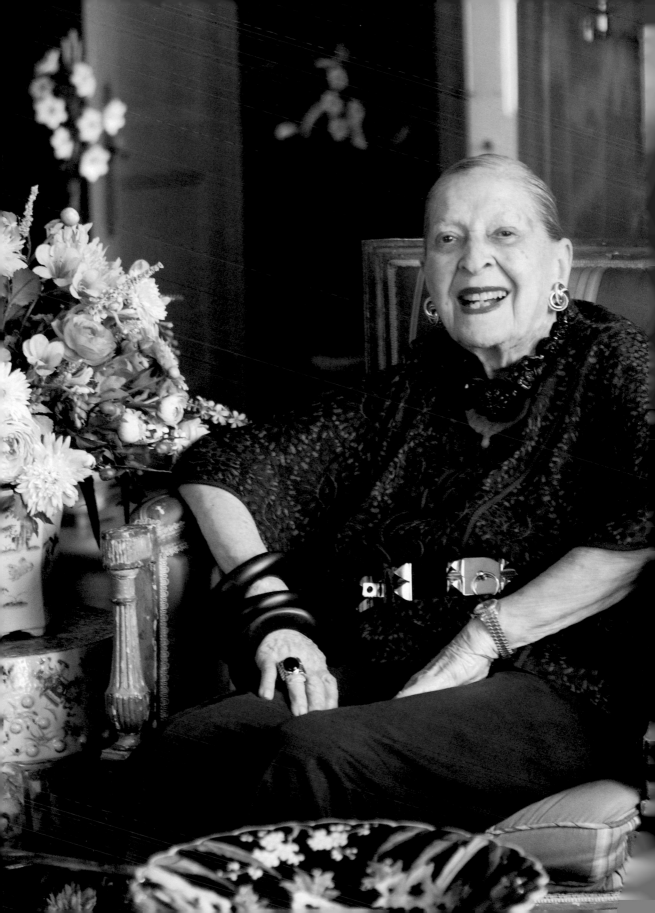

"Inexpensive lipstick
is as good as expensive,
only better."

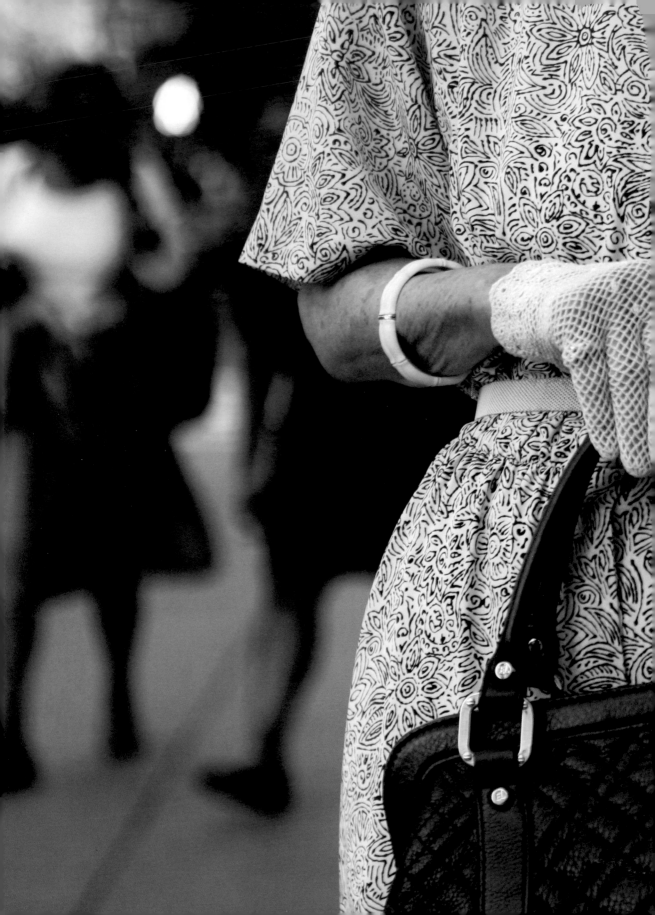

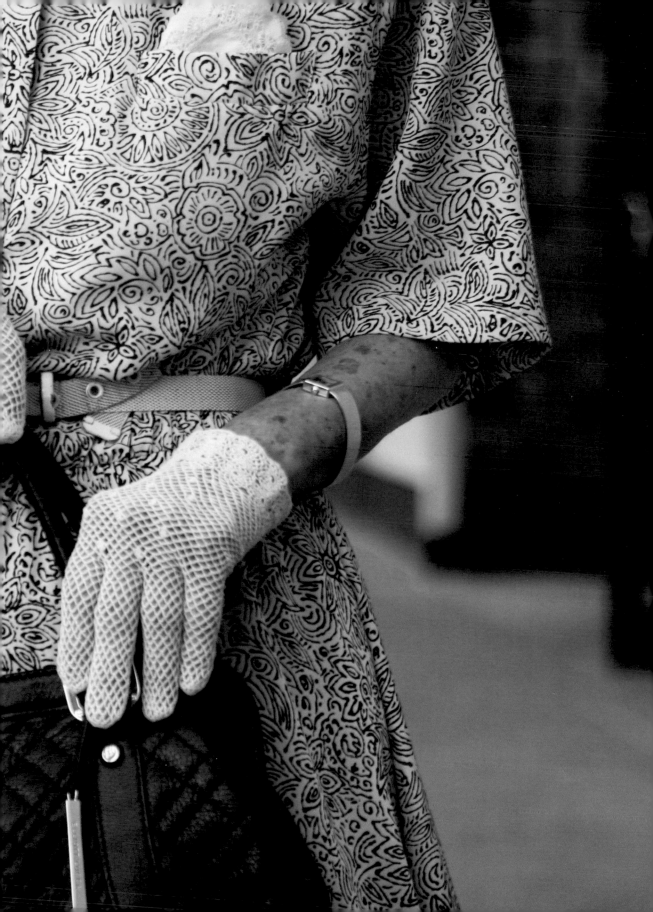

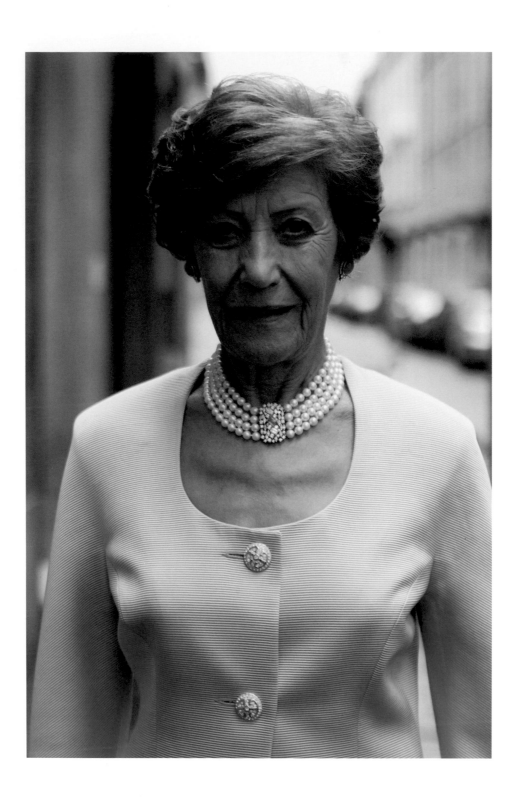

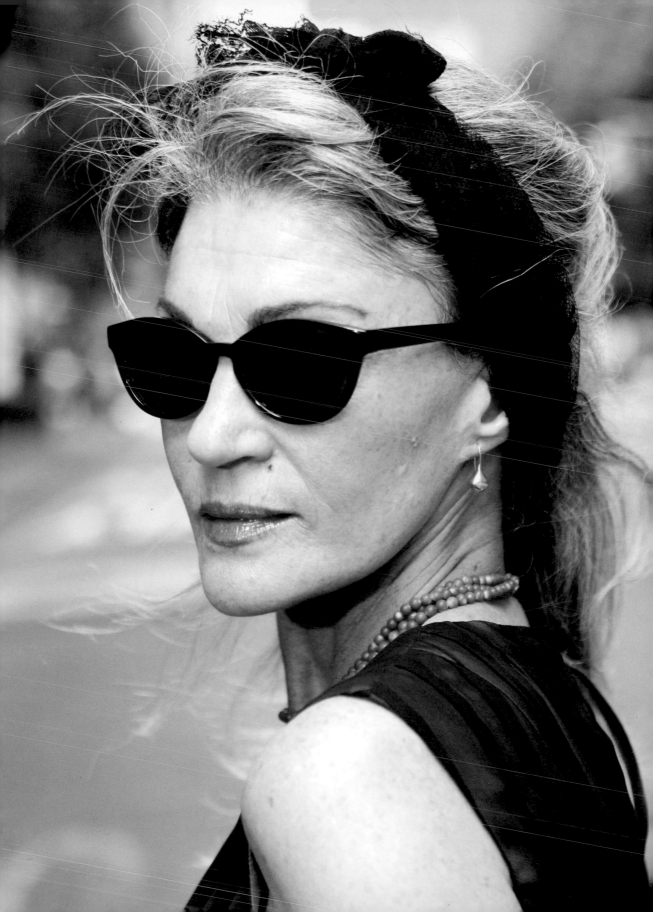

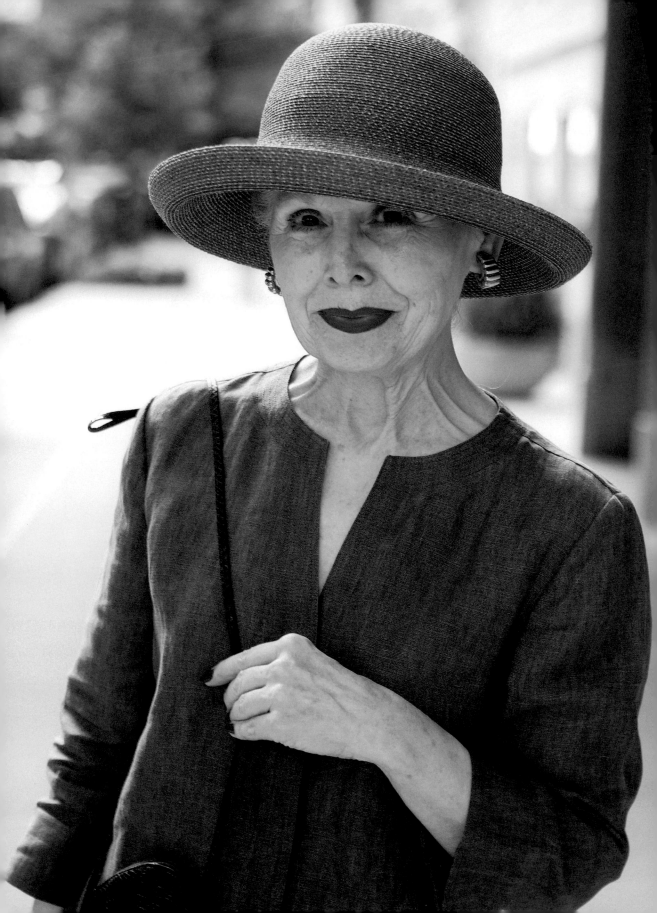

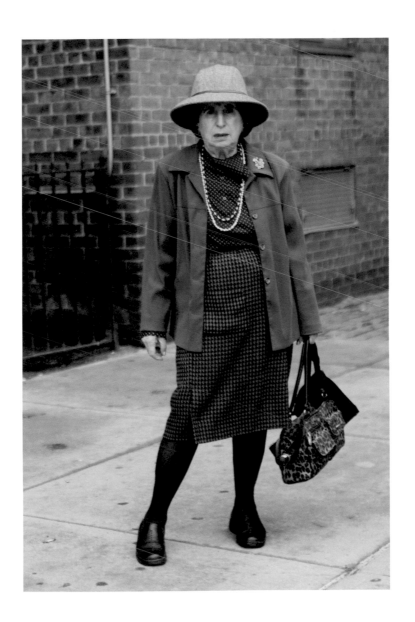

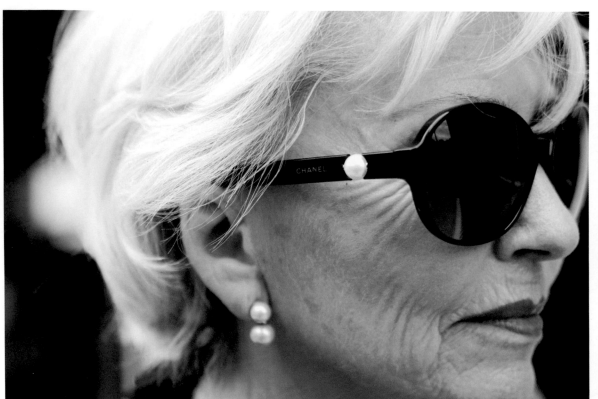

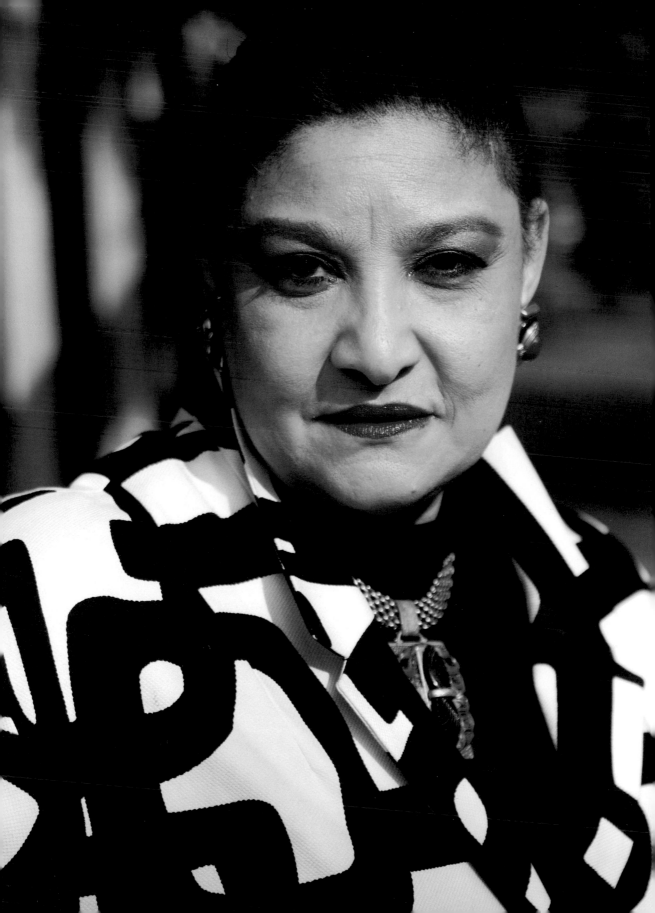

# Carol Markel & Richard Cramer

are both artists whose celebratory spirit and love of color inhabit every aspect of their lives. Harmonious combinations of patterns and brilliant hues make this show-stopping duo a sight for sore eyes. For Richard and Carol, creativity is a priority—style is a vehicle for creative expression.

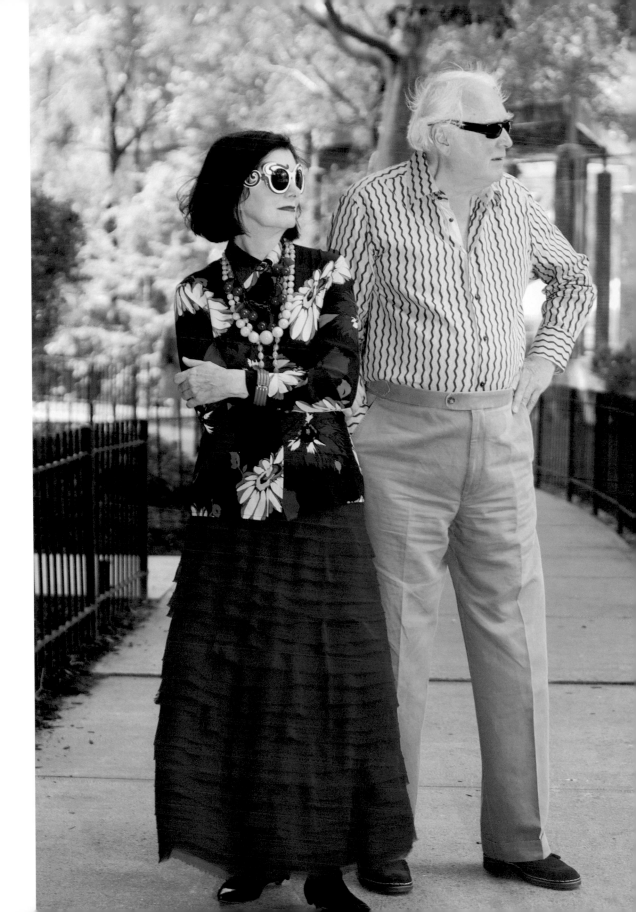

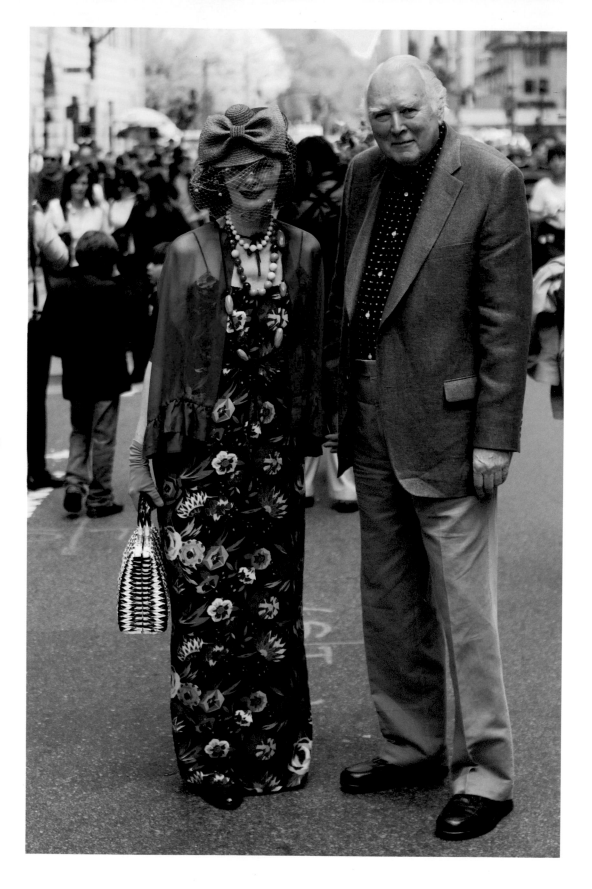

"We must be soul mates to have been together for 45 years, so it follows that we must have influenced each other's style along the way."

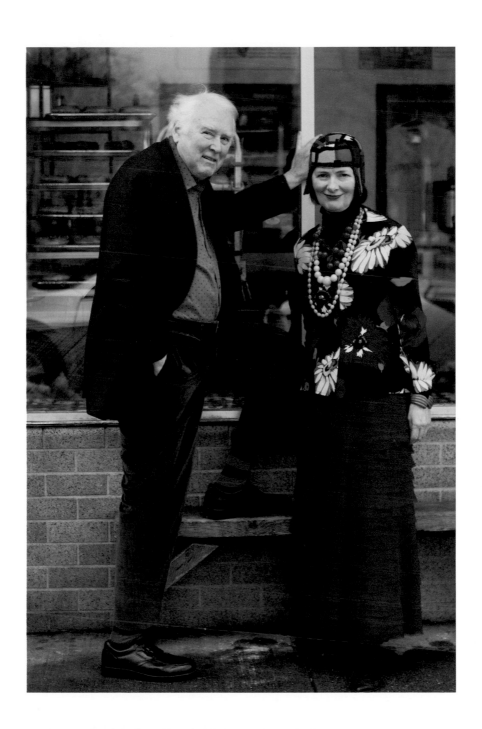

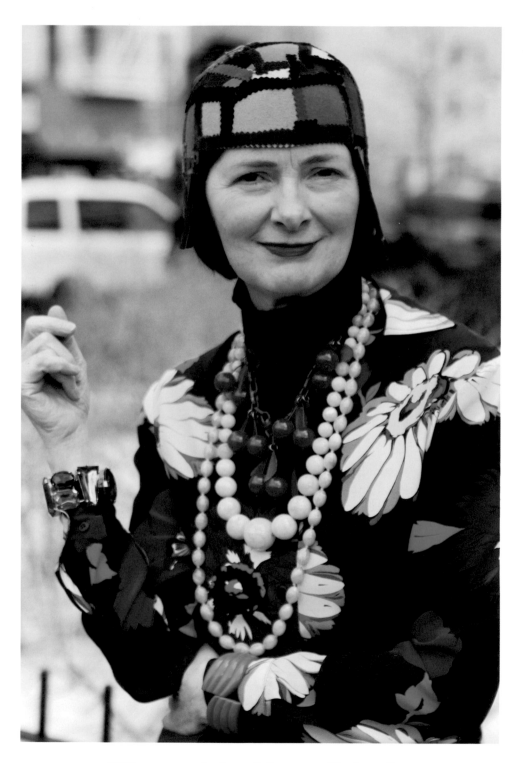

"We are minimal in our living but
extravagantly exuberant in our art."

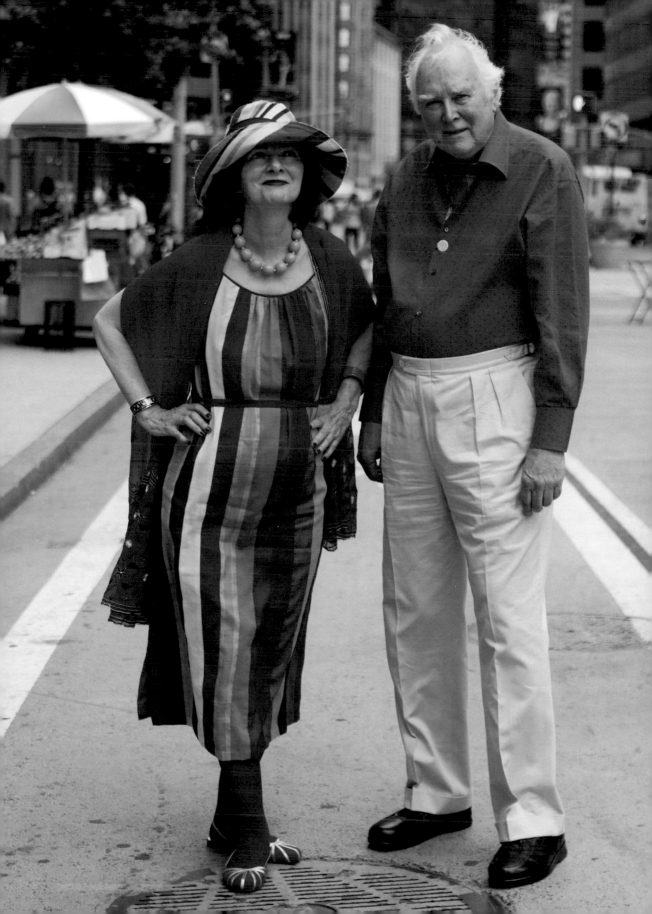

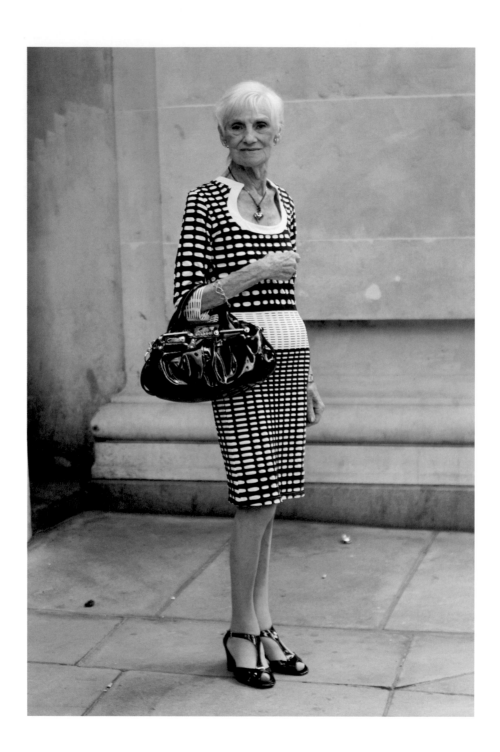

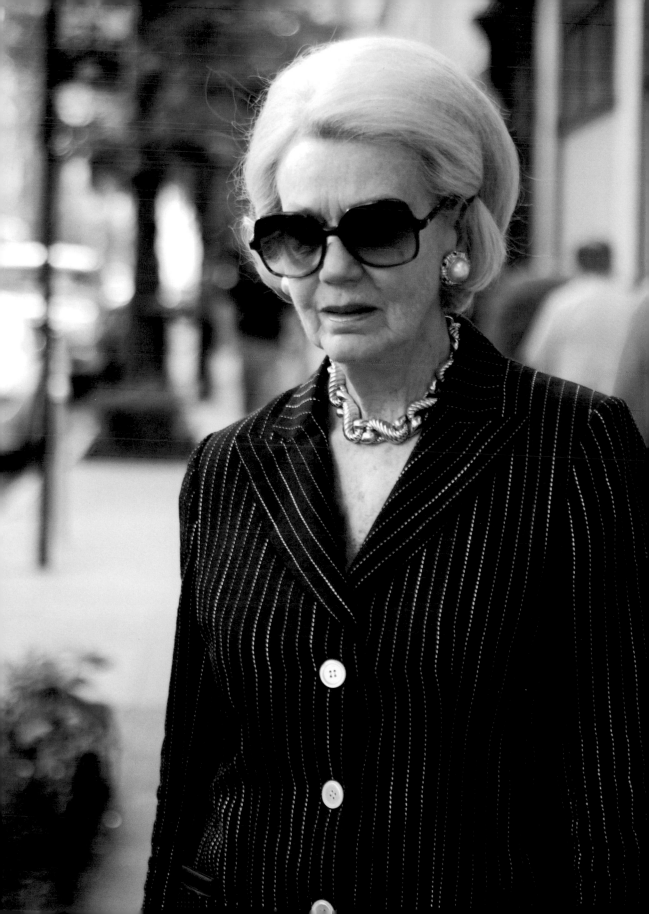

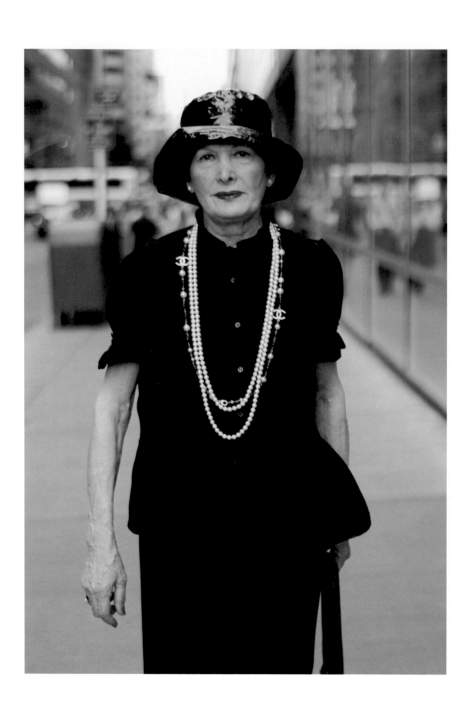

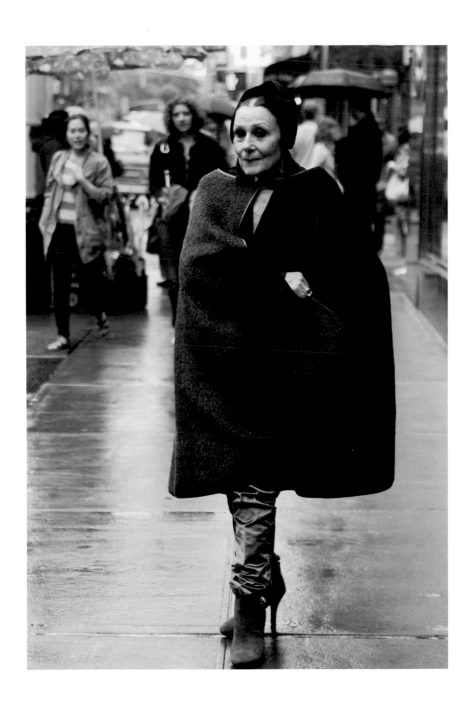

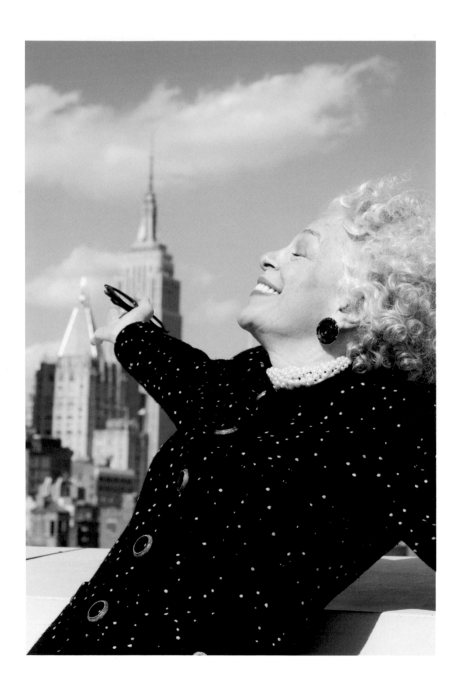

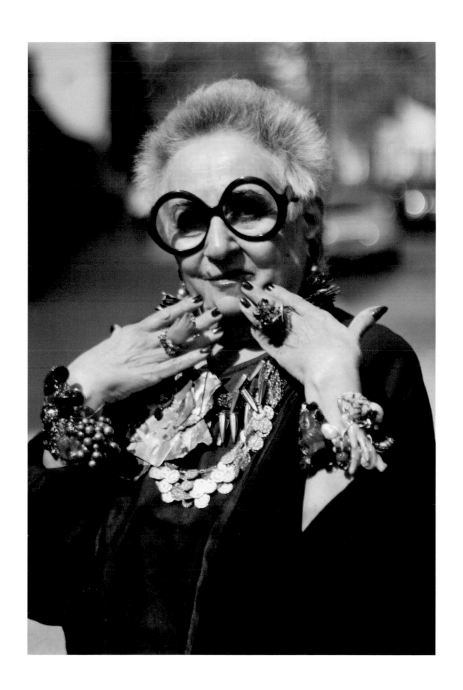

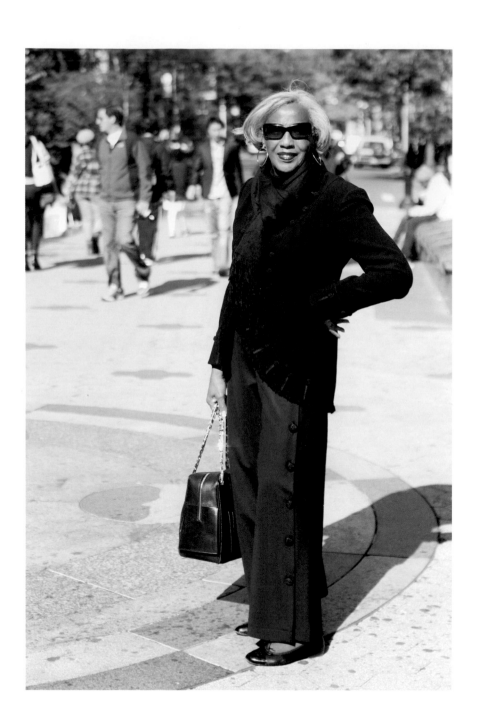

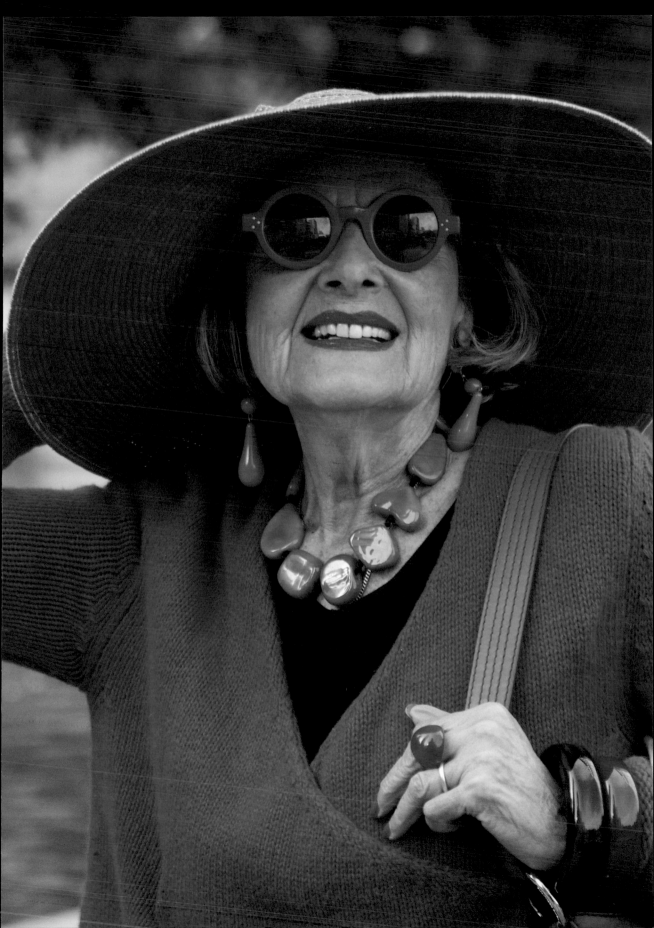

West Village author **Alice Carey** blends classic menswear with subtle feminine touches to create a uniform that is undeniably her own. Her striking red hair and brilliant humor perfectly complement her distinctive and unconventional wardrobe choices. As a young woman she followed trends—now she sets her own.

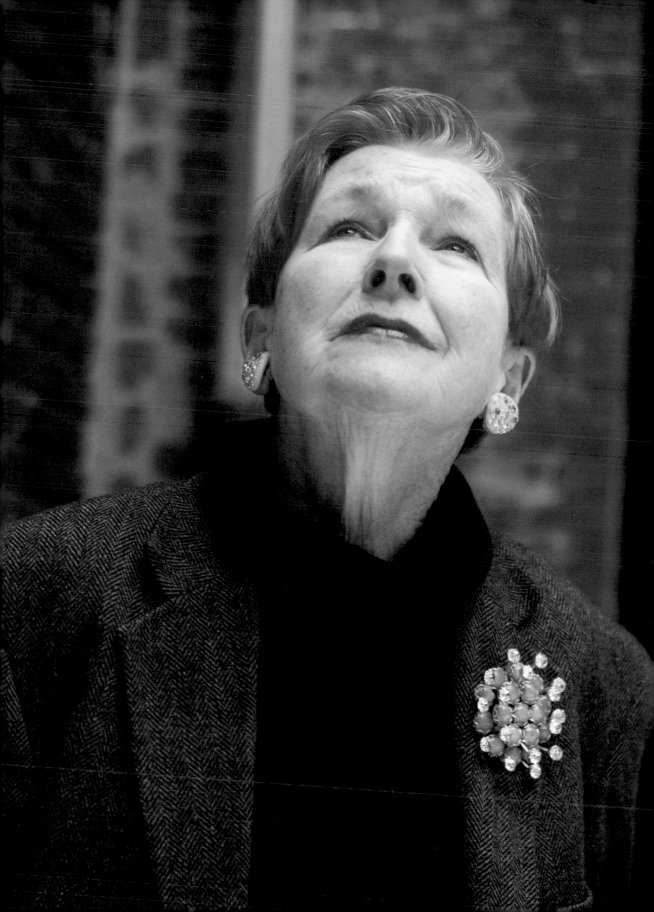

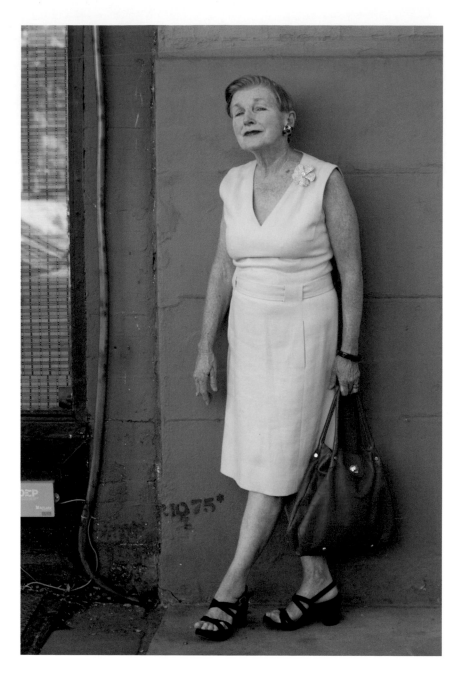

"You don't want to look crazy. The object is to look as chic as you can—but your average person in the street would never wear this."

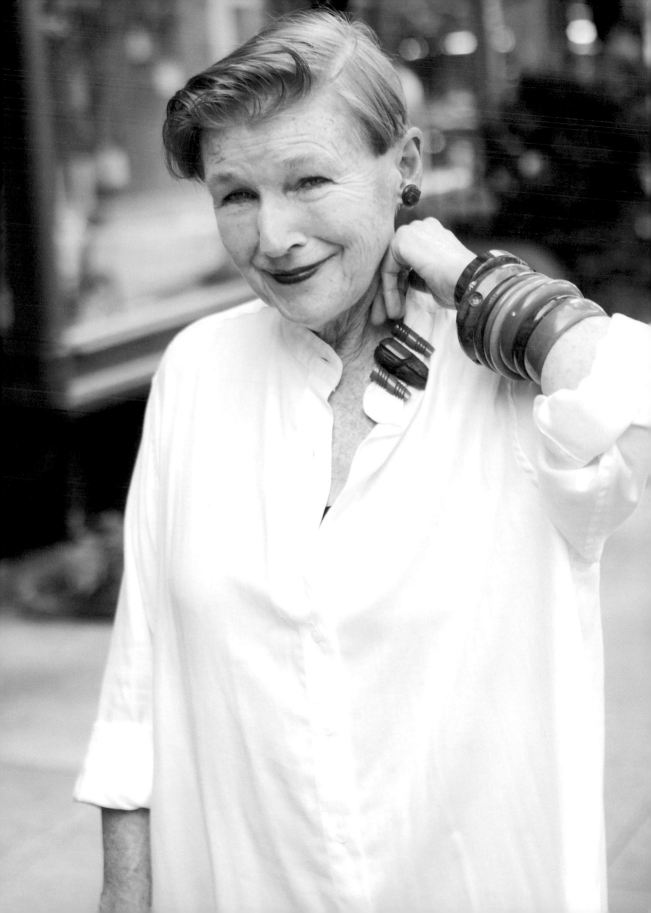

"Fie on
women in
sneakers
and
sweats!"

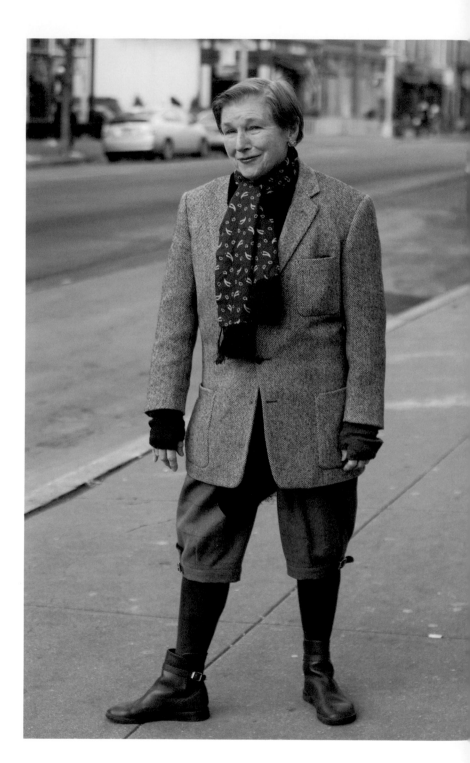

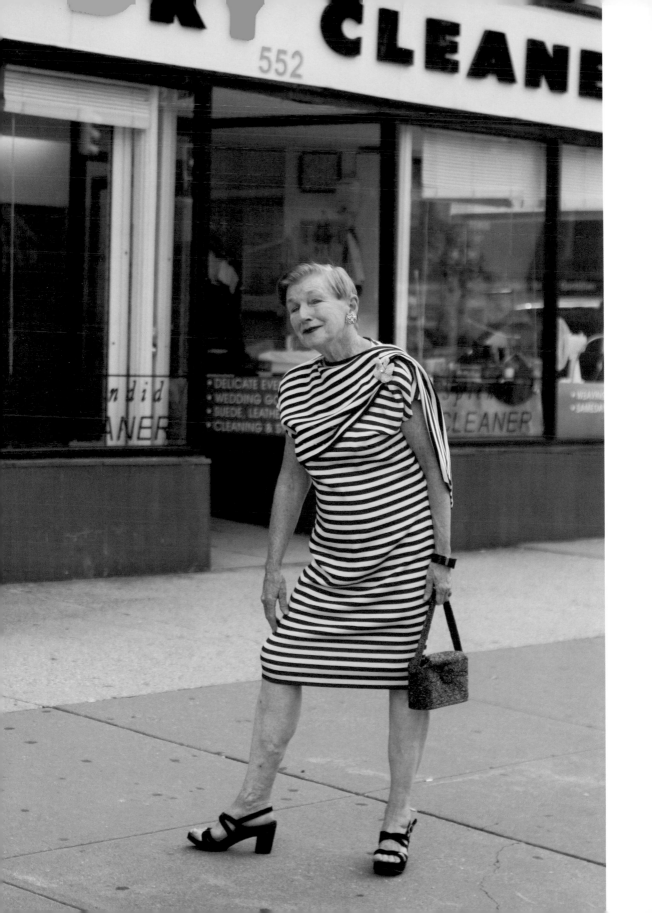

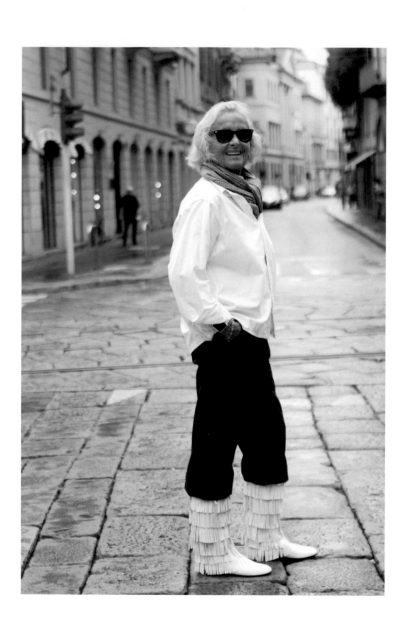

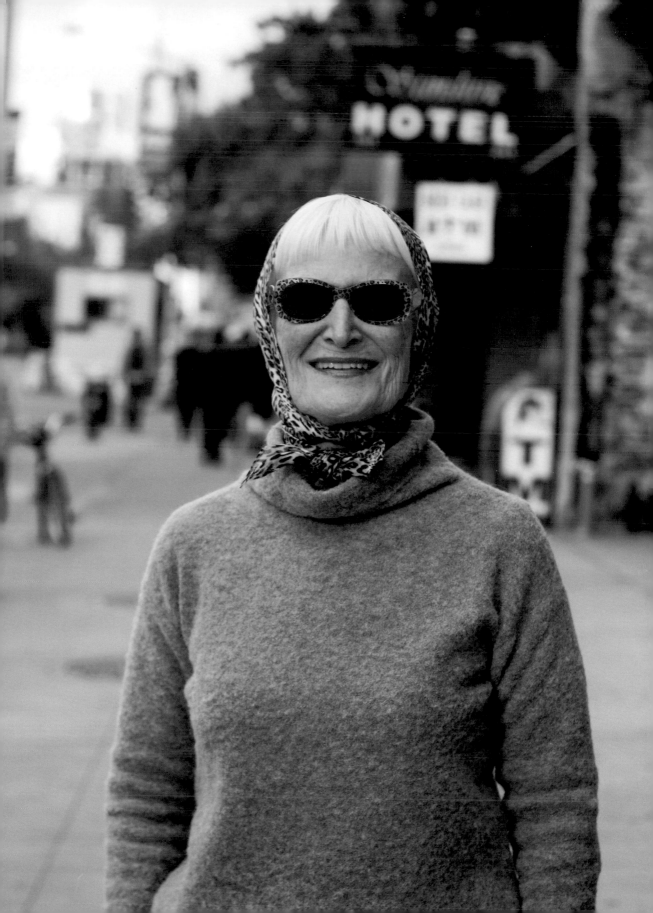

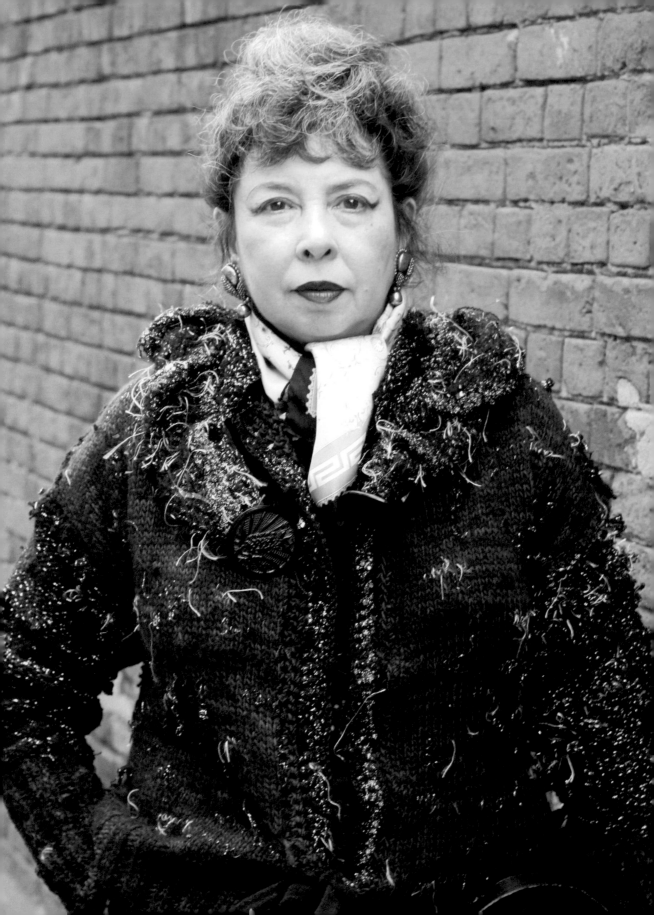

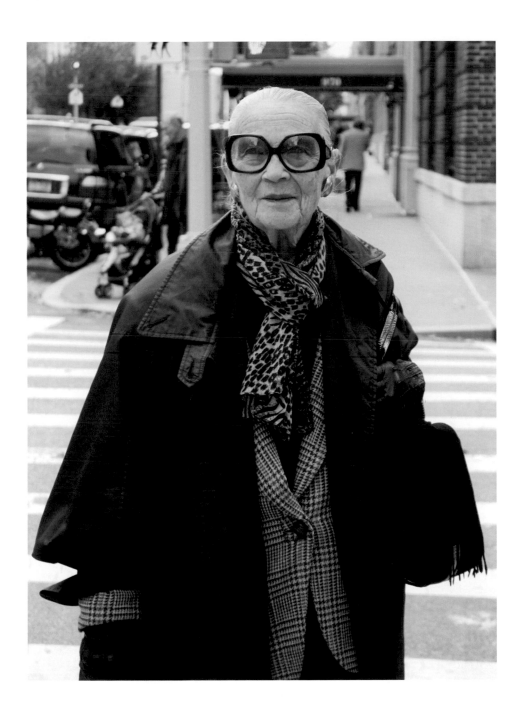

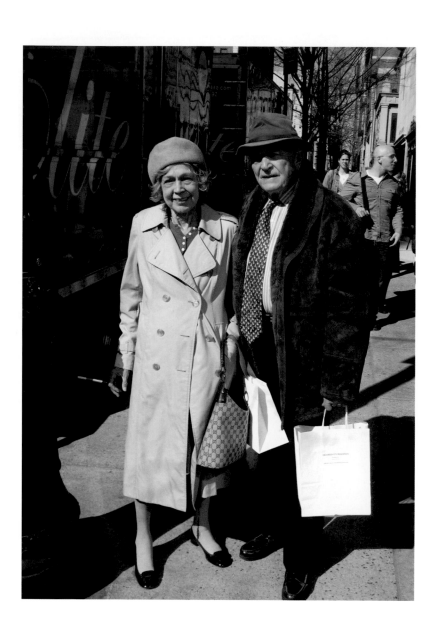

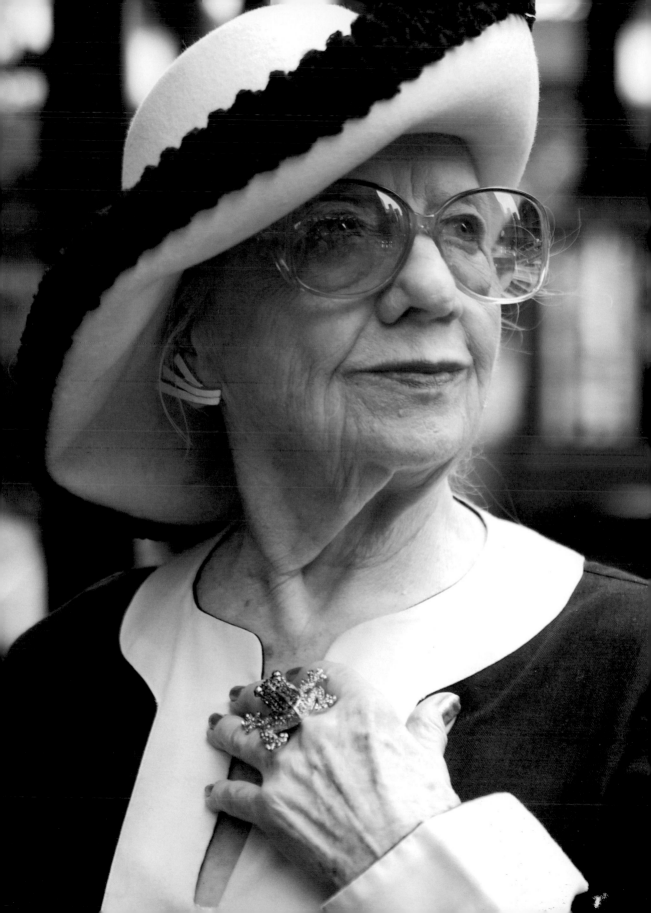

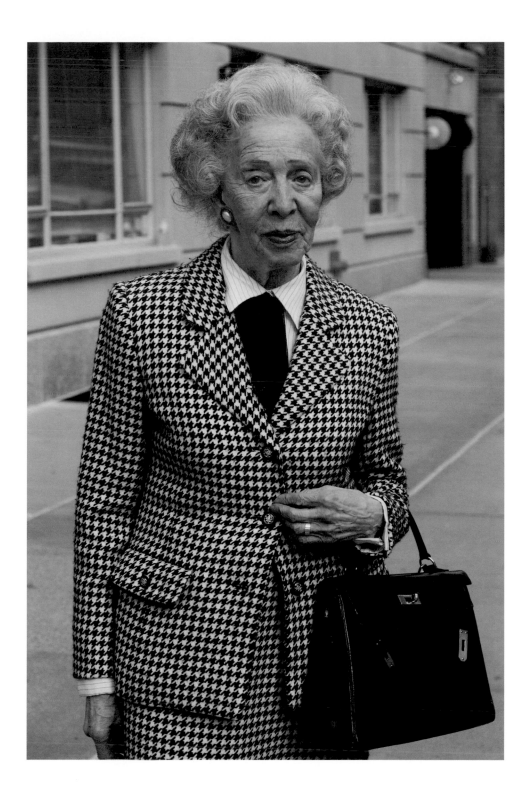

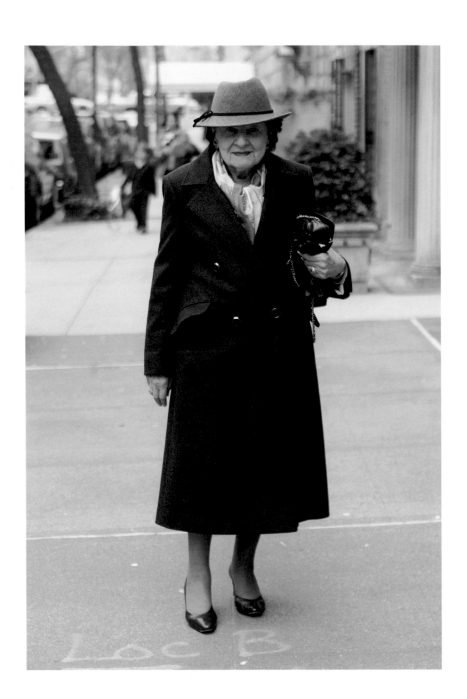

For **Debra Rapoport**, getting dressed every morning is literally a work of art. She wraps fabric in unexpected ways, turns her skirts backwards or upside down and stacks on kitchen utensils, resulting in the most wonderful creations. Debra believes that style has the power to heal—playing dress-up is a process full of self-discovery and joy.

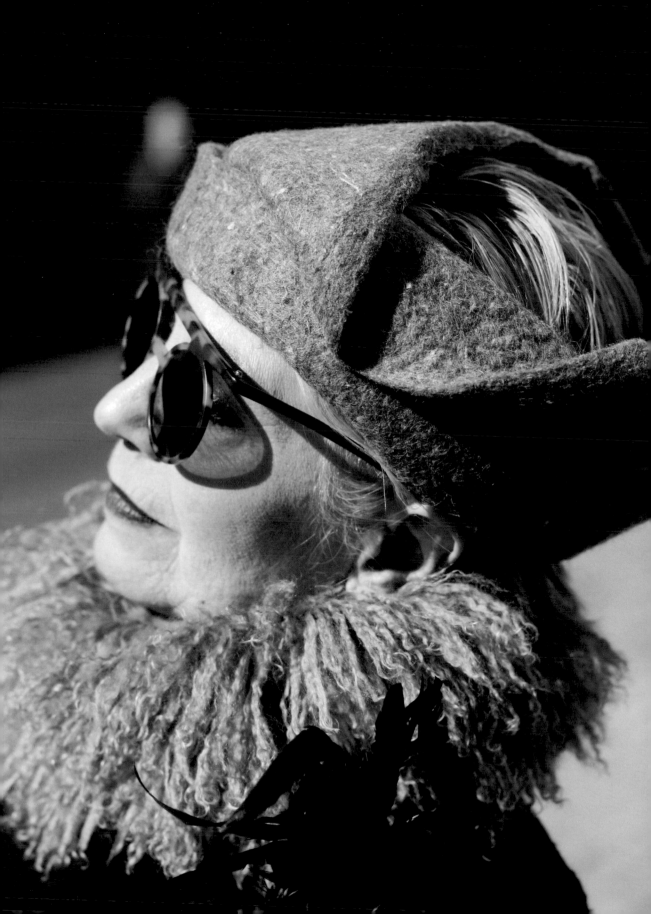

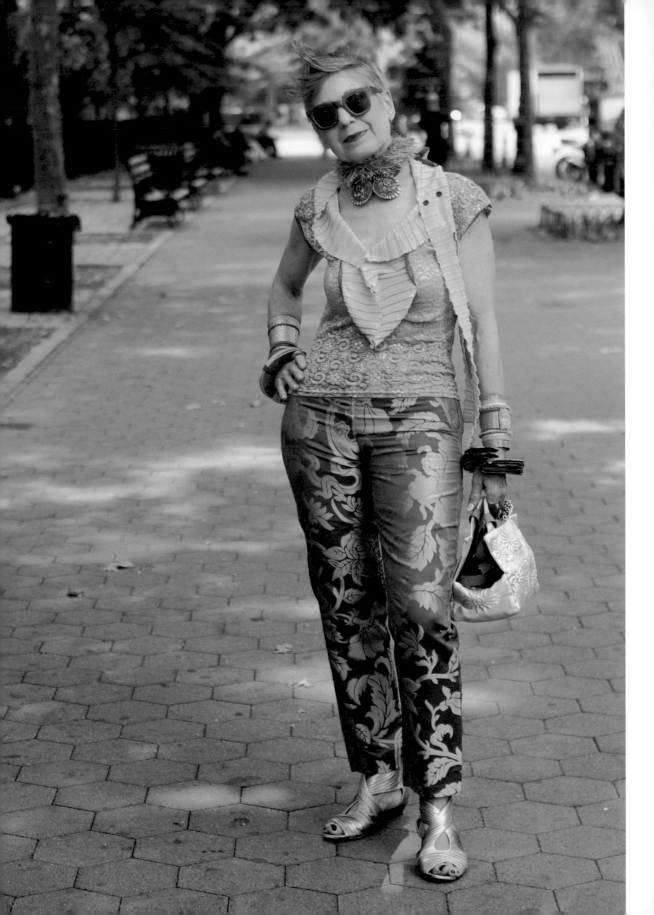

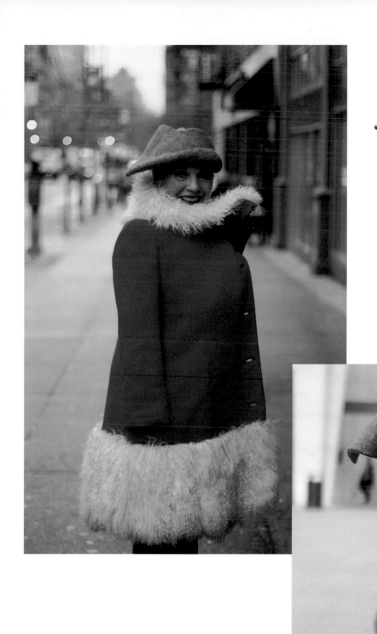

"I don't believe in age-appropriate dress; just make your personal statement and feel confident about it. Tomorrow is another day and another look."

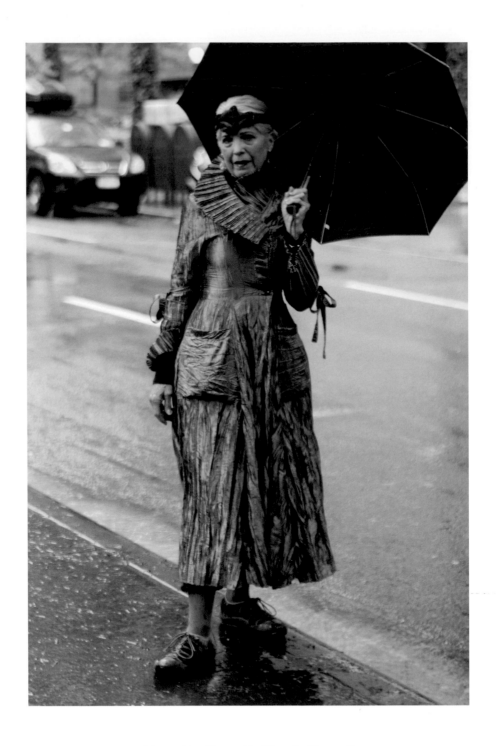

**"Look Good, Feel Good.
Feel Good, Look Good."**

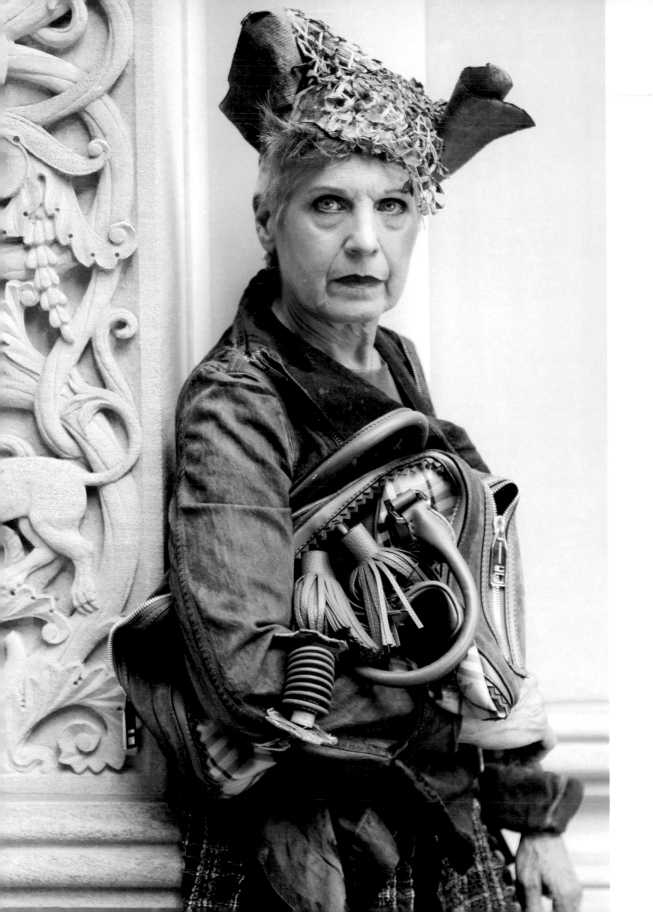

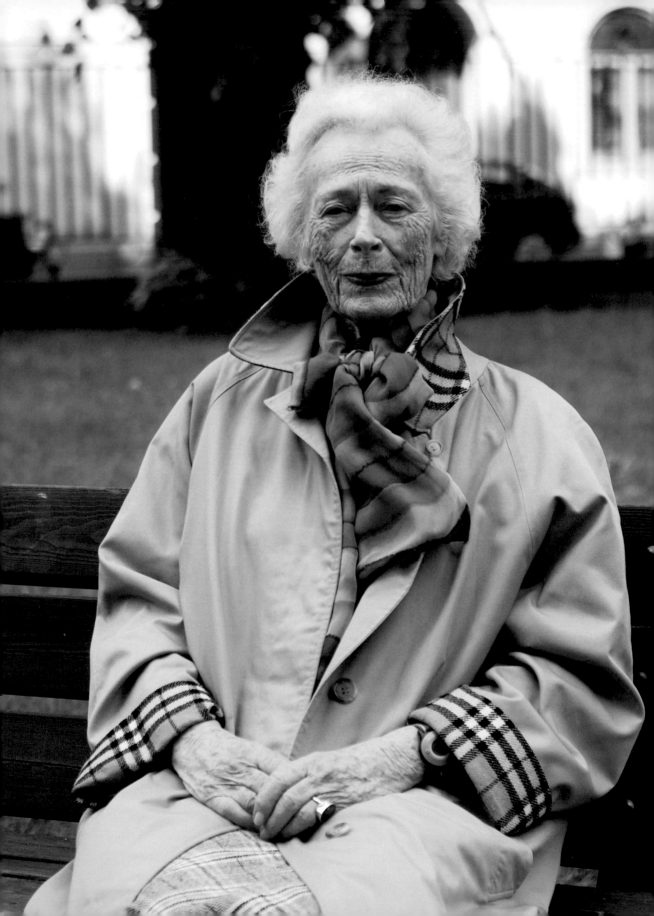

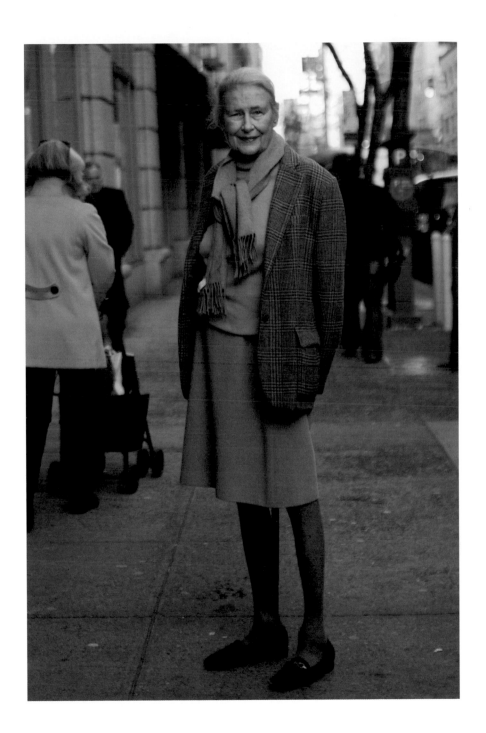

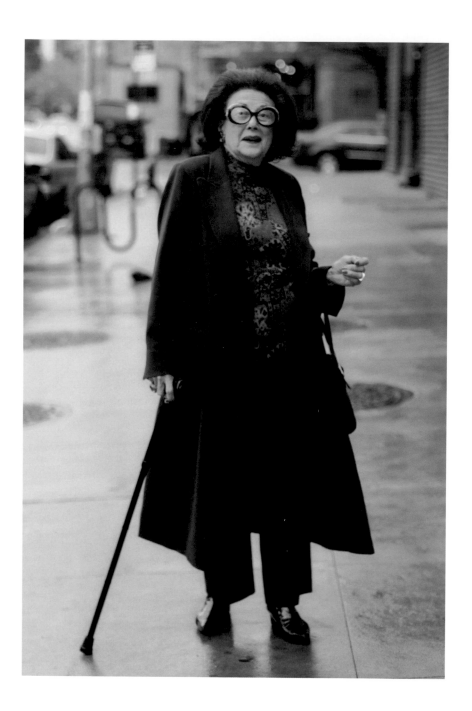

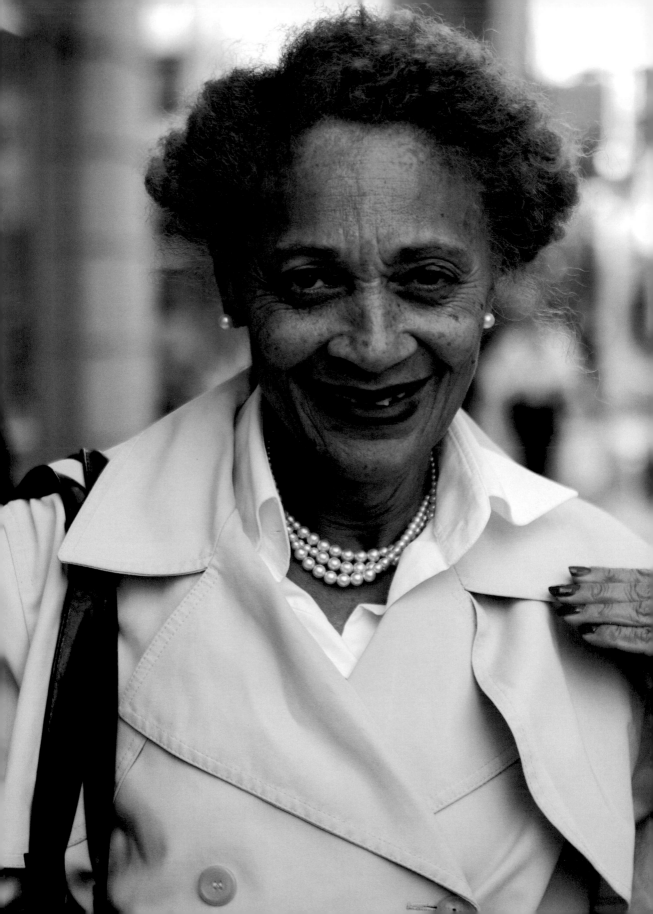

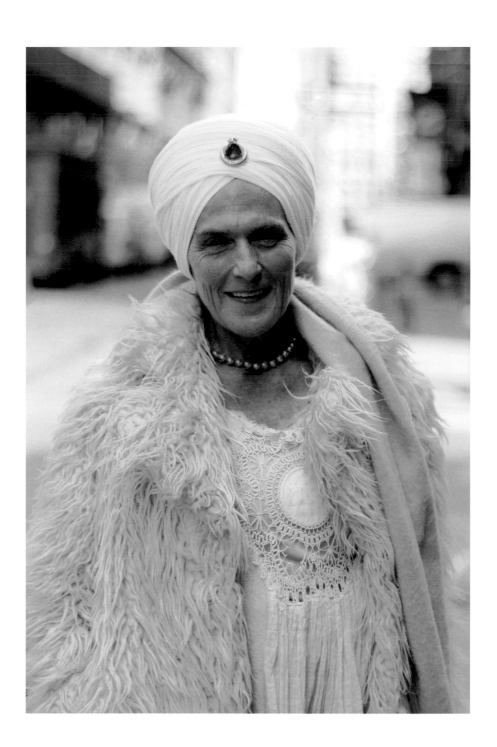

When I first saw **Ilona Royce Smithkin** and her amazing eyelashes, I realized immediately that I was in the presence of someone very special. Known primarily for her talent as an artist and more recently as a cabaret performer, Ilona's spirit and artistic nature shine through her wild and wonderful costumes. Whether magically transforming old scarves into beautiful dresses, or fashioning capes out of discarded umbrellas, Ilona constantly proves she is a true original.

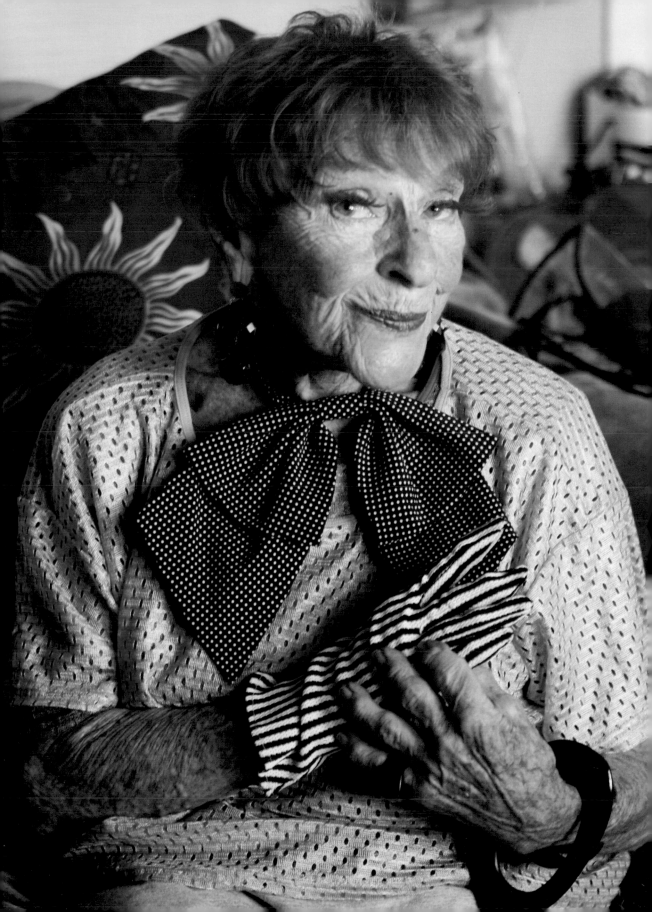

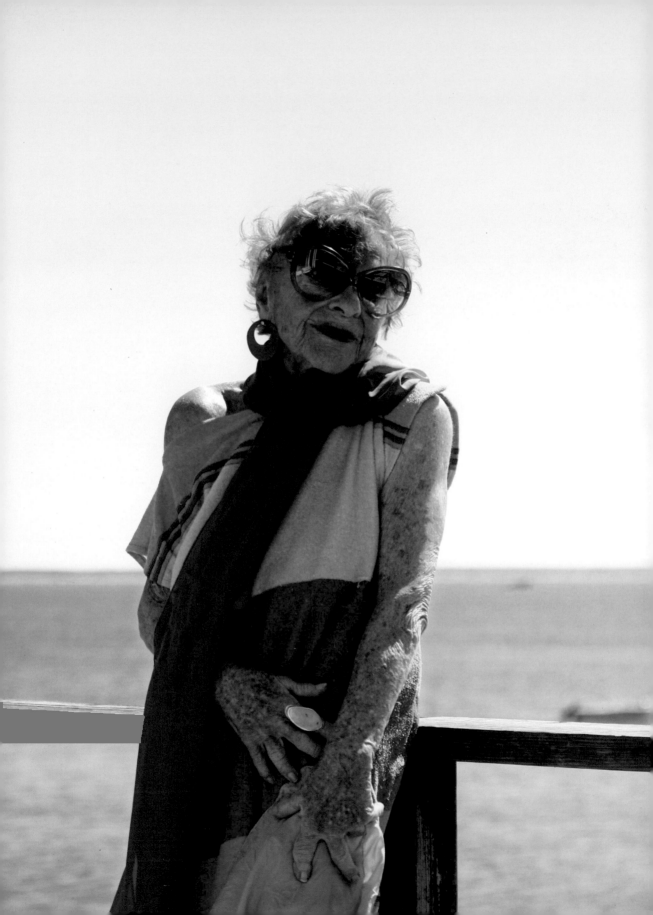

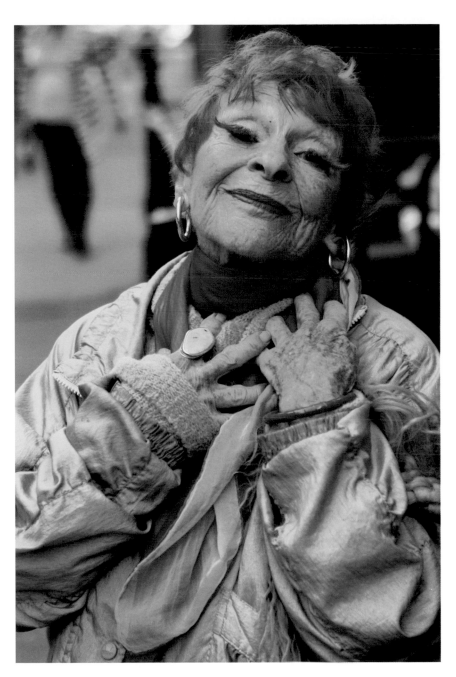

"Feel beautiful inside,
and you will be beautiful
outside."

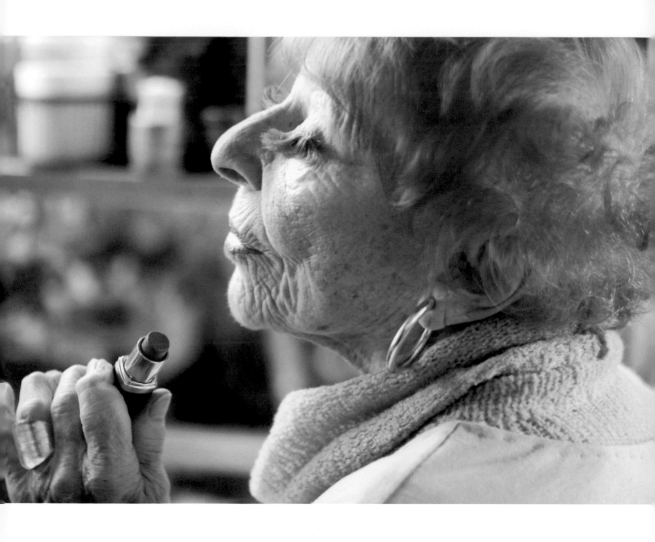

"If you try to imitate too
much, you will look like
nothing. Never compare.
You are you!"

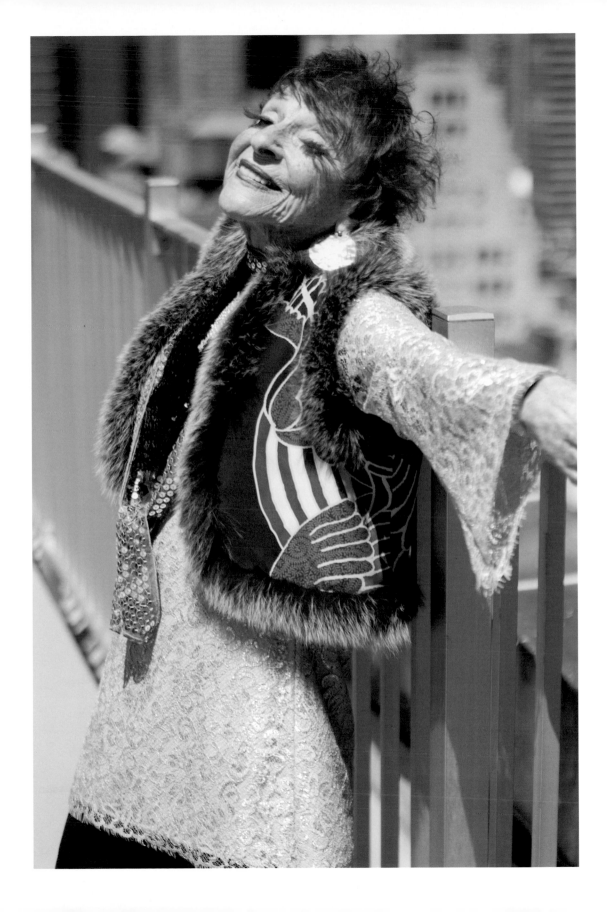

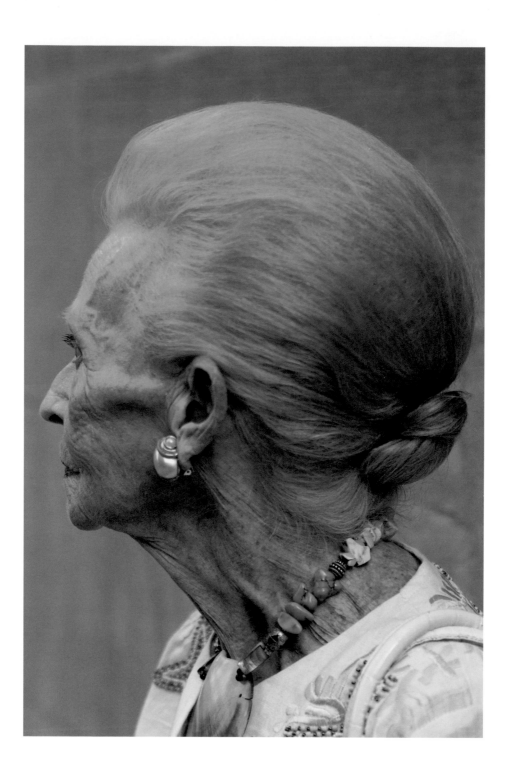

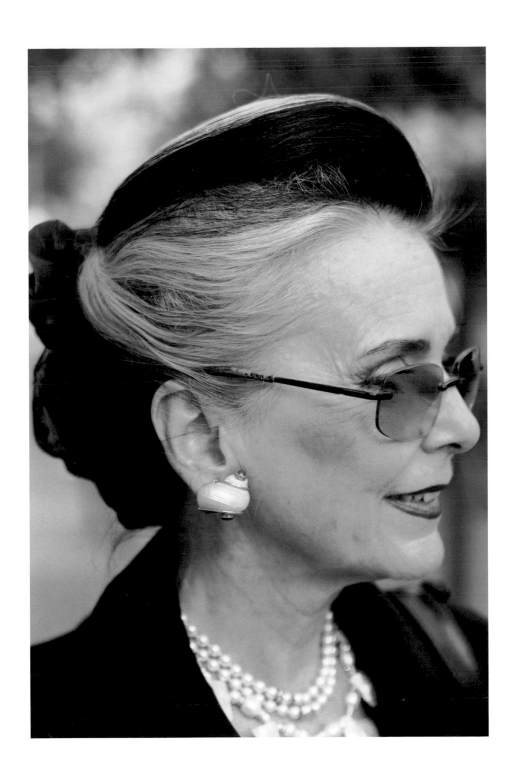

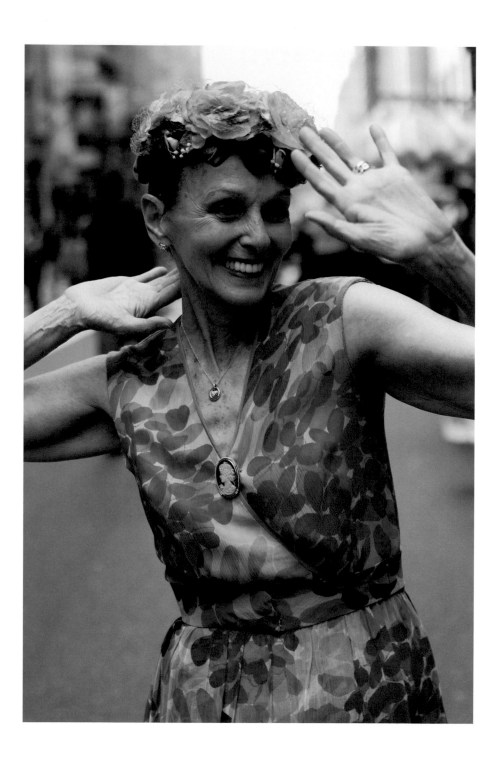

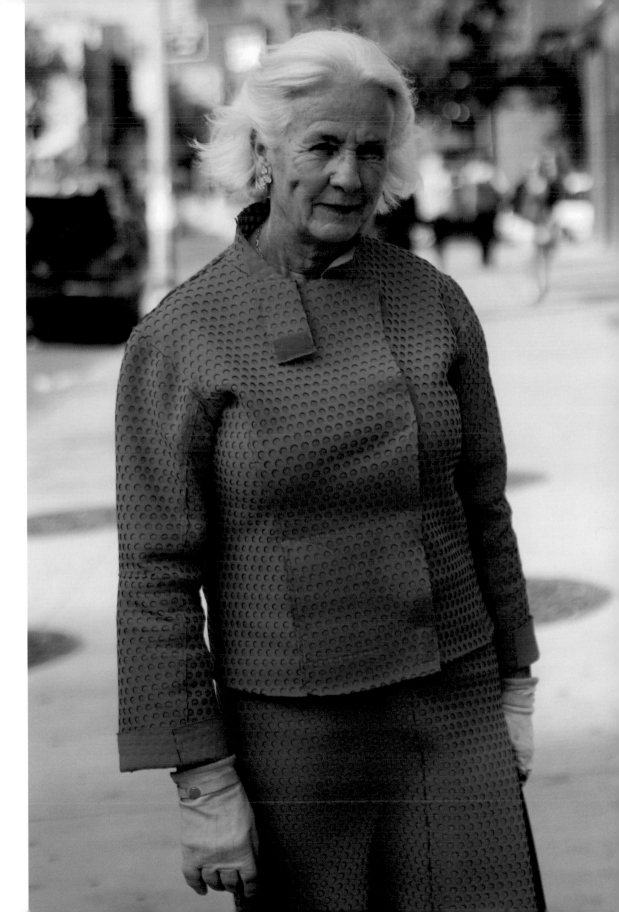

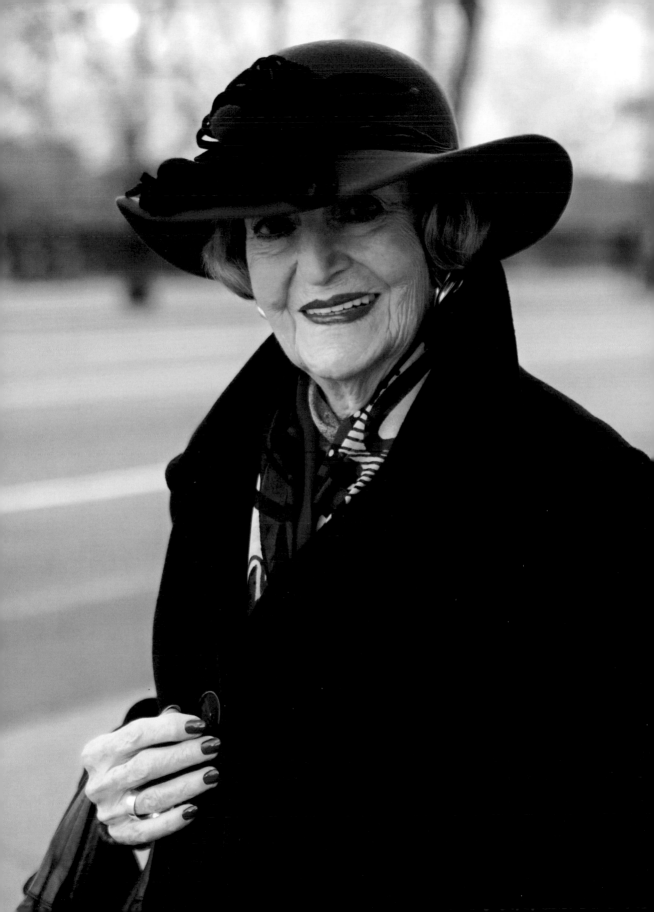

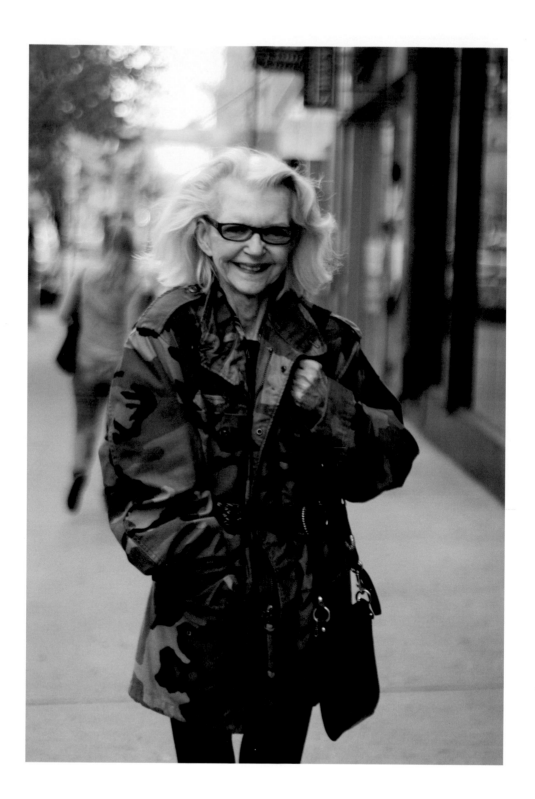

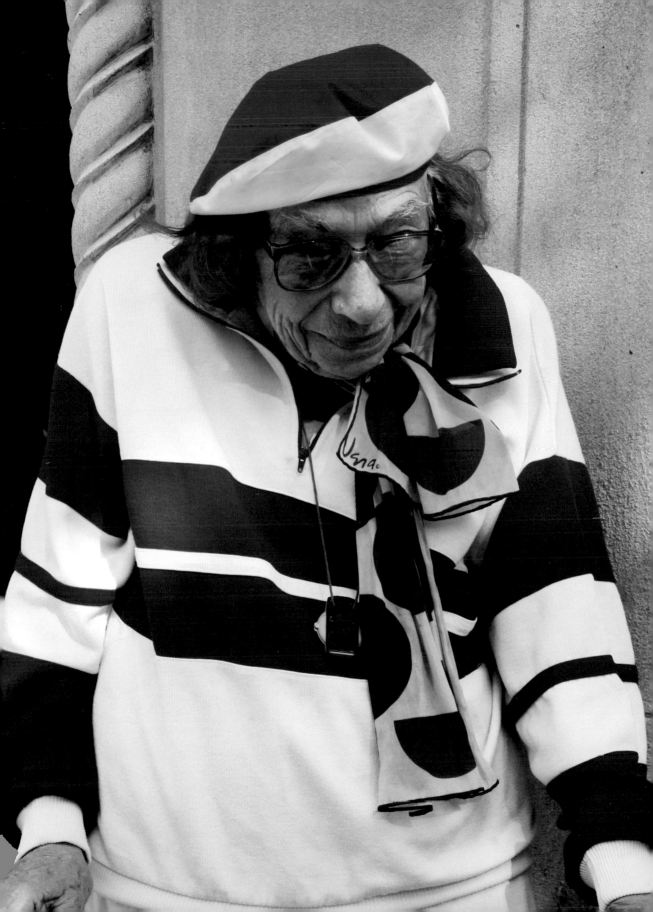

My first sighting of artist and writer **Beatrix Ost** in Central Park stopped me dead in my tracks. Her dark lipstick, elegant black hat, and hint of blue hair against her pale complexion made for a stunning combination. Beatrix believes that great style starts with good food. She scribbled the words "food and love is art enough" on her kitchen wall to remind herself that feeling good is the first step towards looking good.

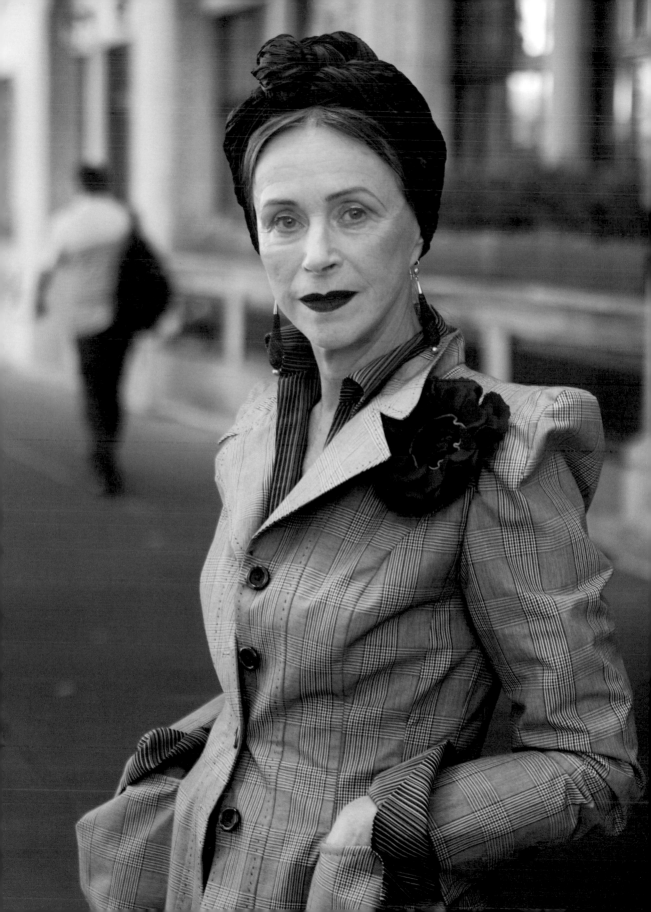

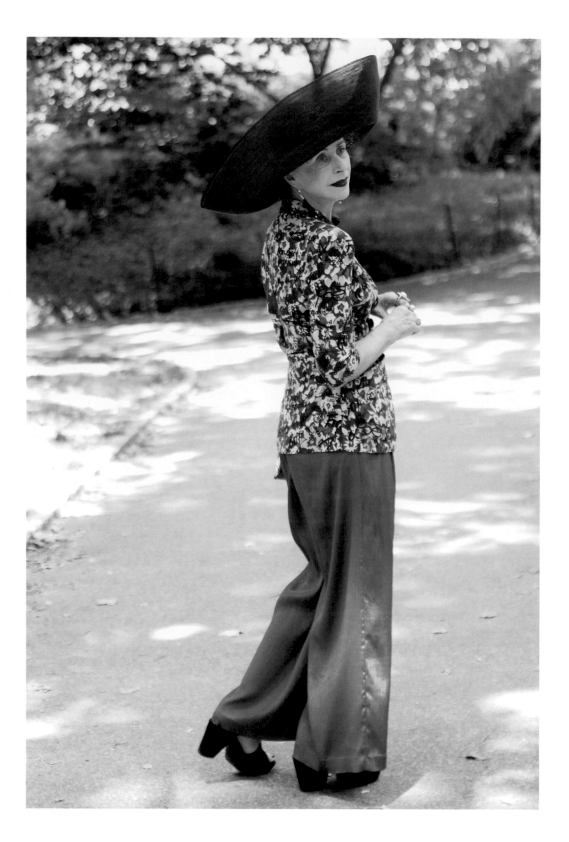

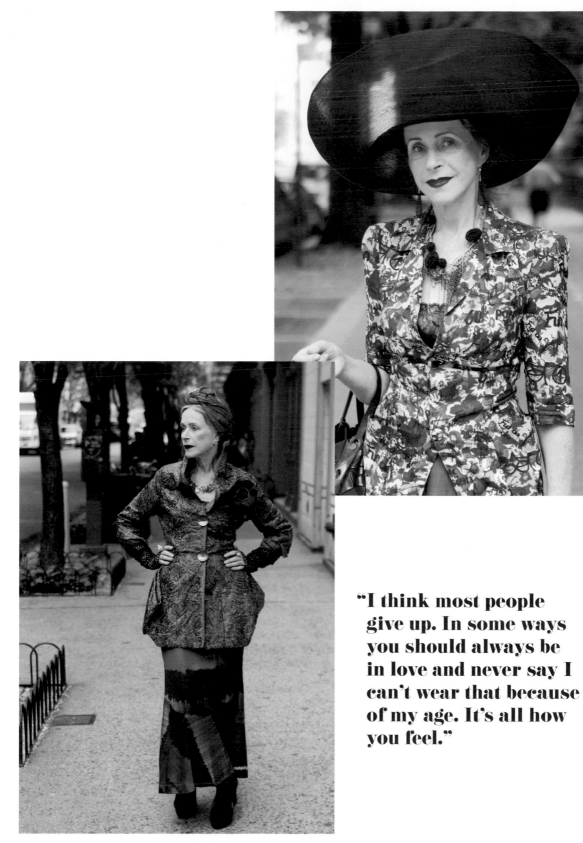

"I think most people give up. In some ways you should always be in love and never say I can't wear that because of my age. It's all how you feel."

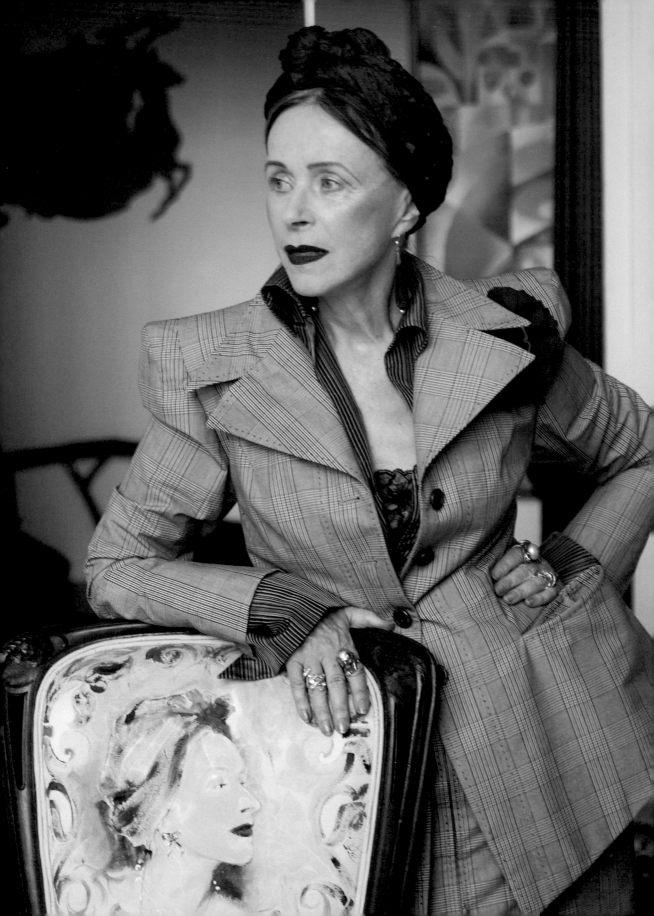

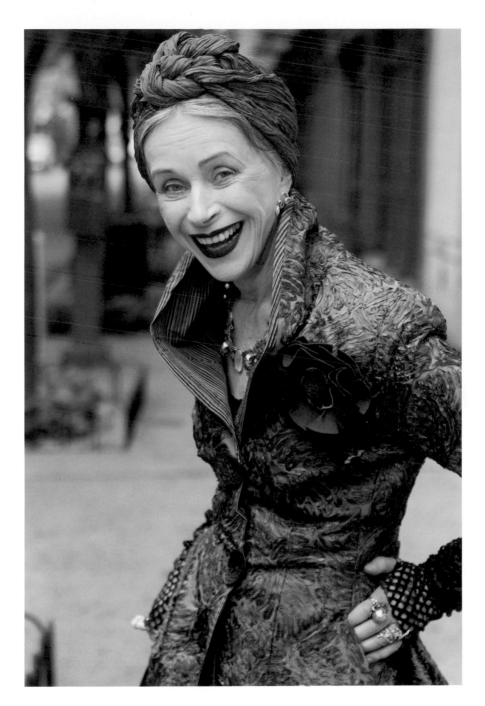

"In your body is a good
place to be."

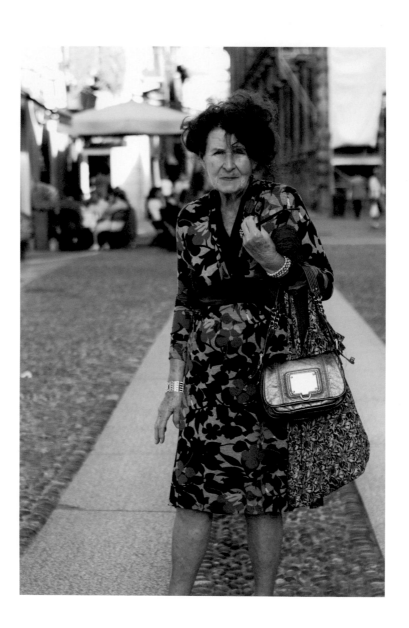

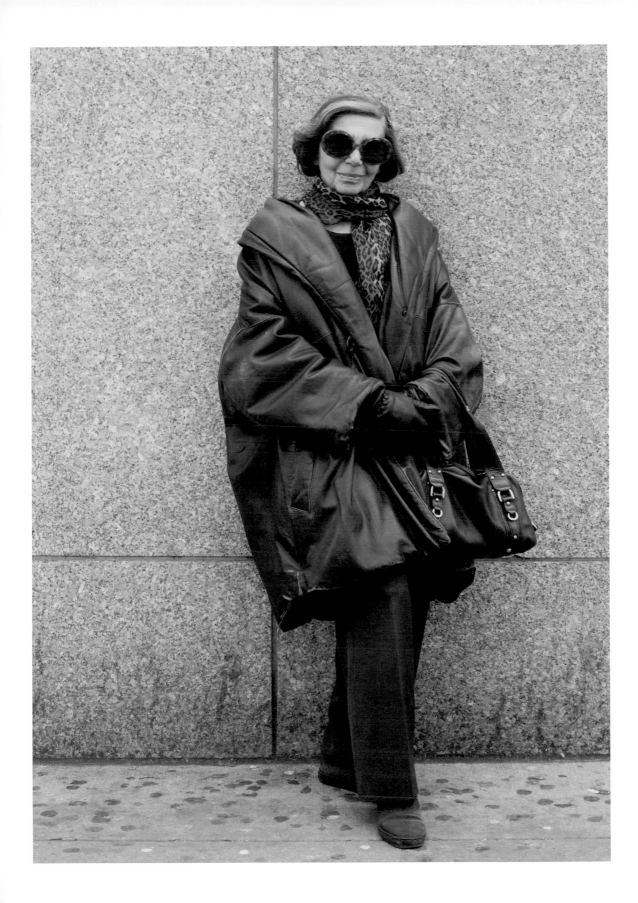

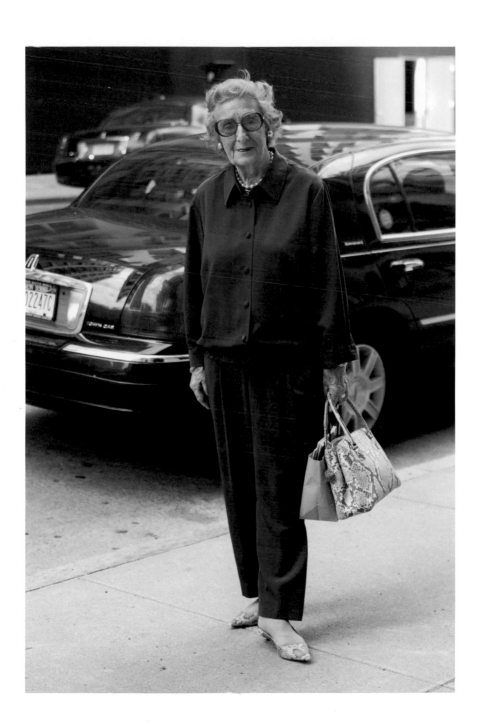

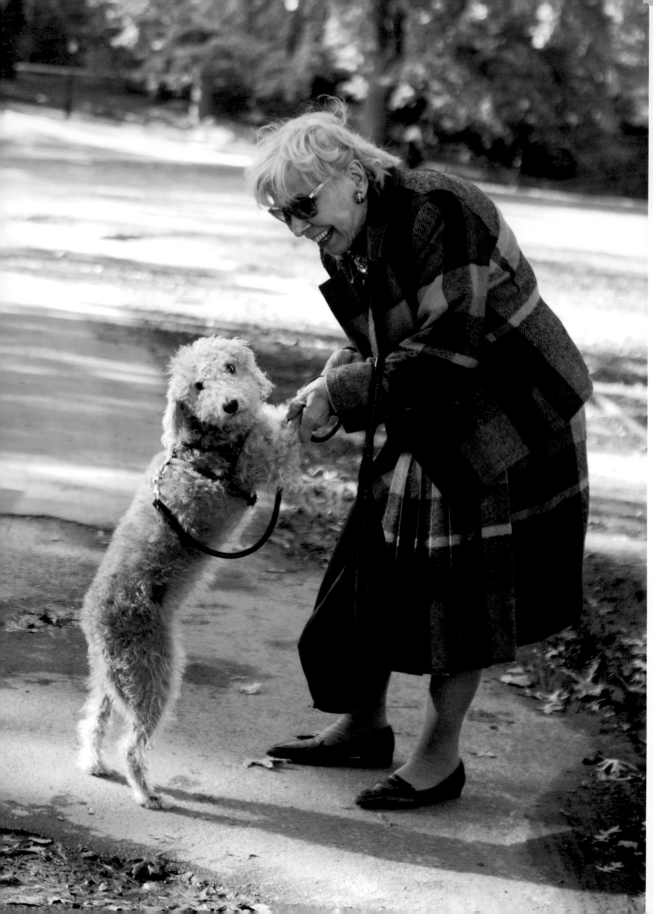

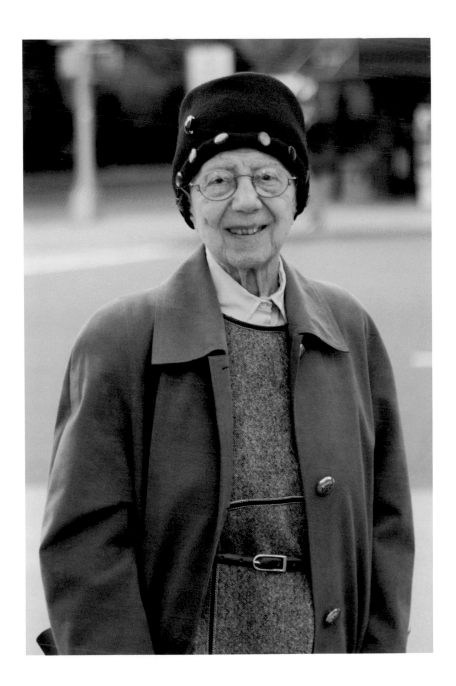

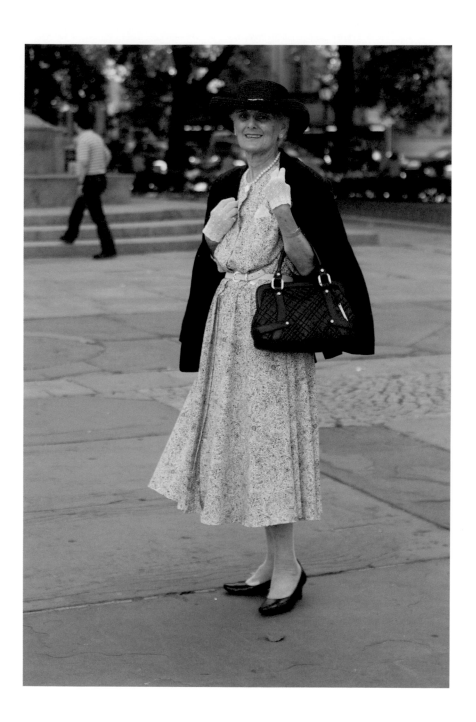

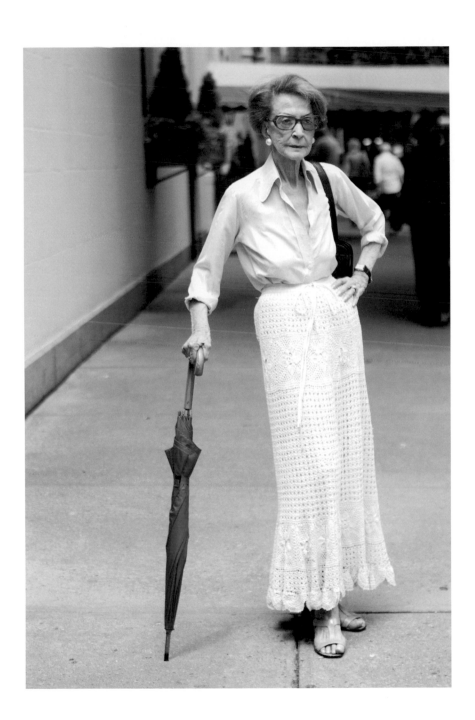

At 80 years old, **Joyce** has acquired a lifetime of style wisdom and insight. For her, elegance is of the utmost importance—a quality, in her opinion, that is refined with age. Rarely seen without her signature pearls and a gorgeous pair of gloves, Joyce is the epitome of classic beauty and charm.

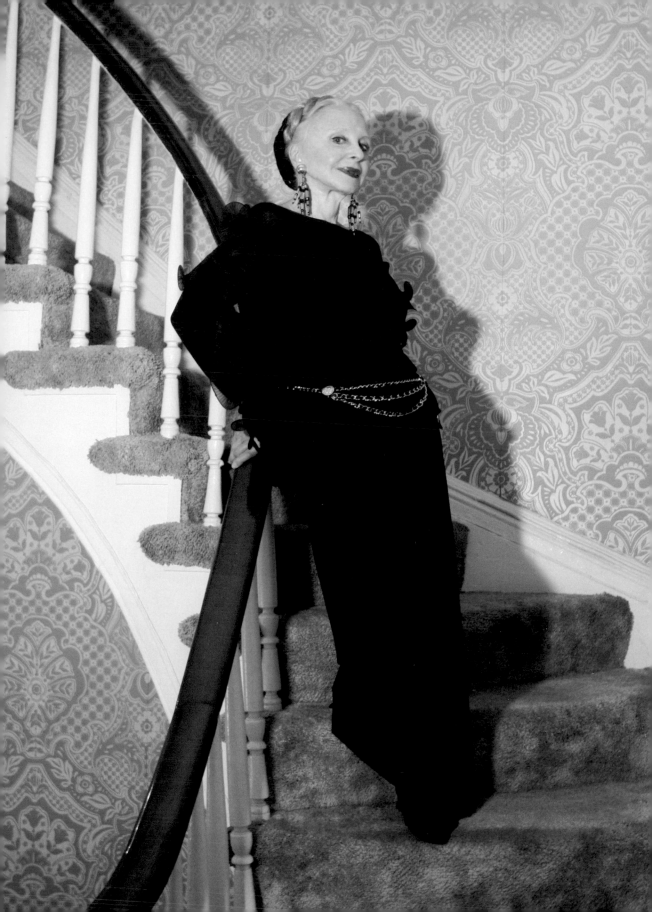

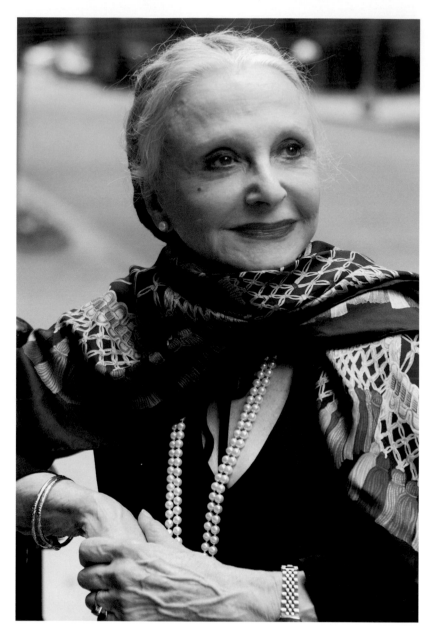

"Style is about the right
jewelry, the right know-how,
the right neckline, and above
all, the right attitude."

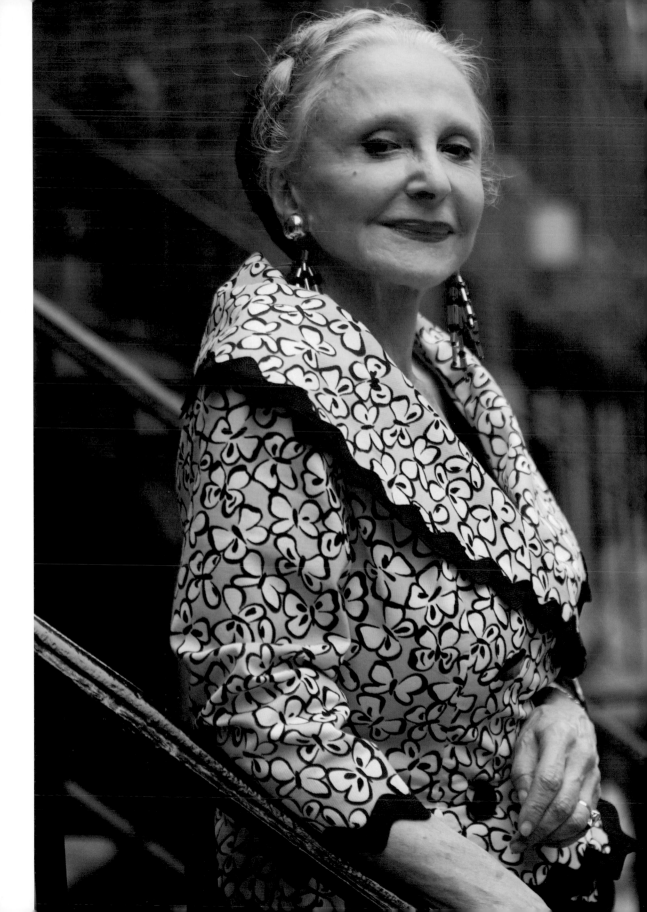

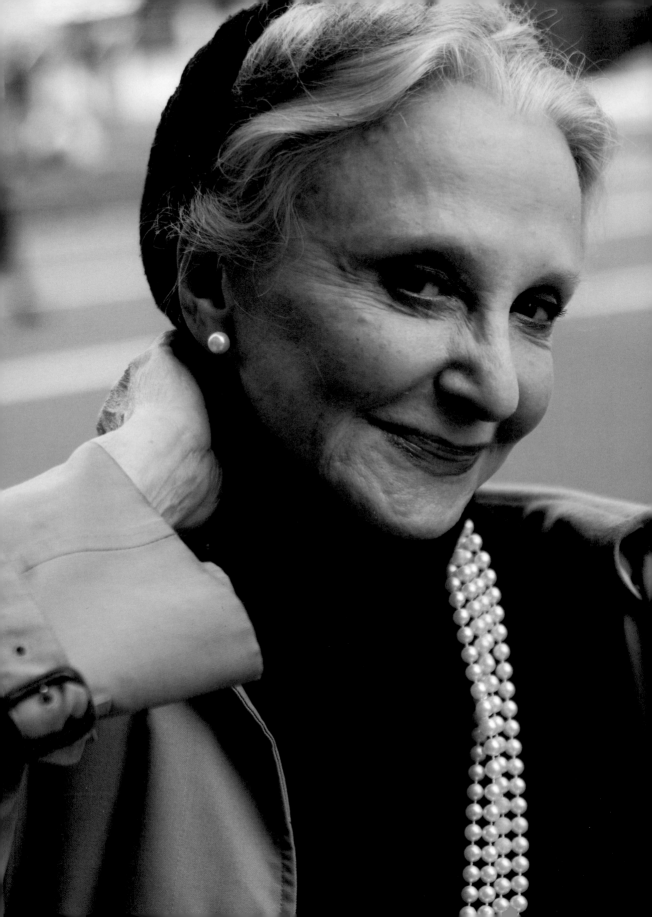

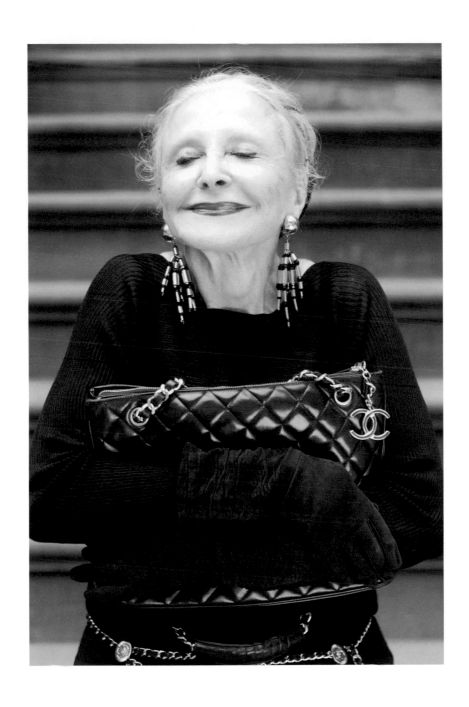

**"You know, for an older woman I don't go for style, I go after elegance. That's what I go for. It was always elegance."**

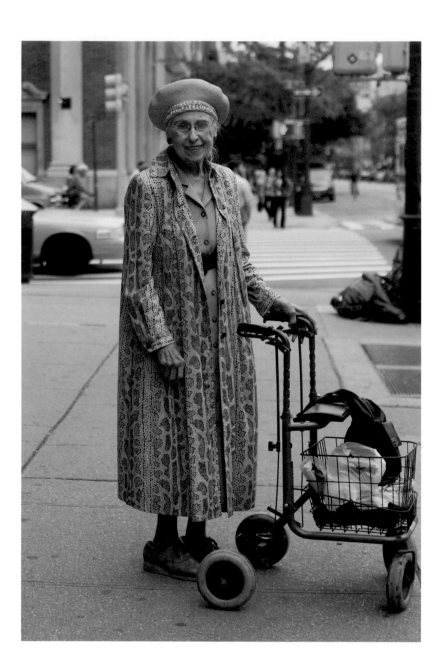

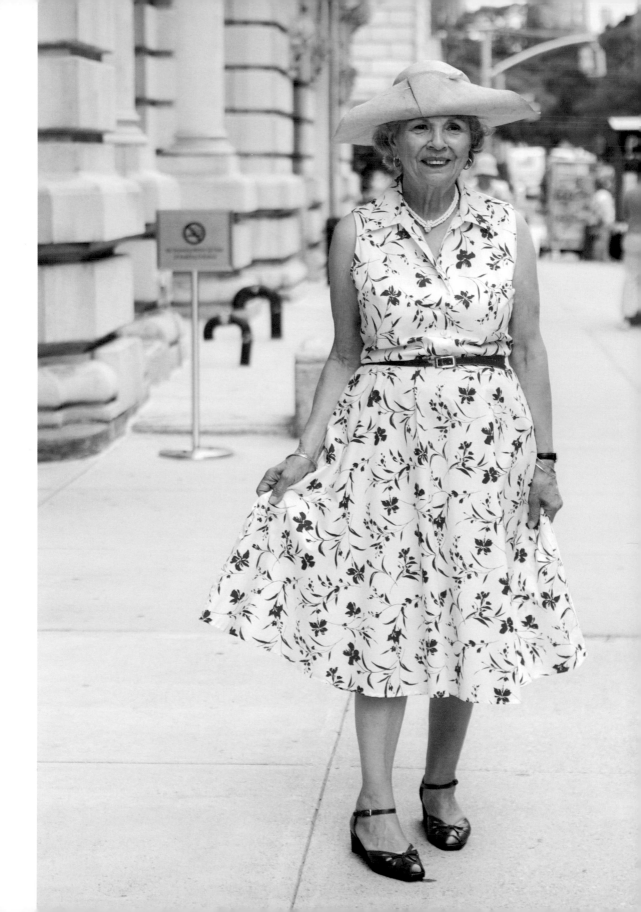

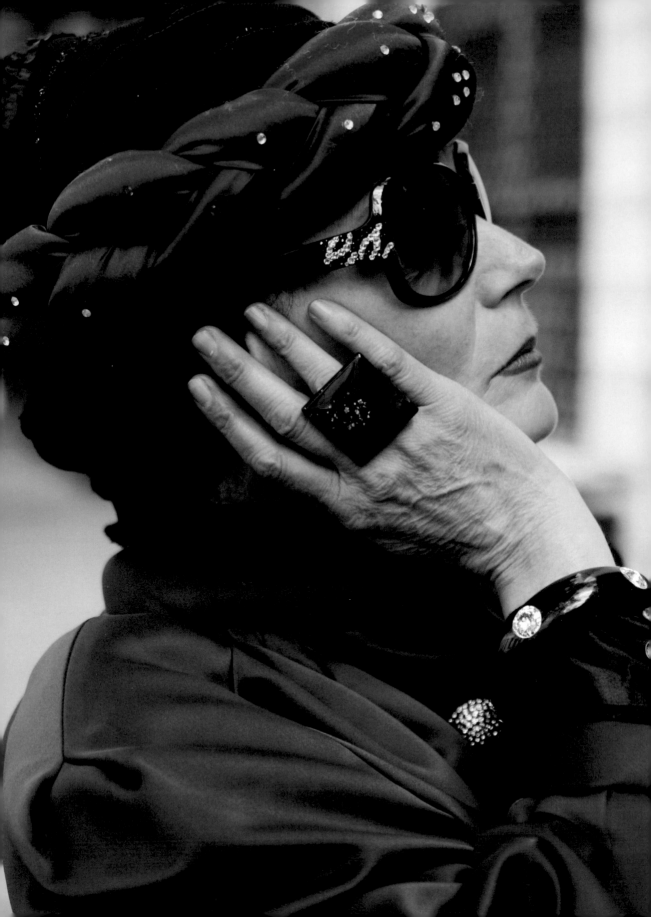

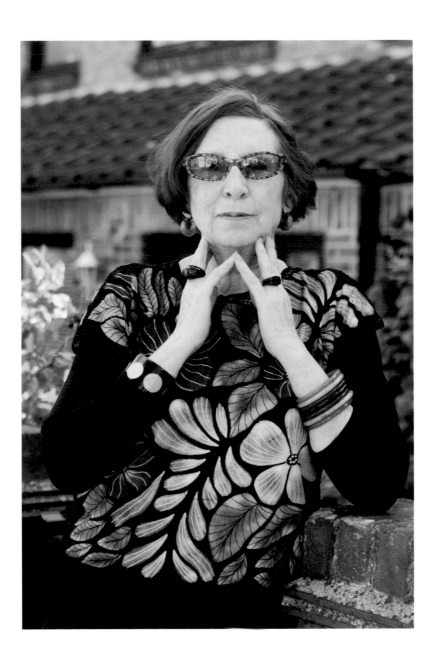

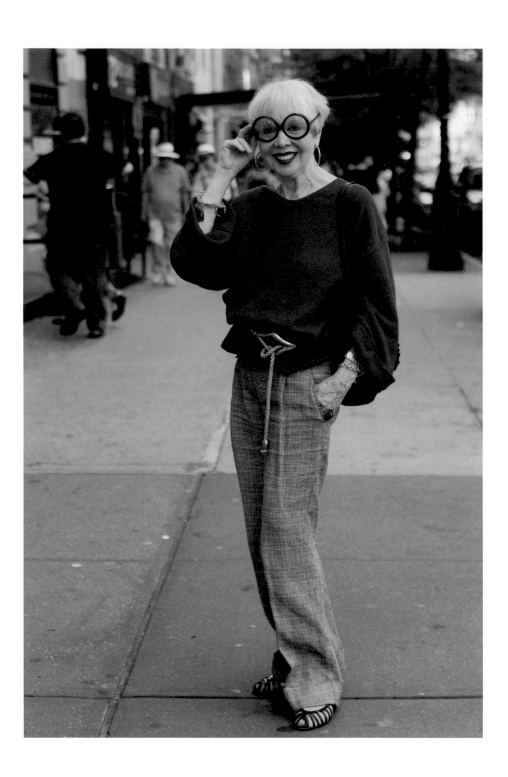

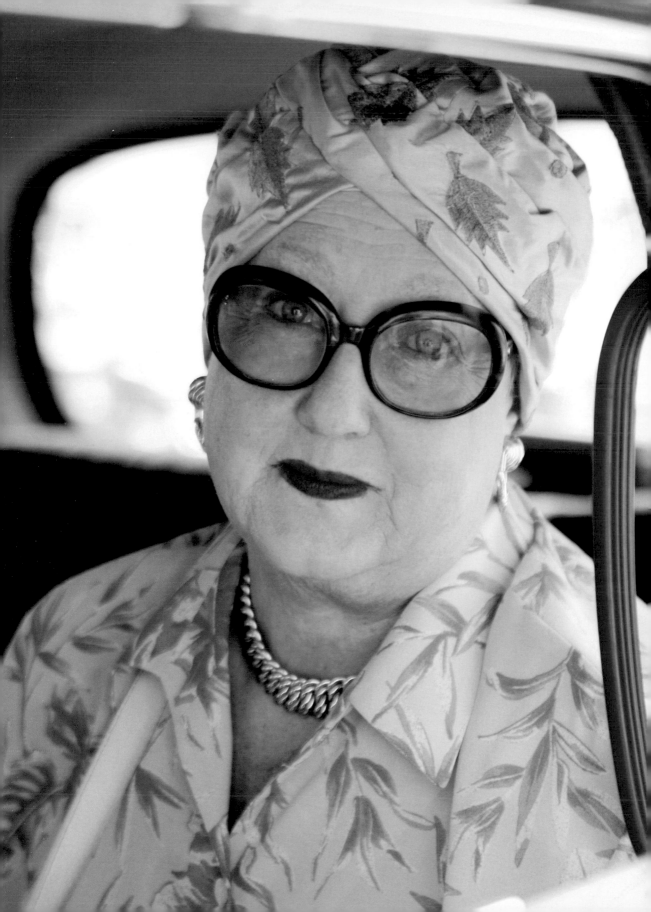

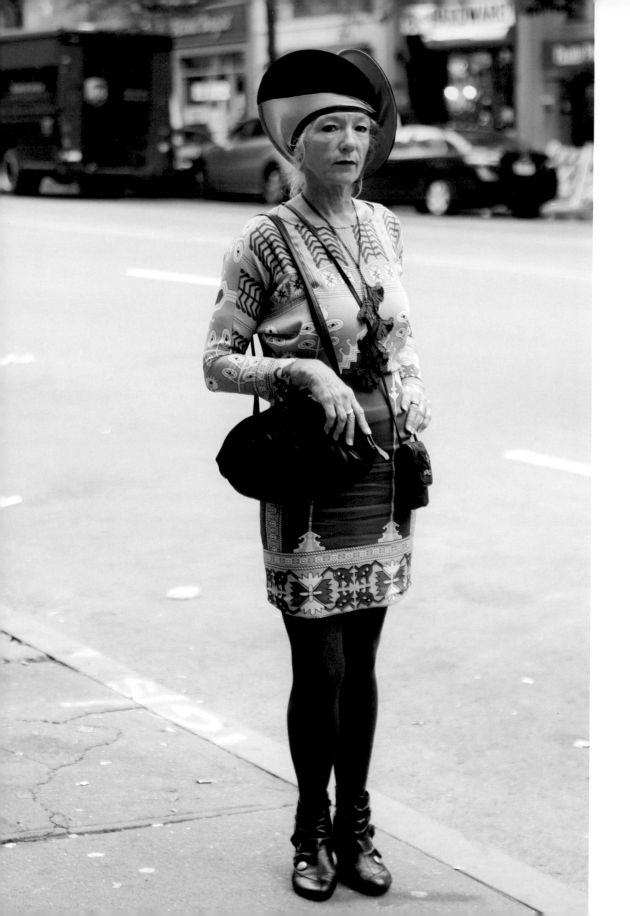

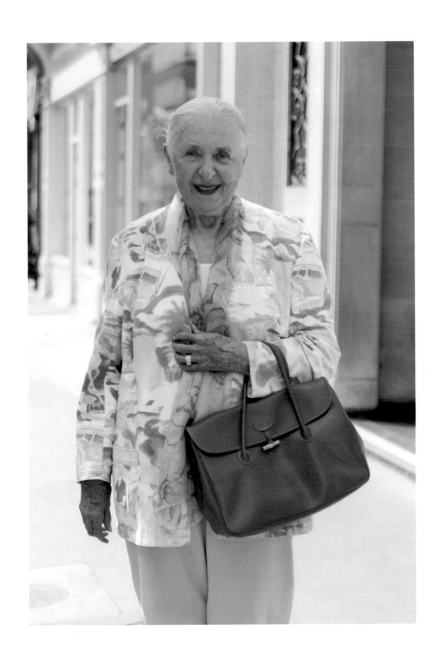

Vintage styles are a favorite among the *Advanced Style* set and **Linda** is definitely no exception. She wears her 1930s-inspired looks with a sophistication unique to women of a certain age. Linda's perfectly tailored suits aren't complete without one of her handsome hats and some well-chosen accessories.

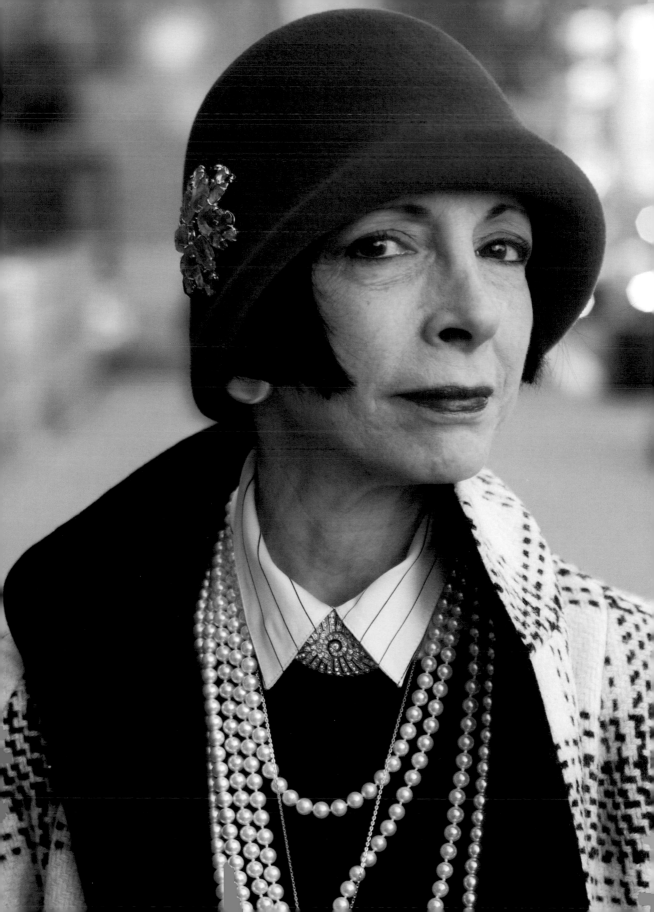

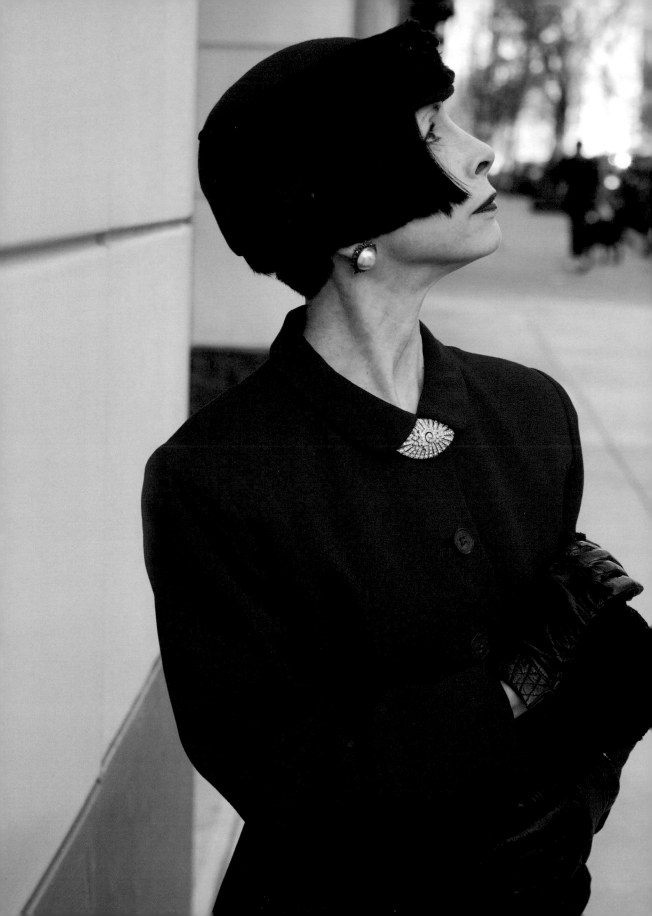

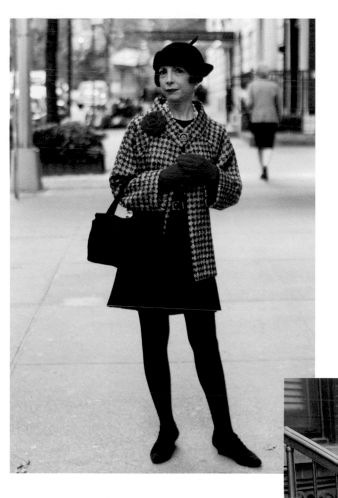
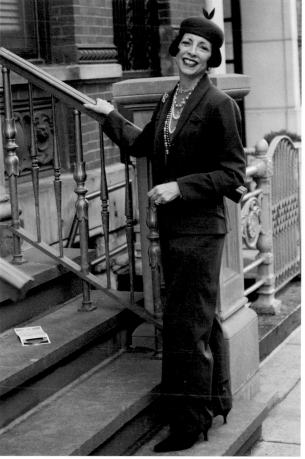

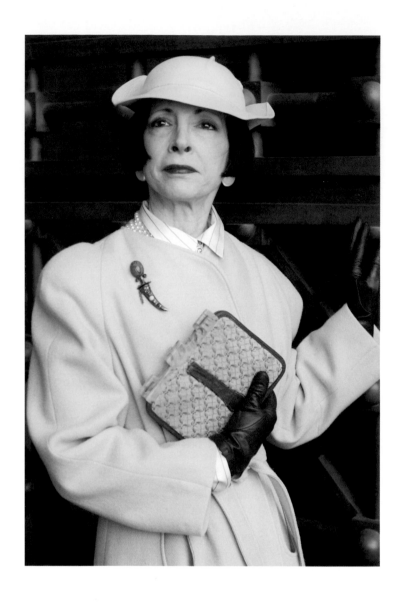

**"When you are younger, you dress for other people. When you are older, you dress for yourself."**

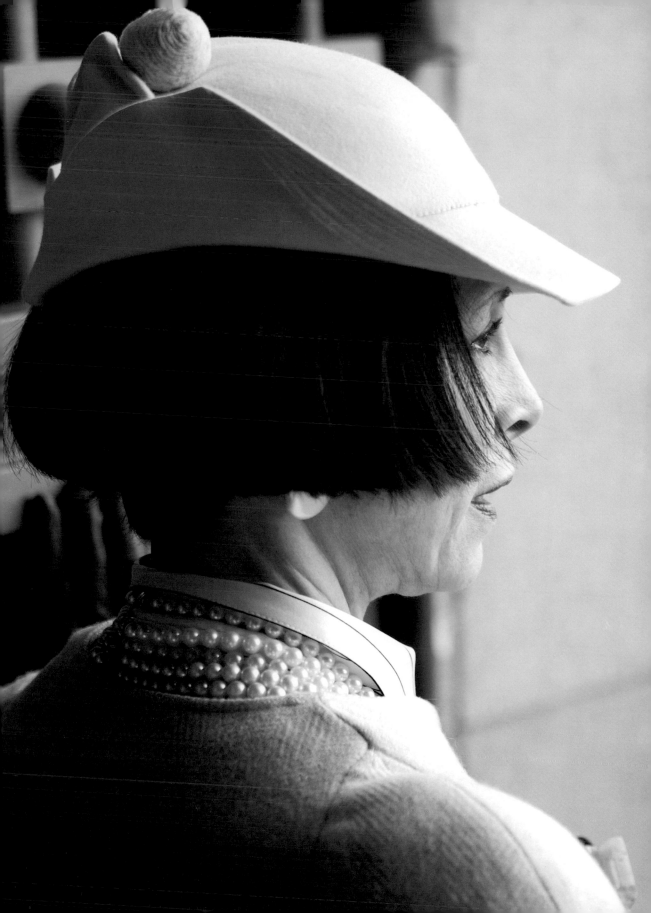

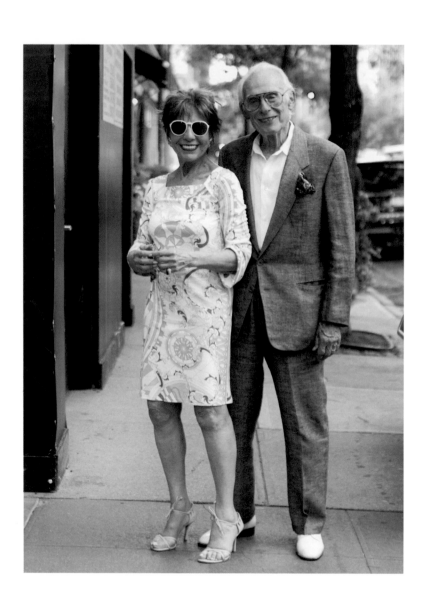

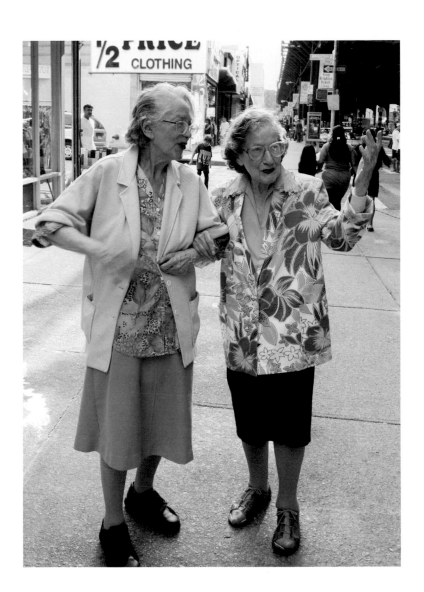

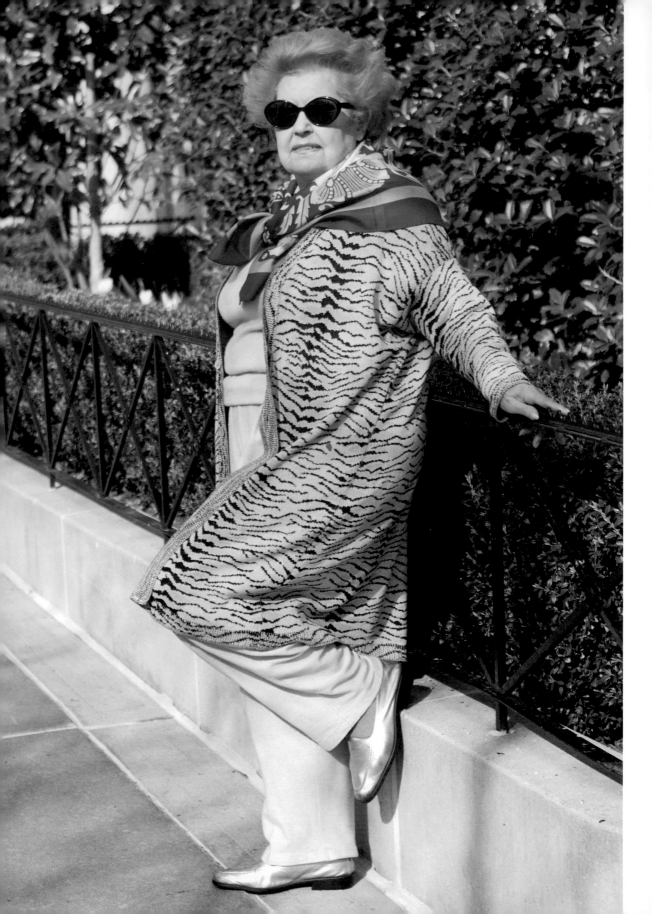

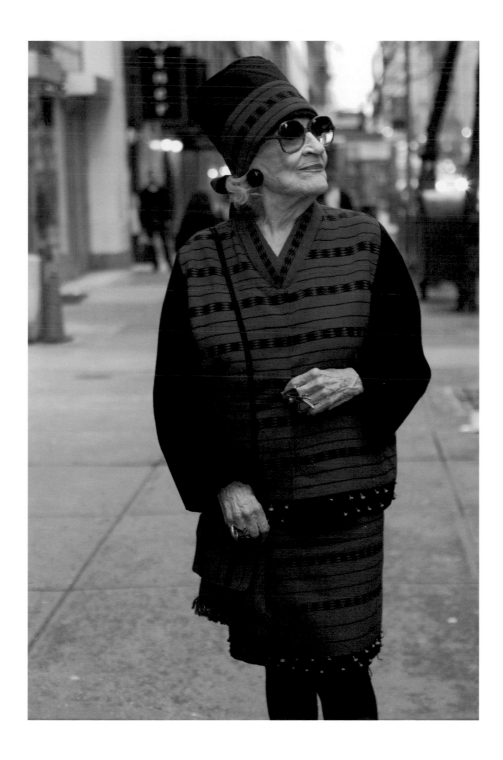

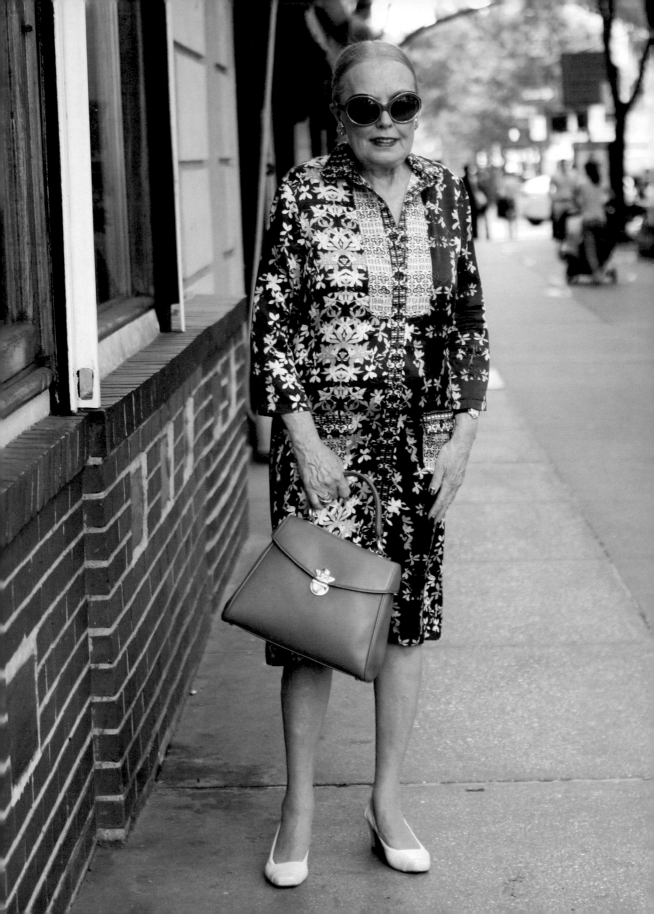

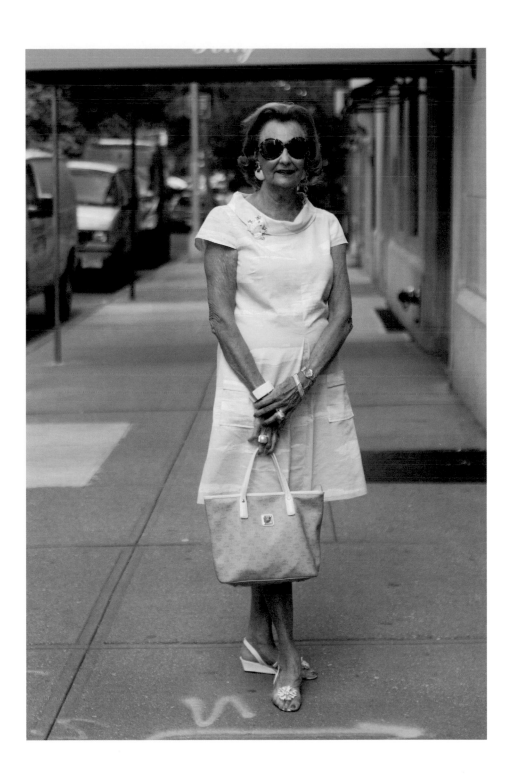

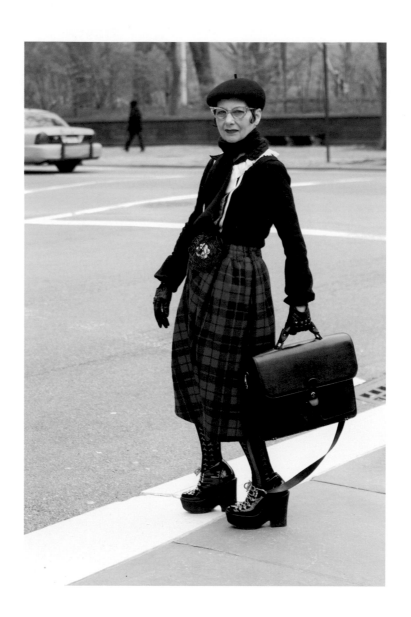

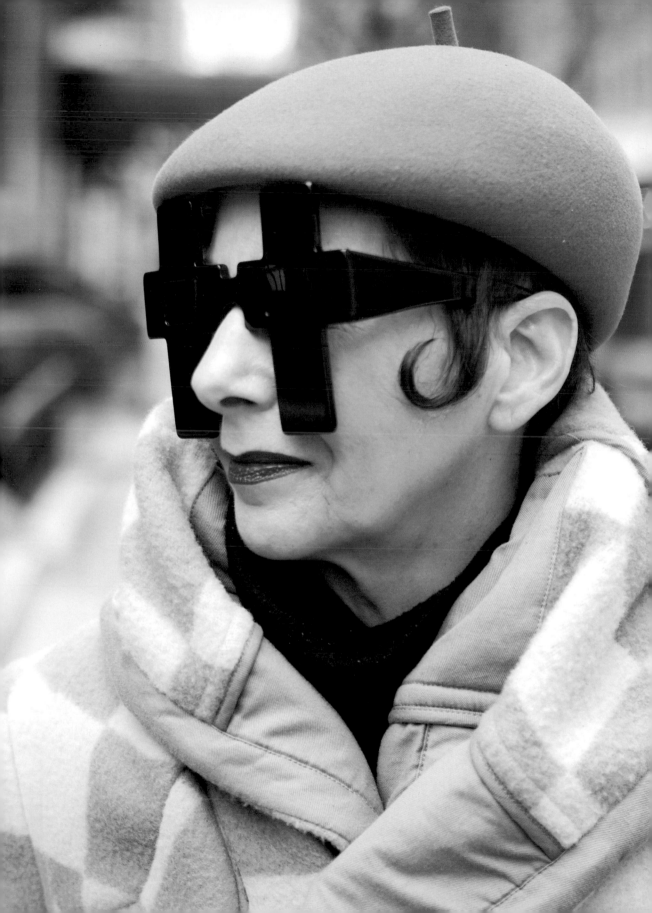

I met **Lubi** while wandering the galleries of New York's New Museum. Although she hails from my hometown of San Diego, her avant-garde sensibilities seem better suited for the streets of New York. Her chunky platinum bangs, bright red lipstick, and minimal aesthetic made her a shoo-in for *Advanced Style*. Lubi prefers a "less is more" approach, but she has never been afraid of being extraordinarily different.

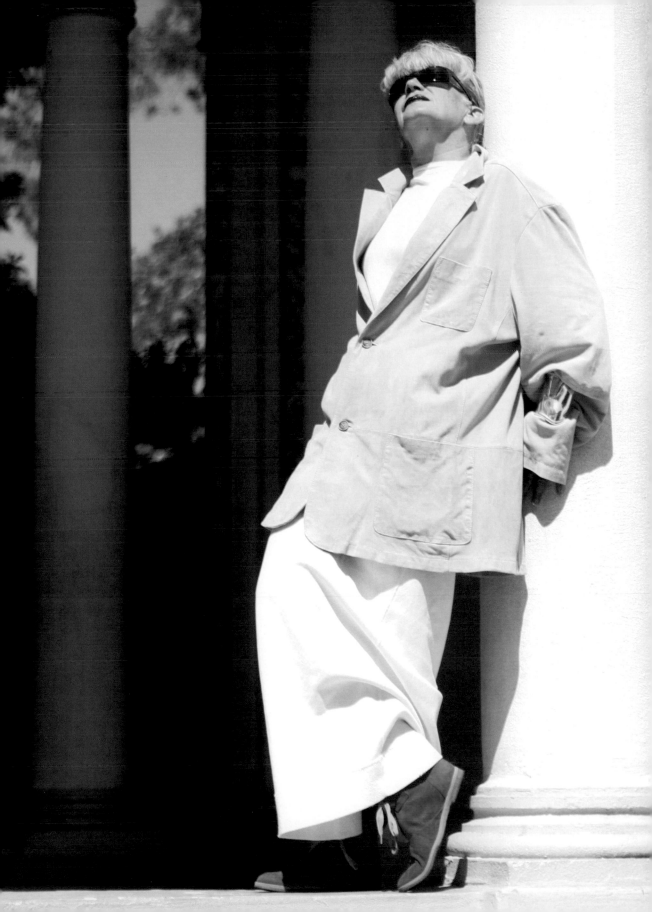

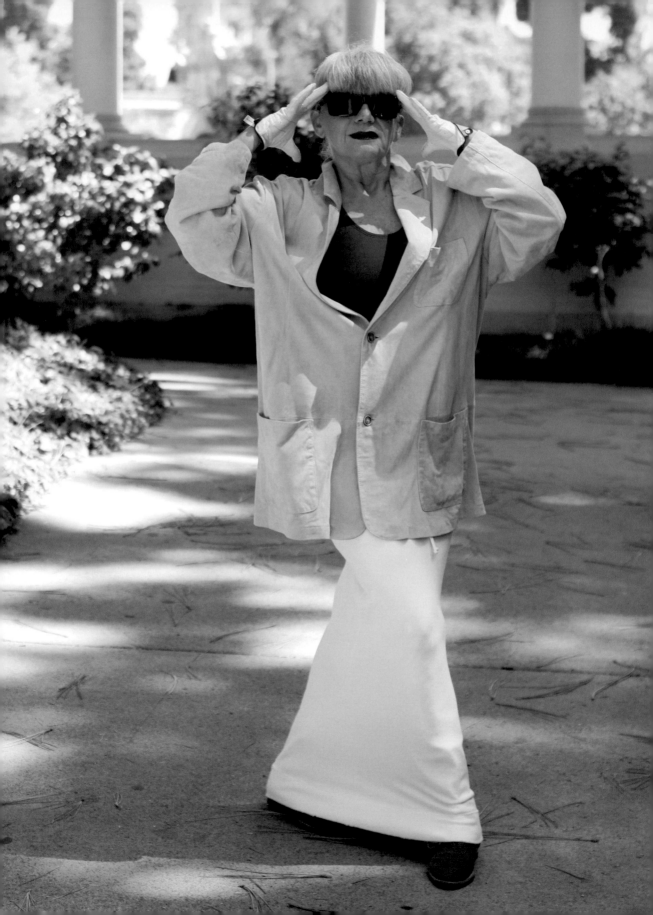

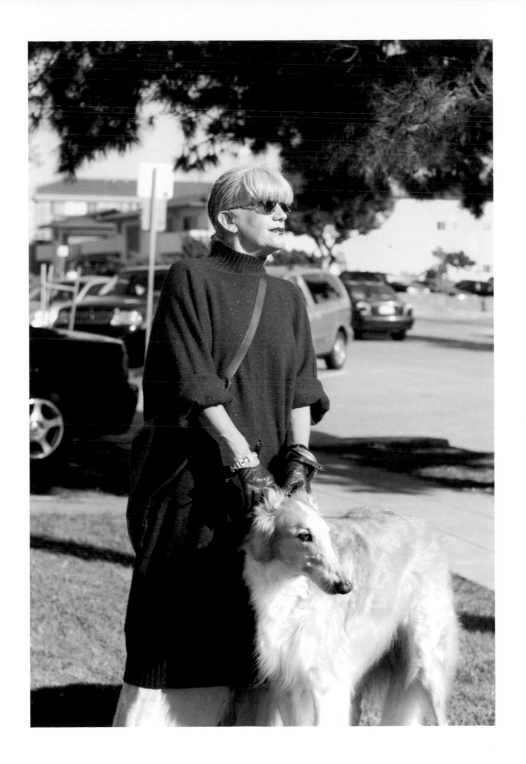

"Some might see it as gray hair, age, genetics, stress, etc. I see it differently. I see it as platinum elegance."

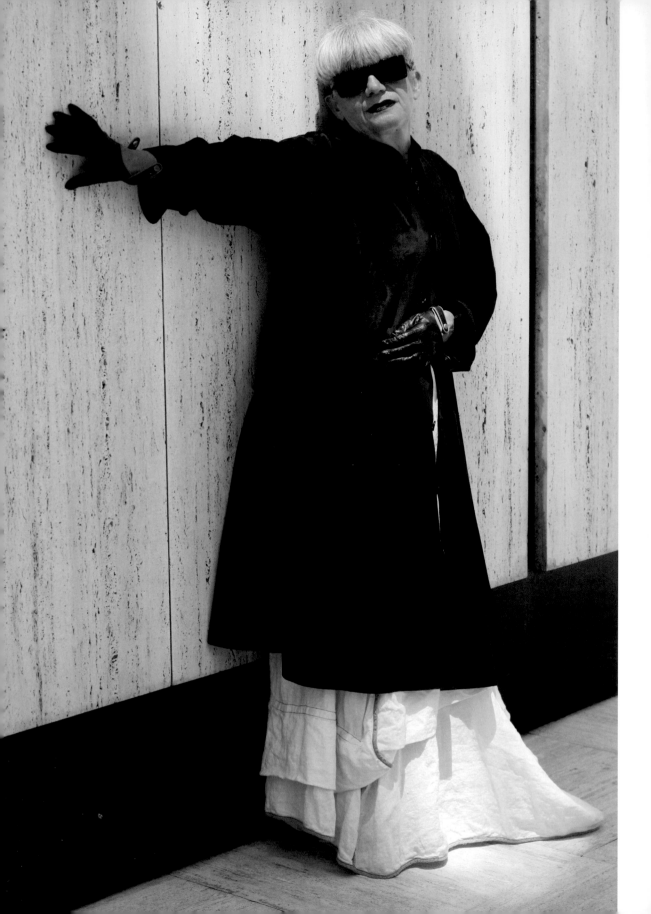

**"I was never fearful of being extraordinarily different. I would rather be considered different and somewhat mysterious than ignored."**

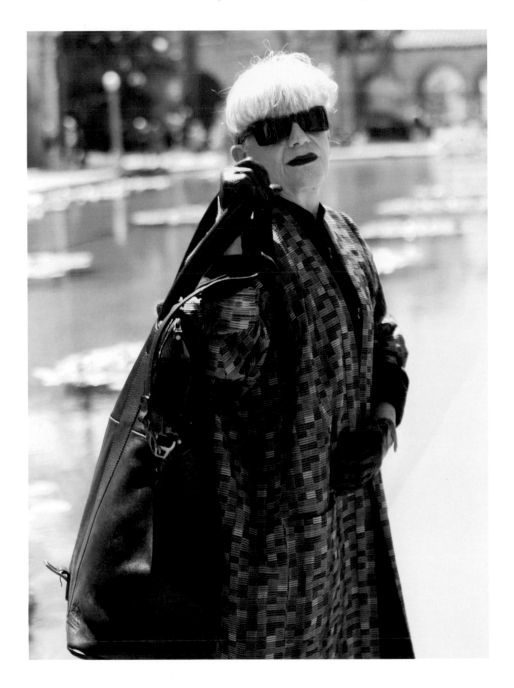

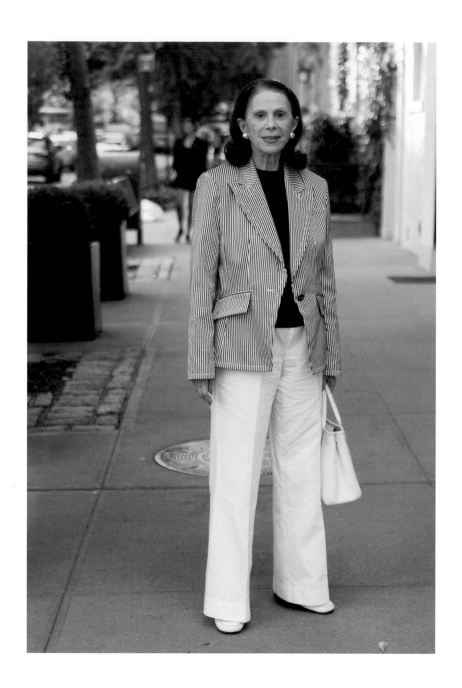

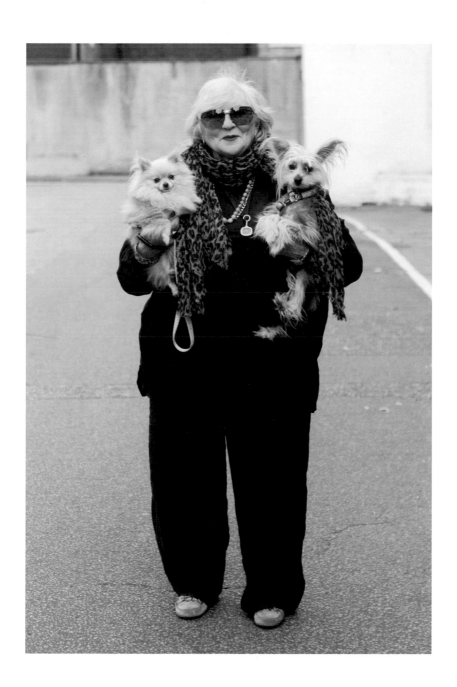

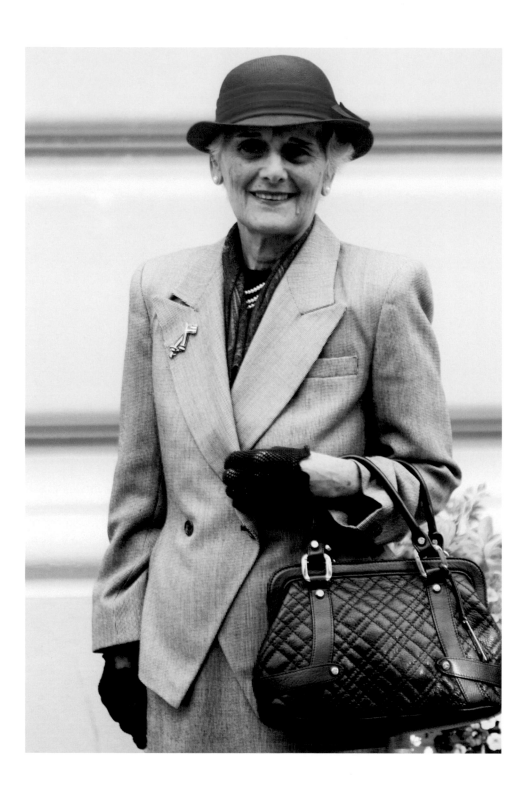
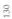

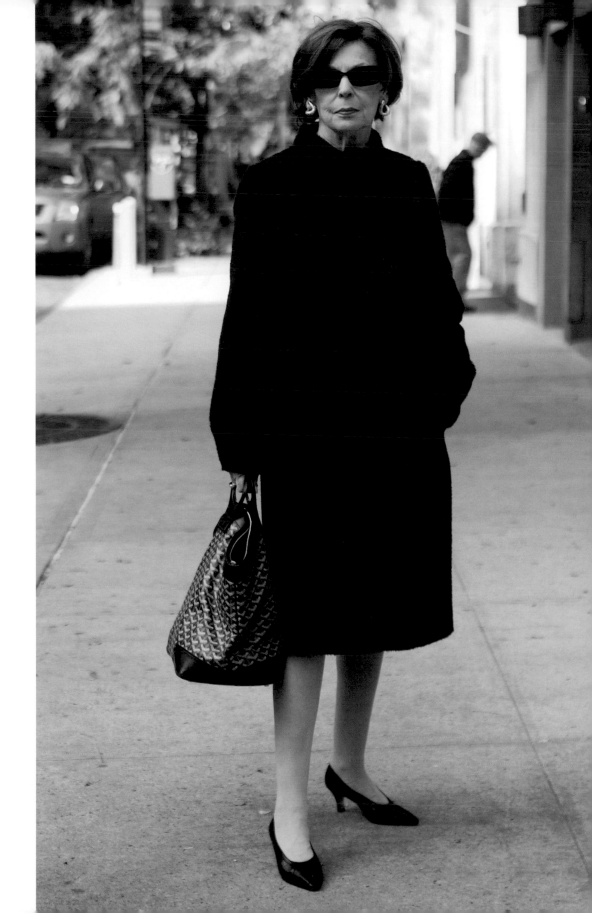

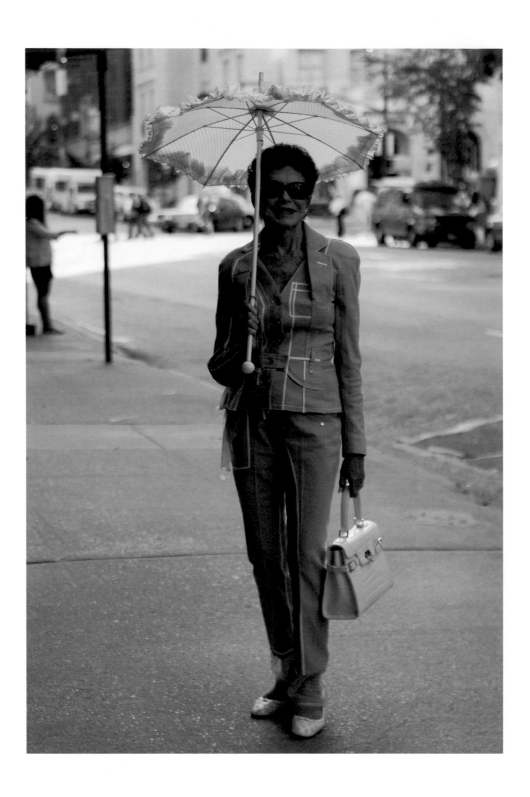

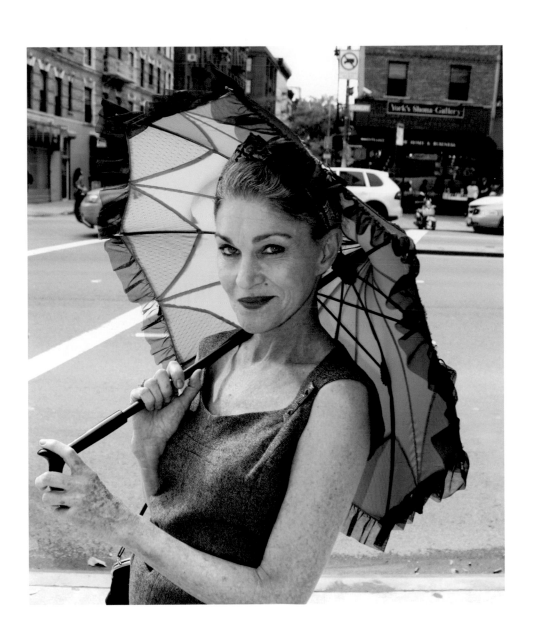

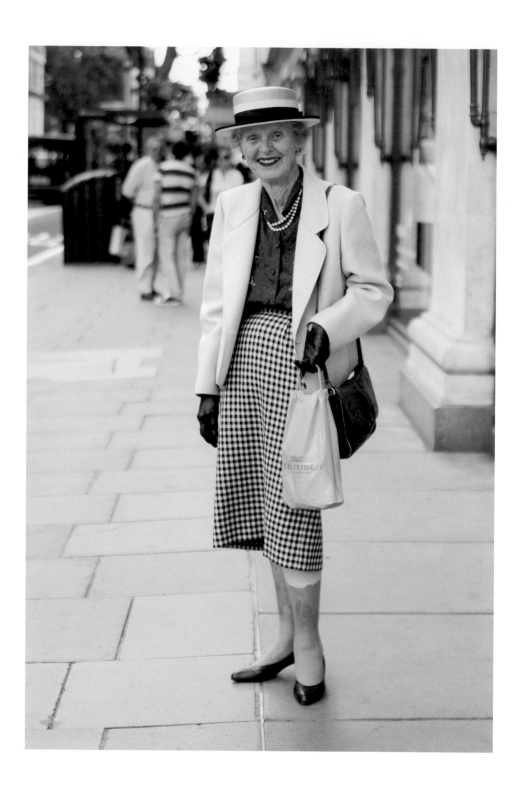

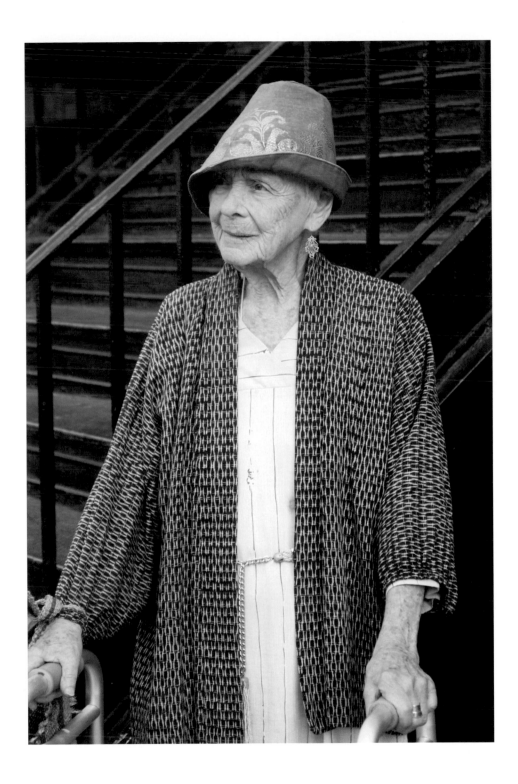

**Ruth** isn't your typical 100-year-old. Her weekly regimen of Pilates, weight lifting, and stretching keeps her in tip-top shape. She never leaves the house without being perfectly dressed because "you never know whom you may meet on the way to the mailbox."

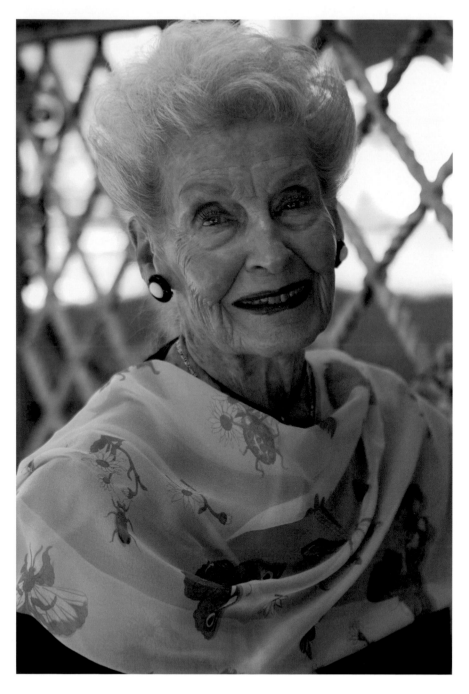

**"It pays to invest in quality;
it never goes out of style."**

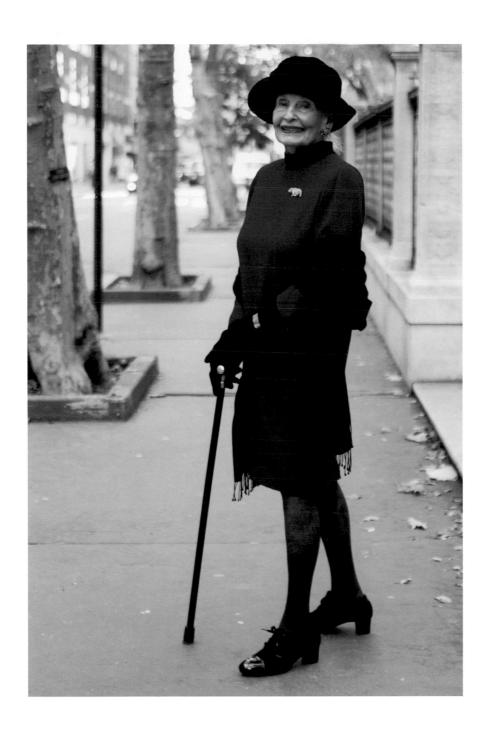

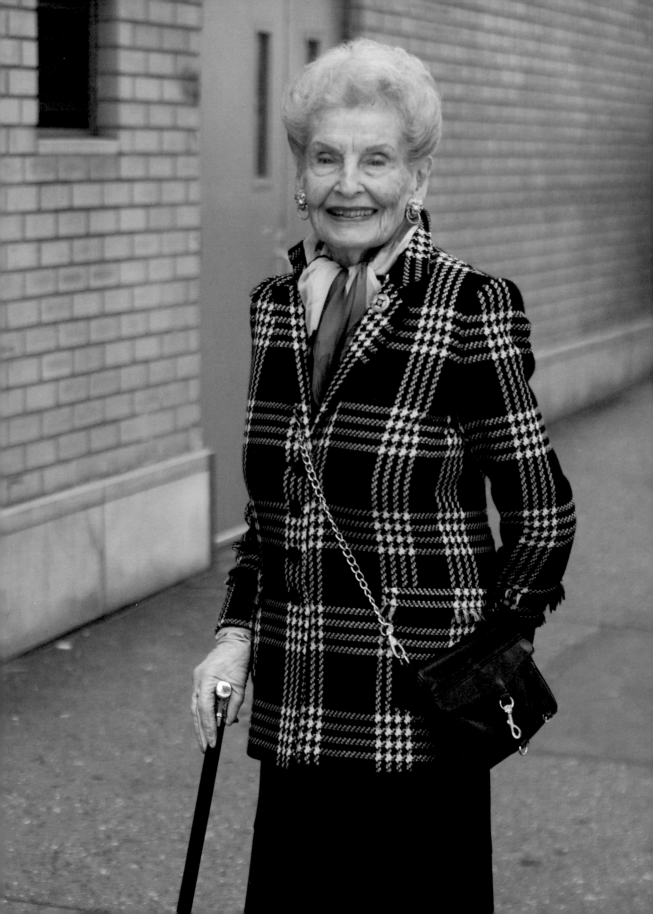

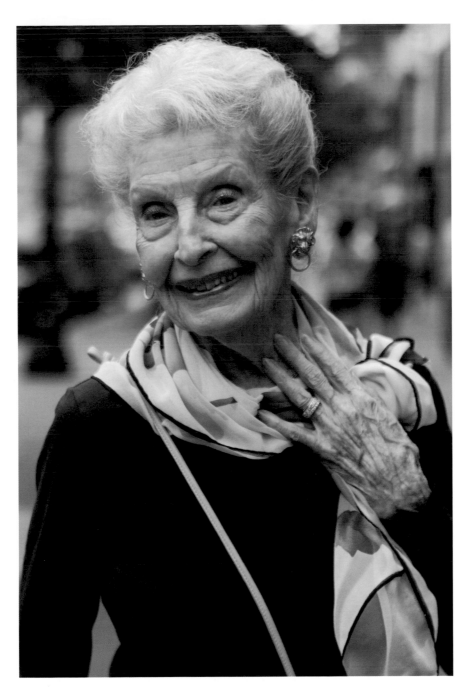

"Celebrate every day and
don't look at the calendar."

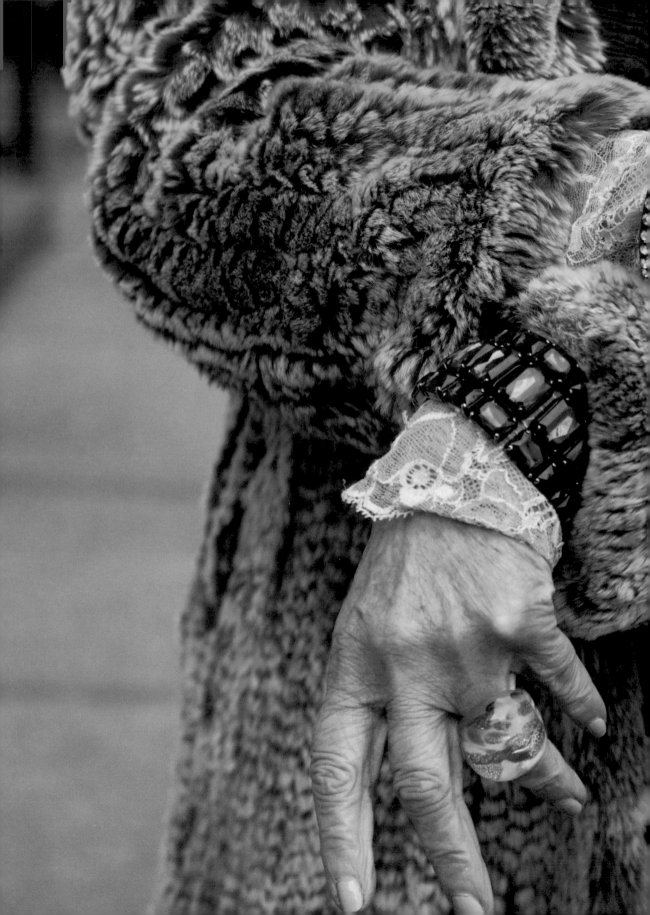

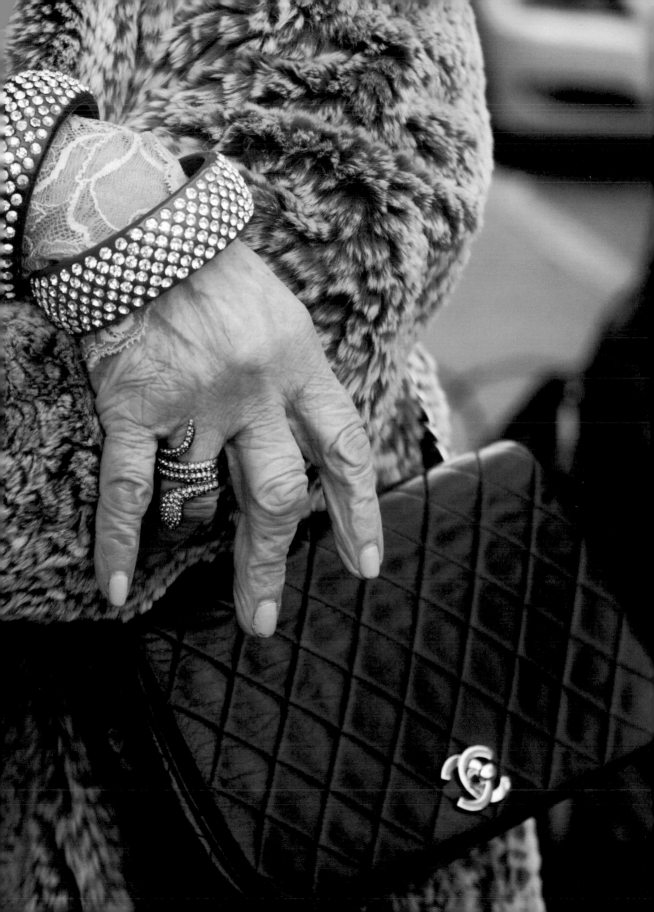

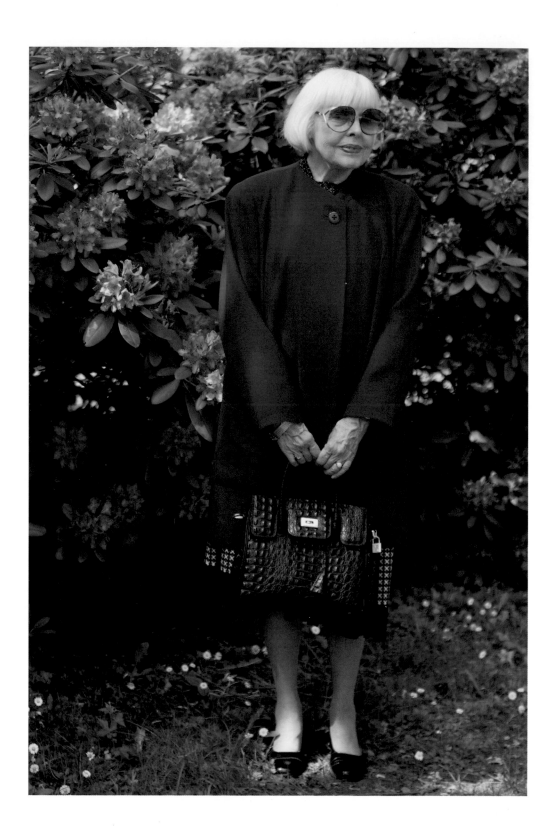

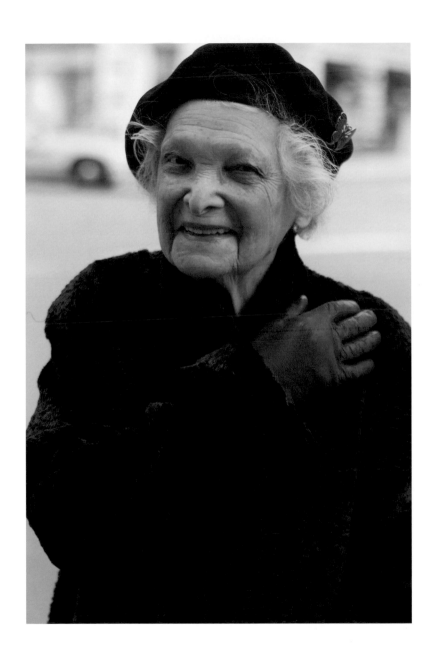

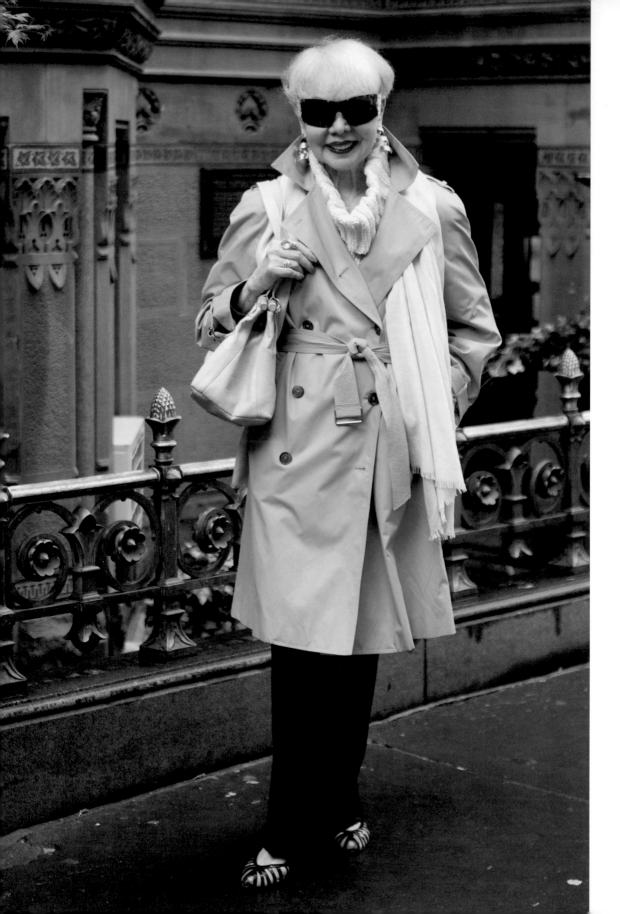

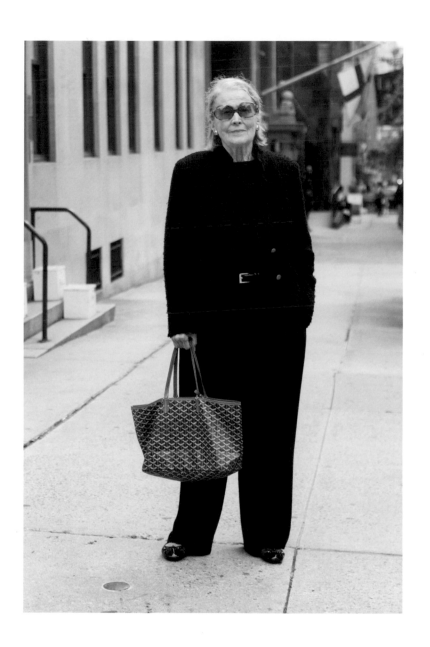

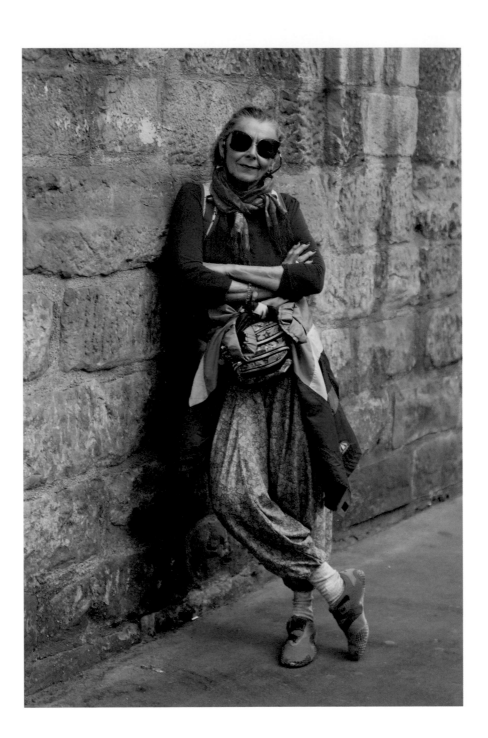

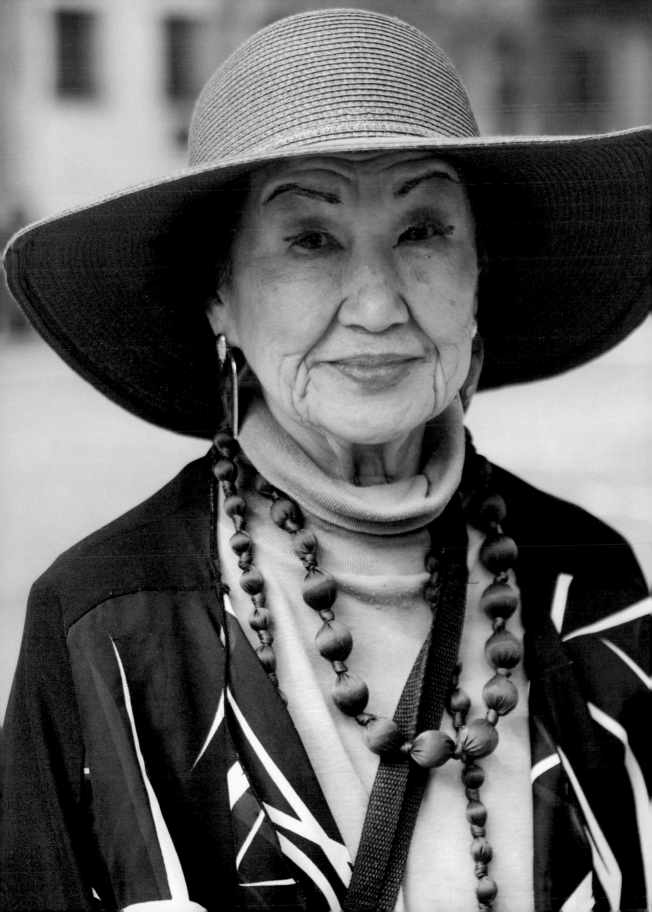

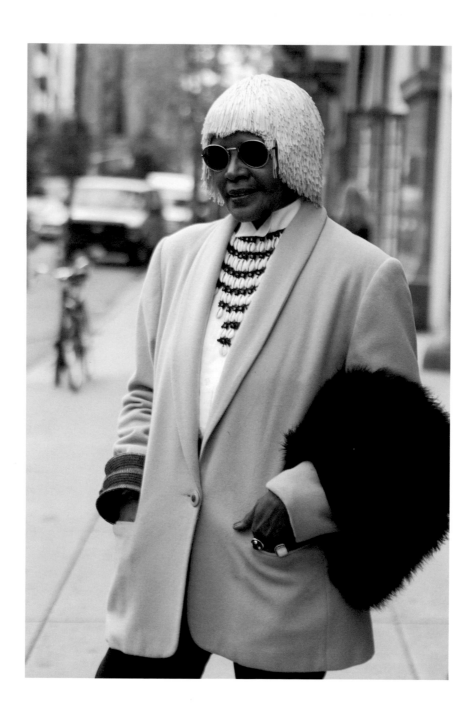

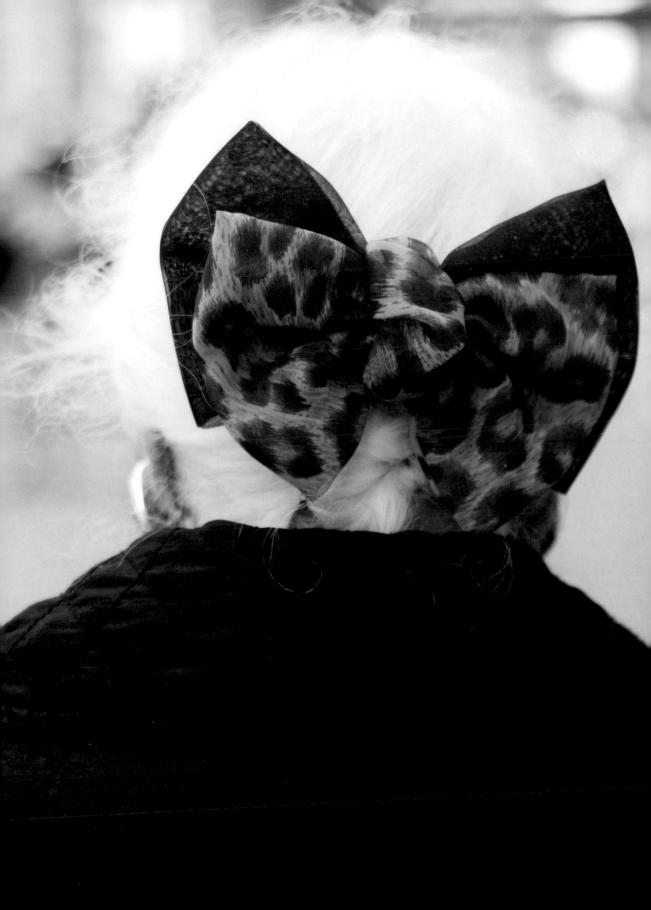

*Advanced Style*'s resident countess of glamour, **Lynn Dell**, has created a world full of flamboyant style and dramatic flair in her Upper West Side boutique. I was first drawn to her bright colors and bold accessories, but it is her energy, enthusiasm, and enterprise that truly define this magnificent woman.

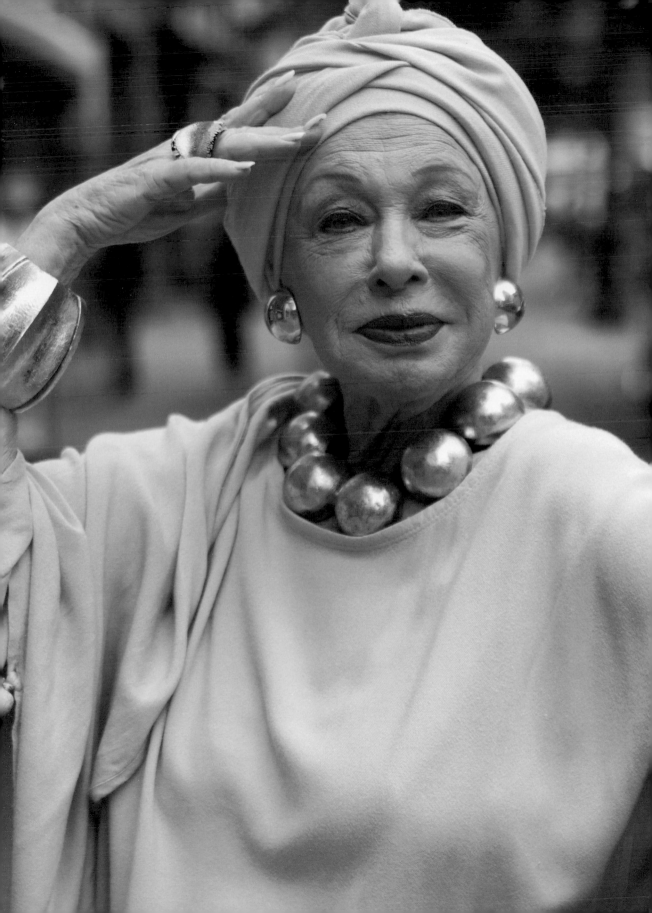

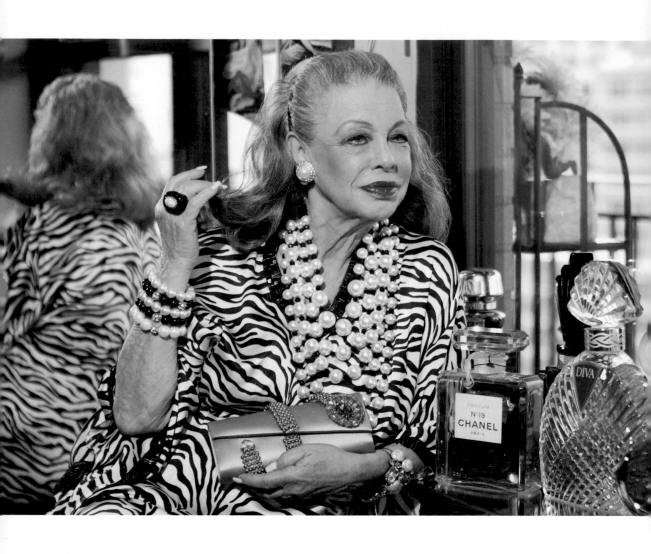

"My philosophy is fashion says 'me too,'
while style says 'only me.'"

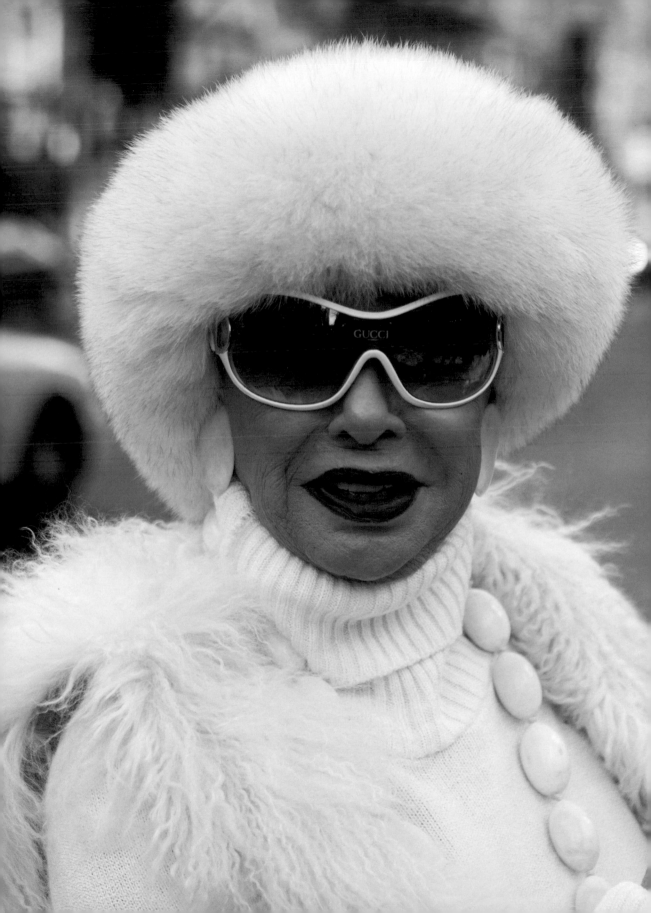

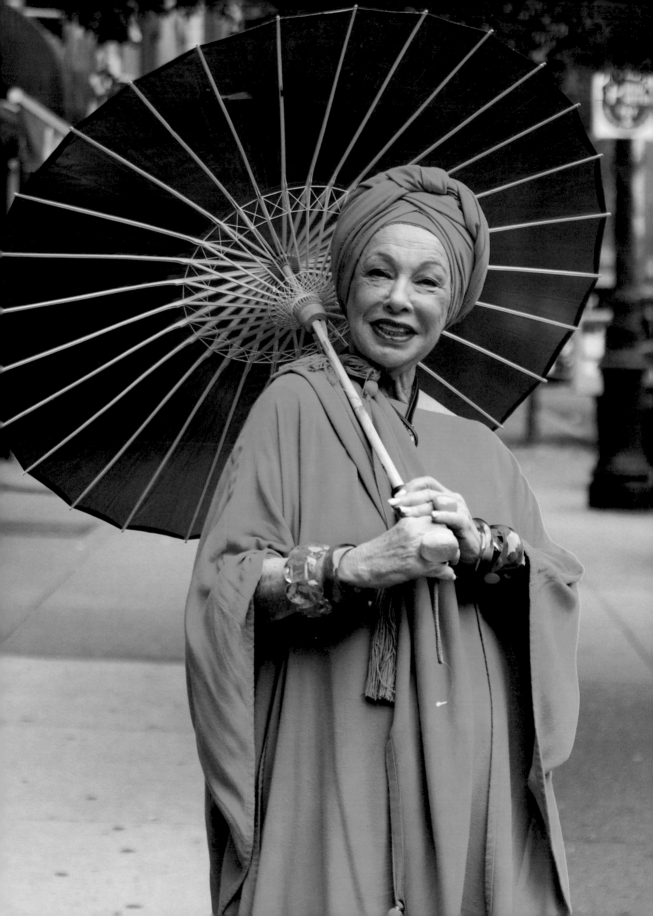

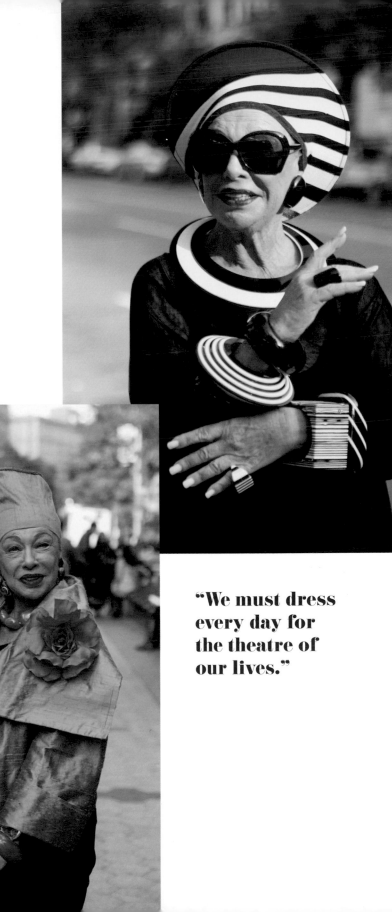

"We must dress
every day for
the theatre of
our lives."

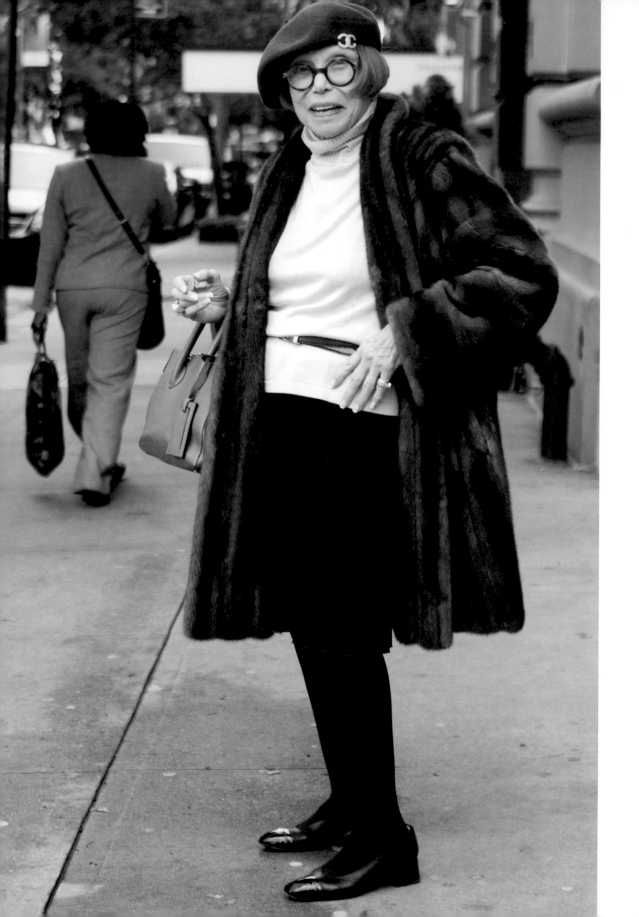

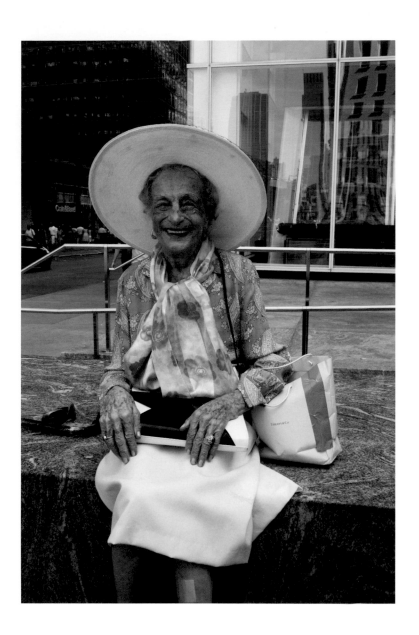

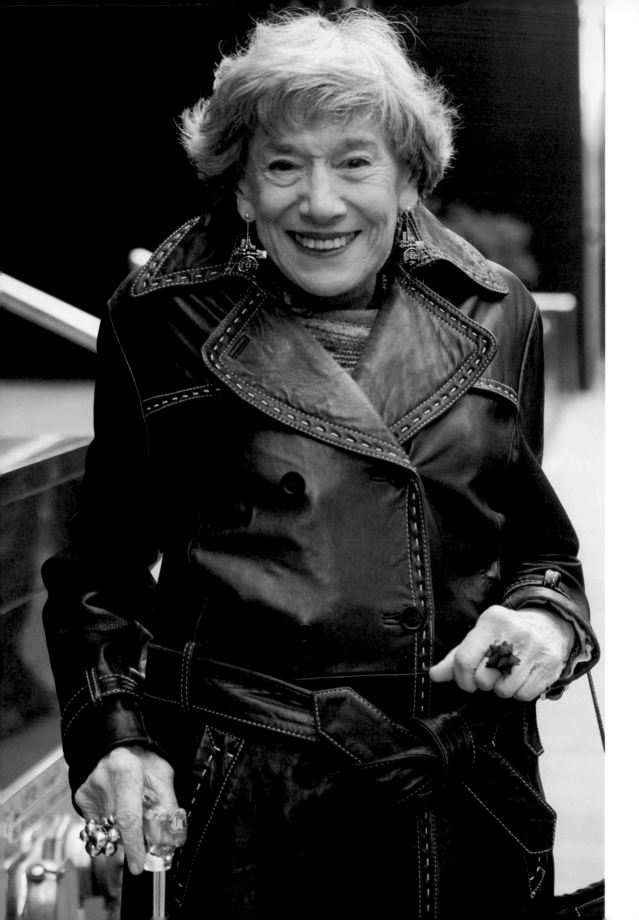

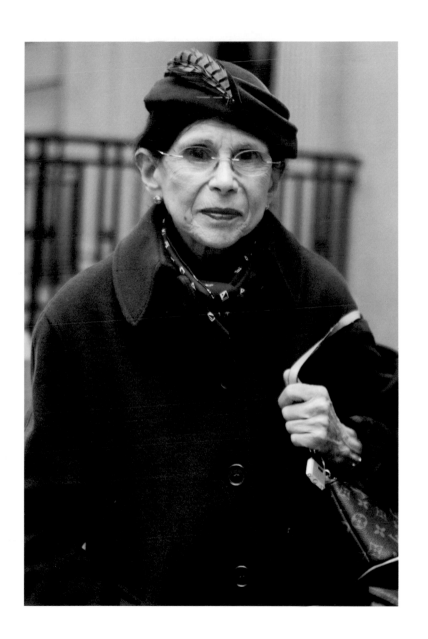

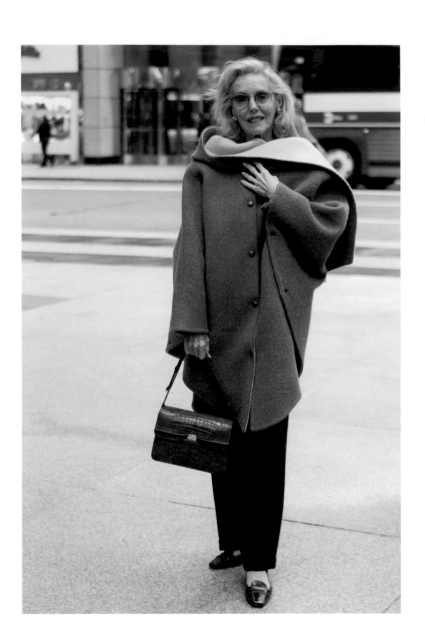

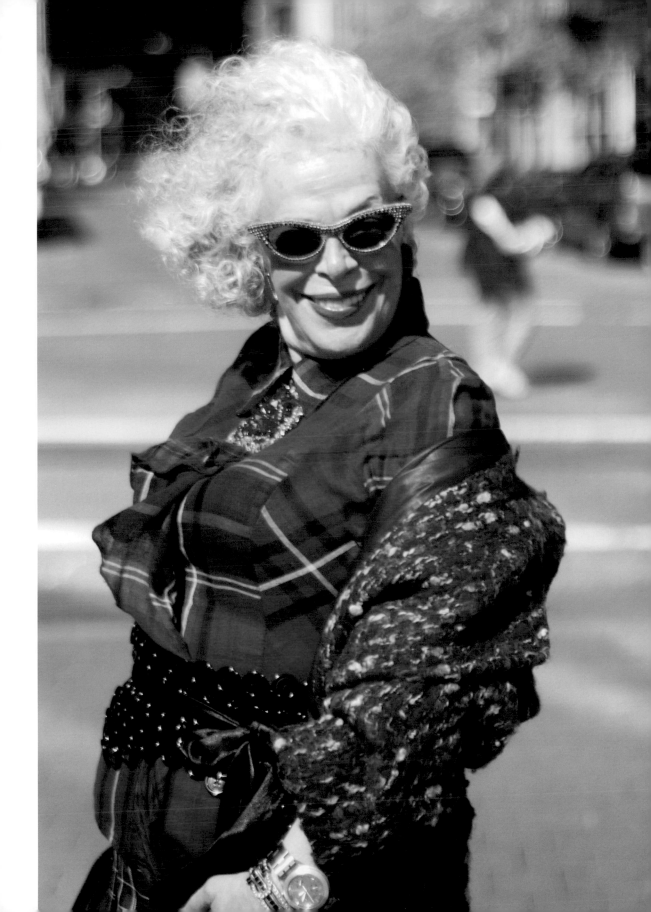

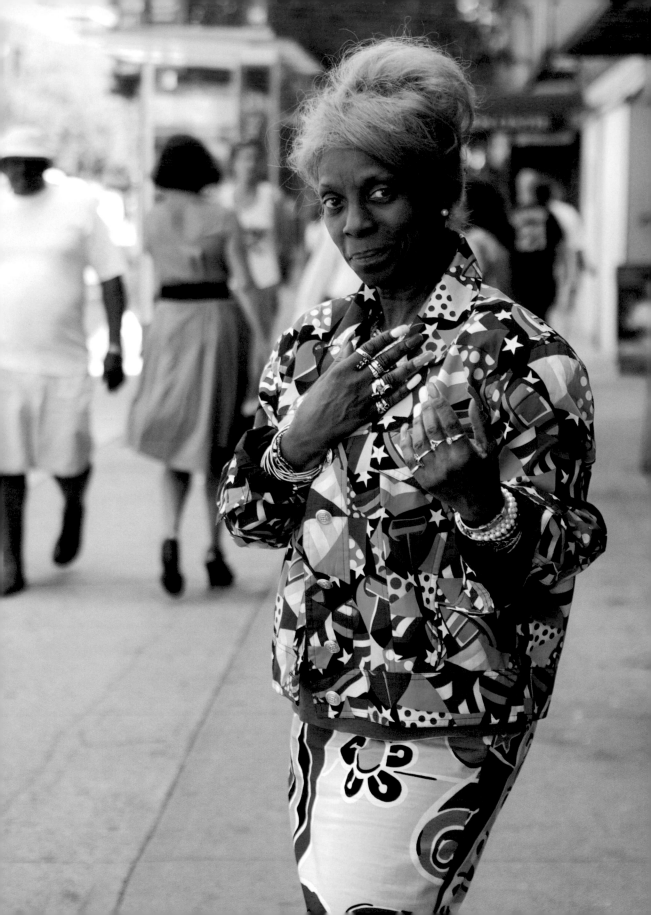

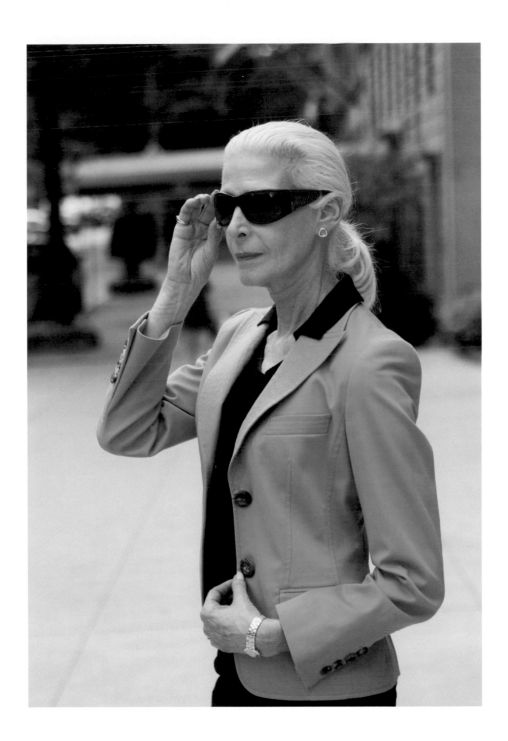

**Mary** has an almost intellectual approach to dressing. Every item she selects plays an important role in striking a harmonious balance of textures and colors. Mary is always amazingly accessorized and is never afraid to speak her mind. Under no condition will she leave the house without the perfect shoes and, more often than not, properly coordinated socks.

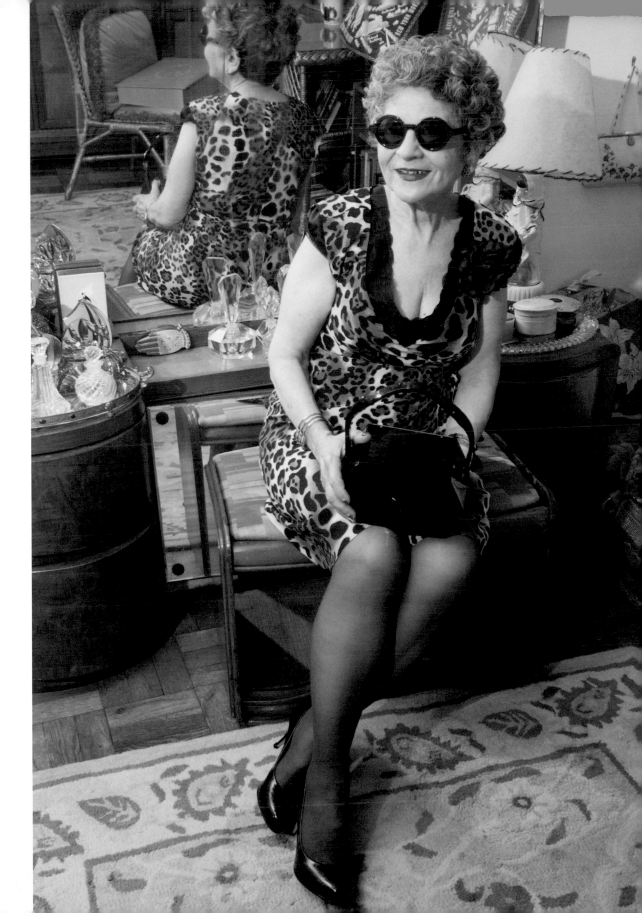

"**Whenever you're in a difficult situation ask yourself, 'How would Fred Astaire handle this?'**"

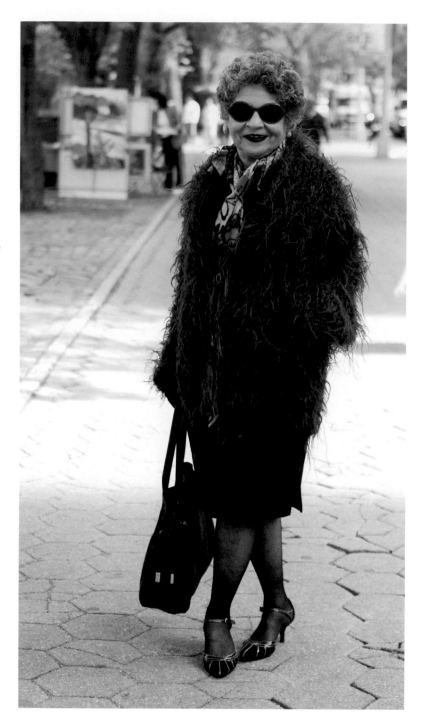

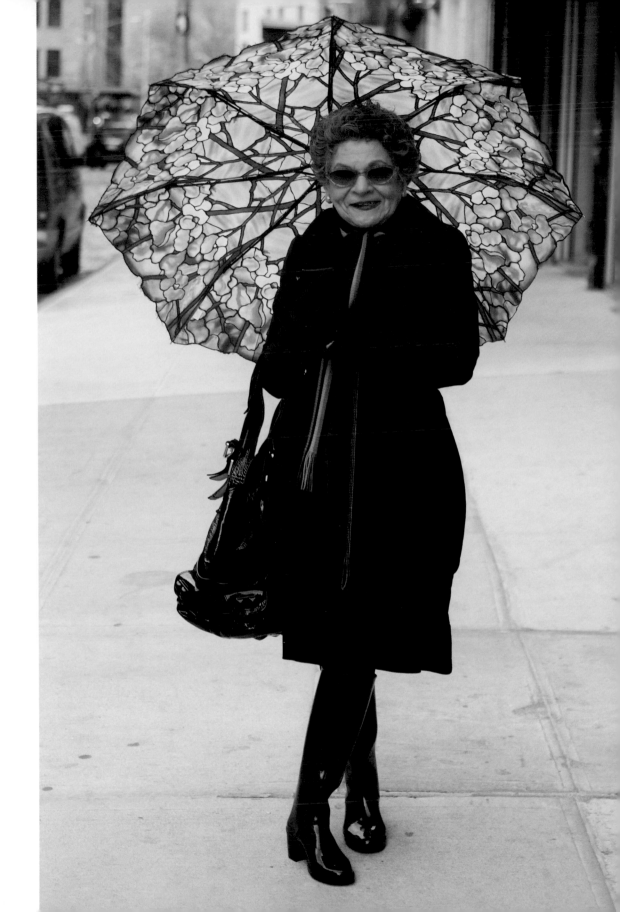

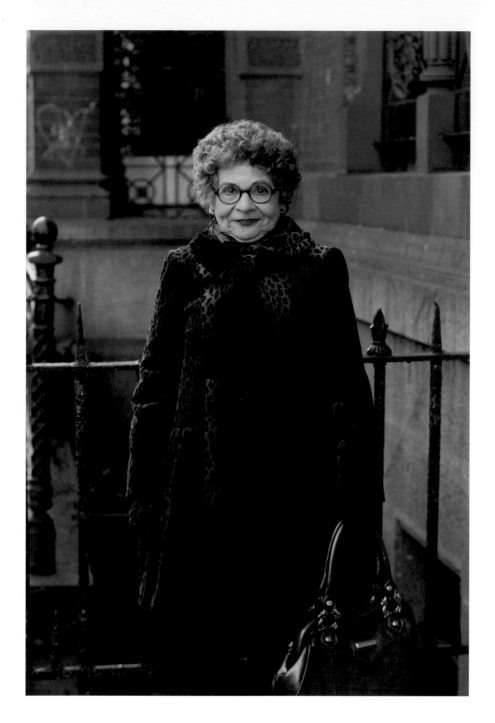

"Sunglasses are better than a face-lift.
They hide the ravages of time and let
you spy."

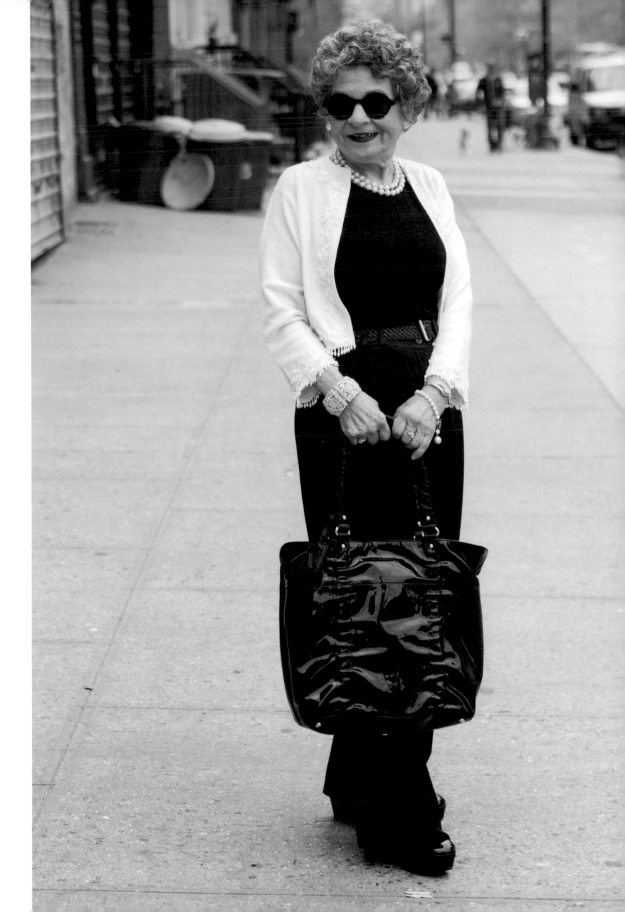

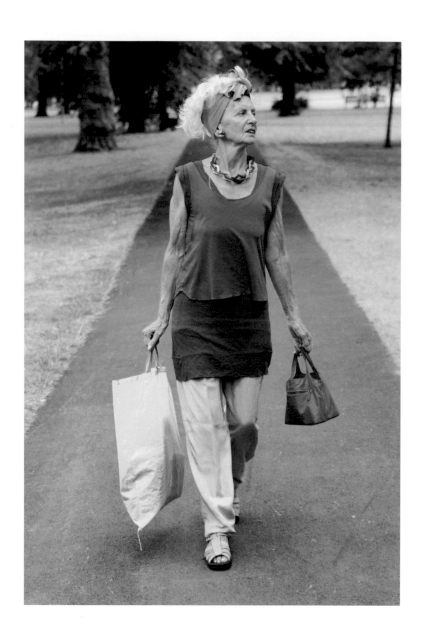

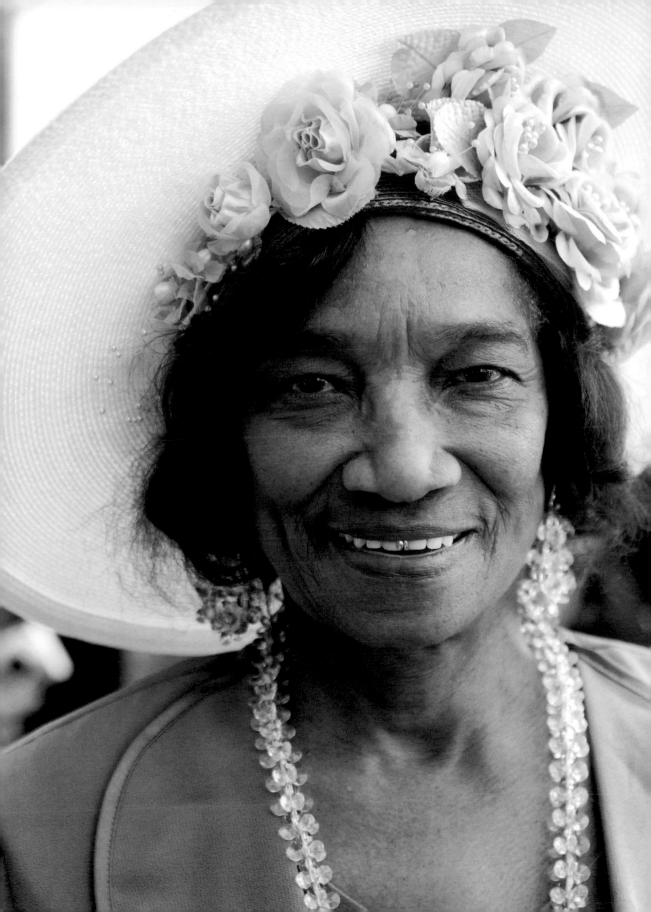

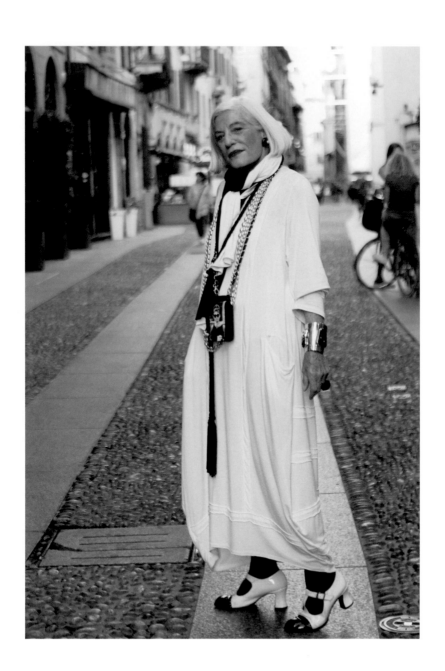

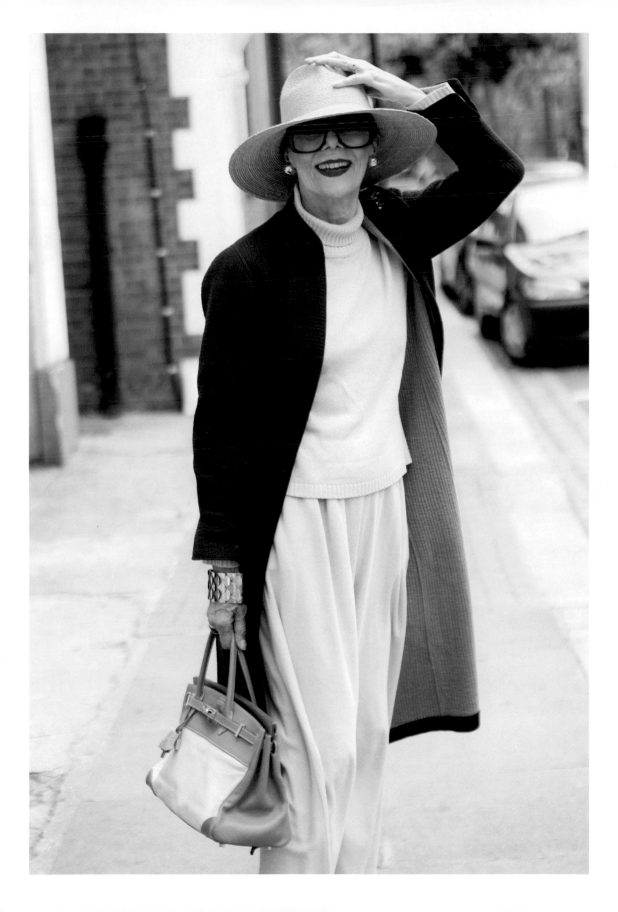

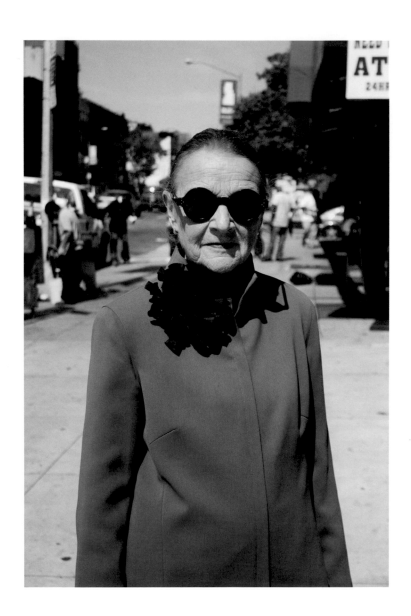

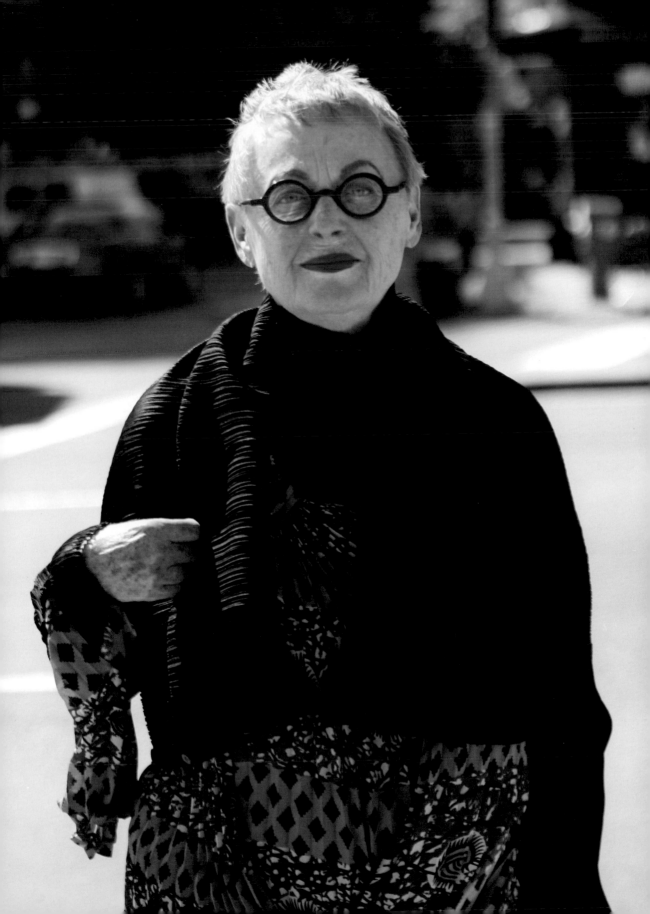

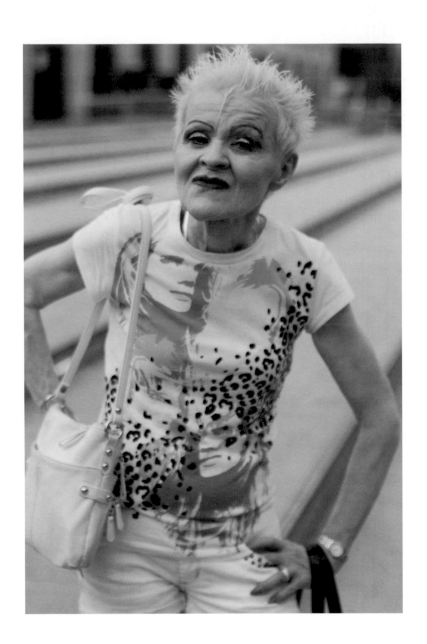

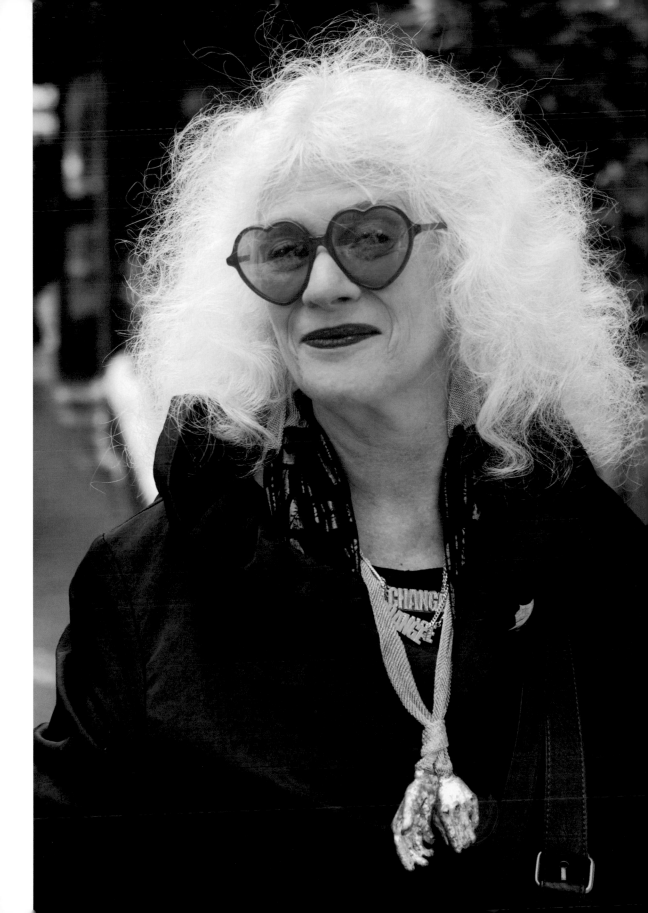

**Tziporah Salamon** can be spotted riding her bike around town, always dressed to the nines. Her vast collection of vintage and ethnic clothing makes her a favorite amongst fashion bloggers and a popular face on the weekly style pages. Tziporah's love of fashion has been with her since an early age, but it is with time and experience that she has perfected her signature look.

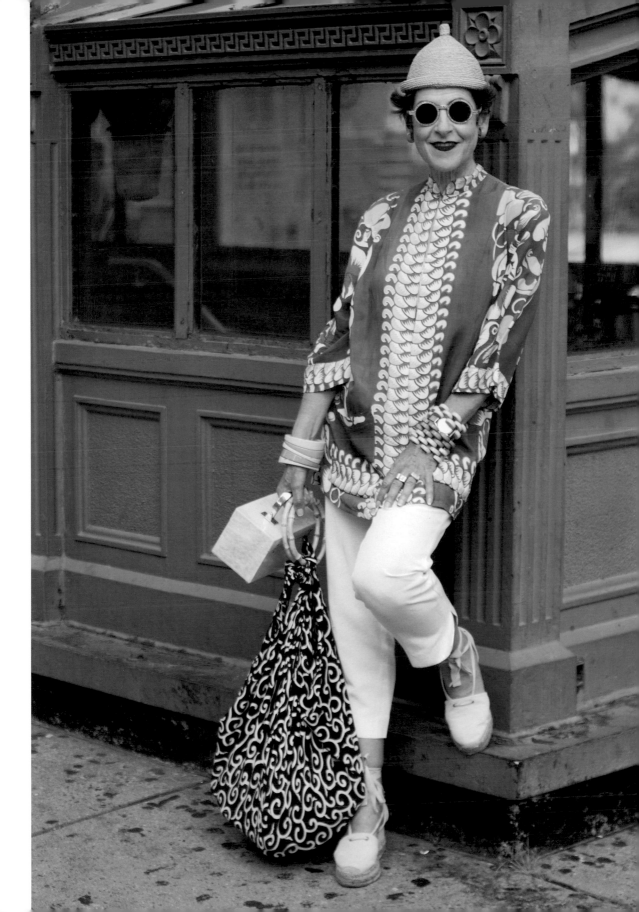

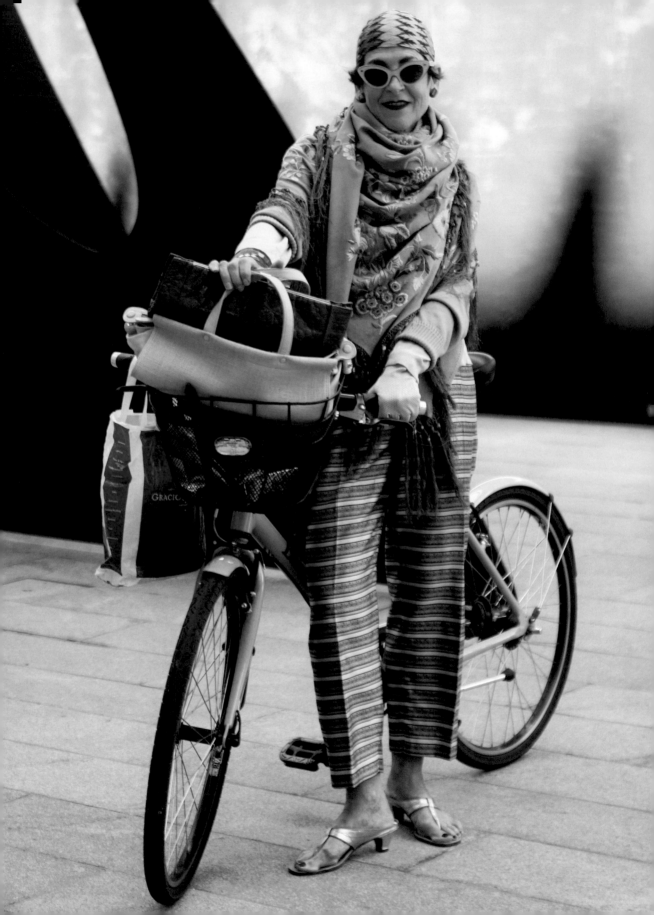

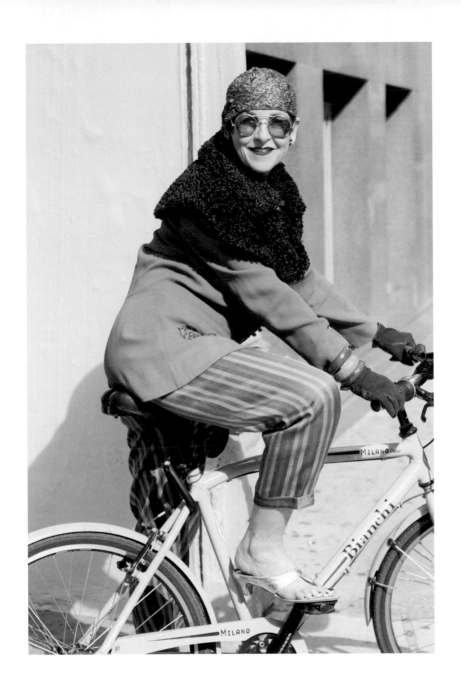

**"Study what women who dress well
do and learn from them."**

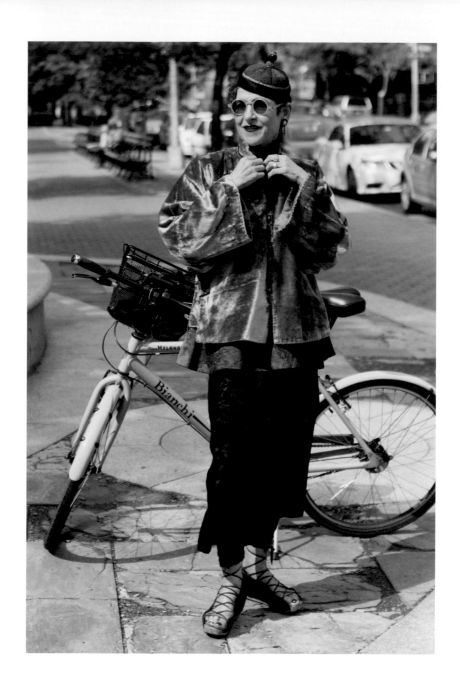

"And sometimes it's a fine line from costume to chic so I aim for the latter and work on it until I achieve it."

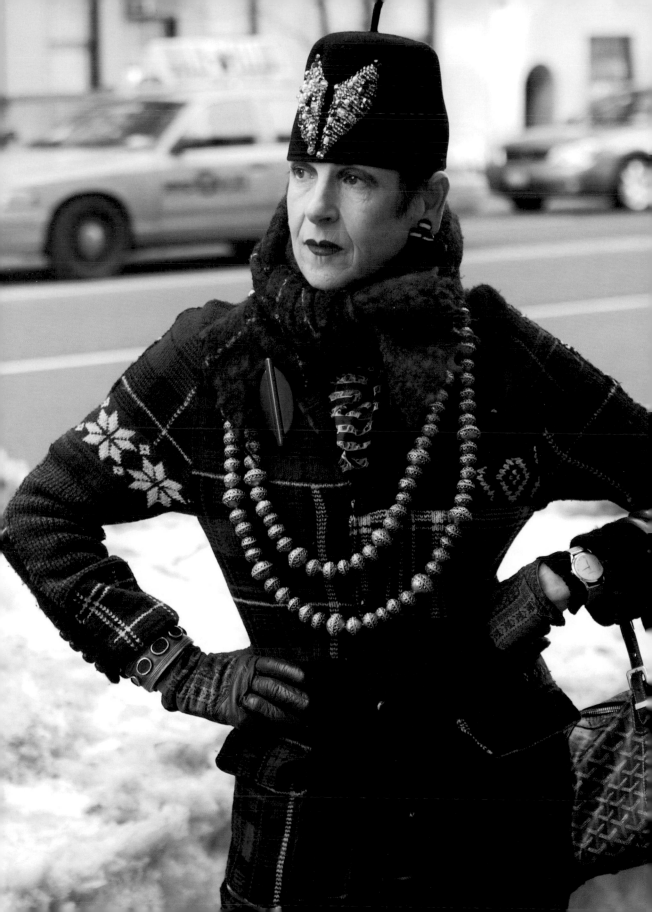

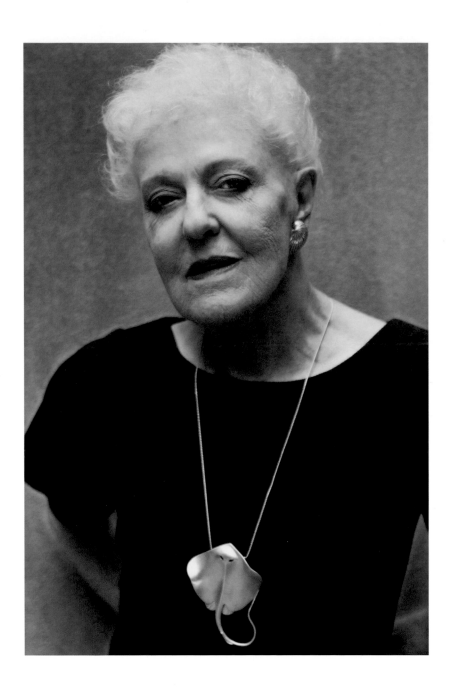

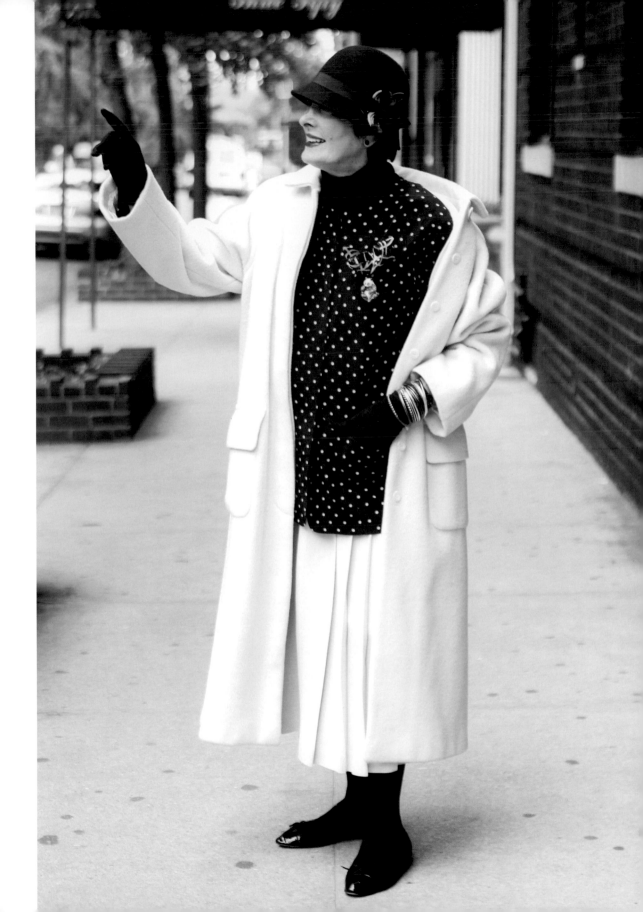

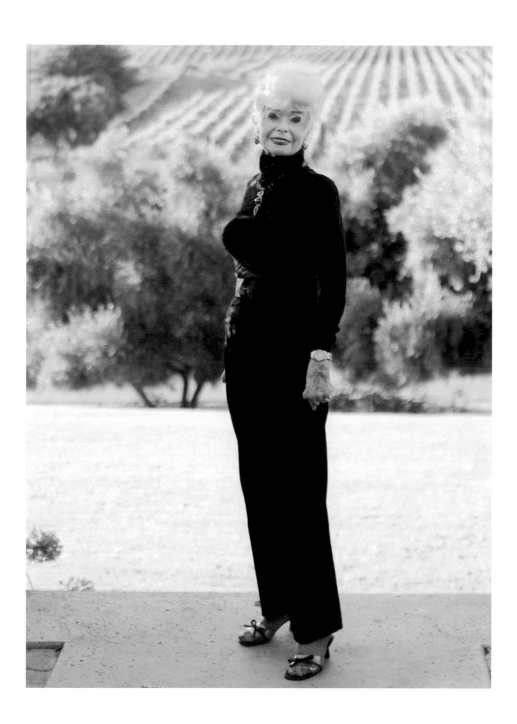

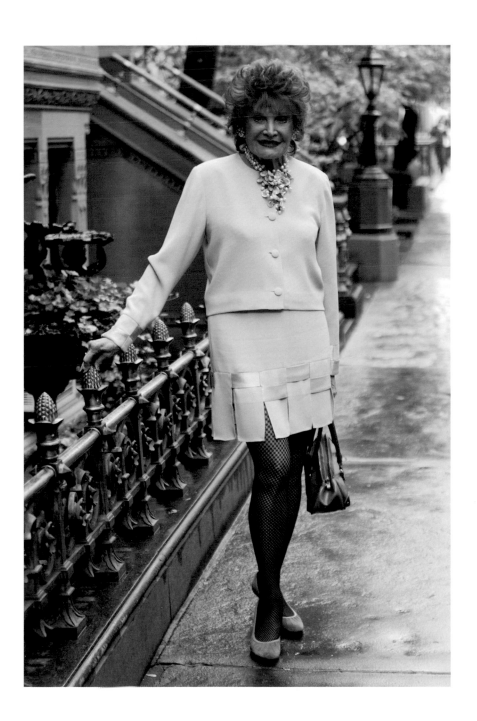

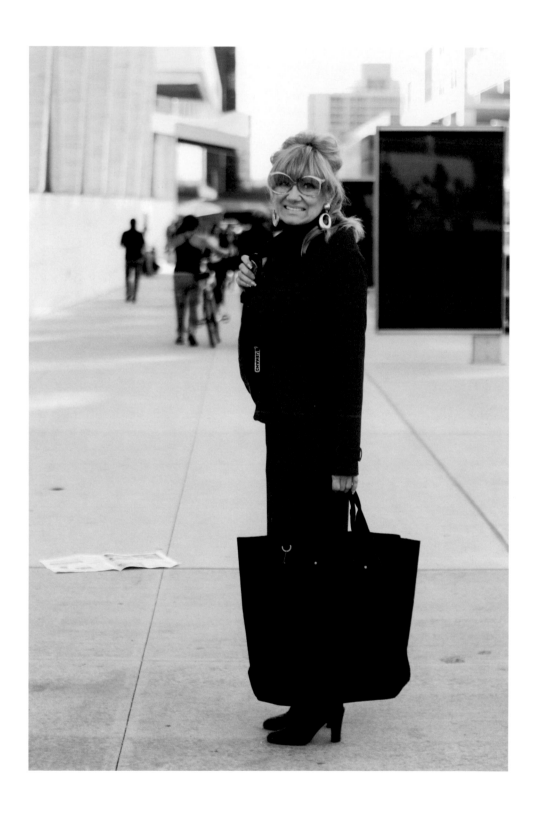

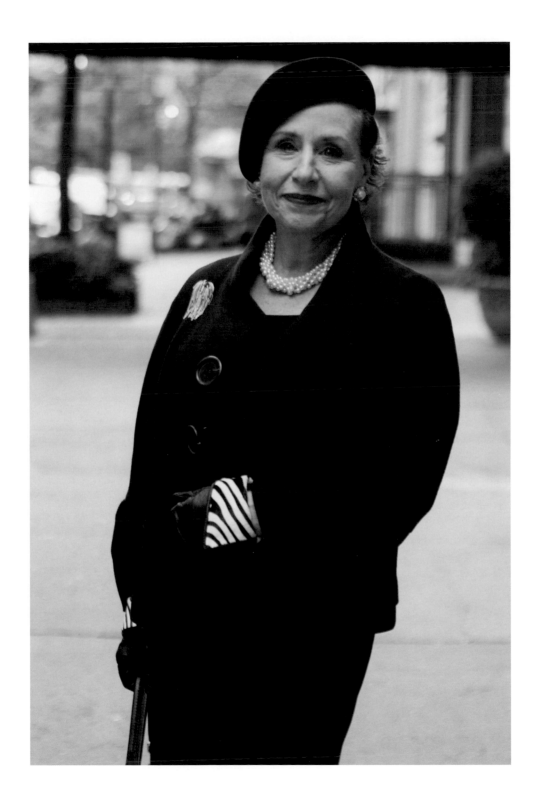

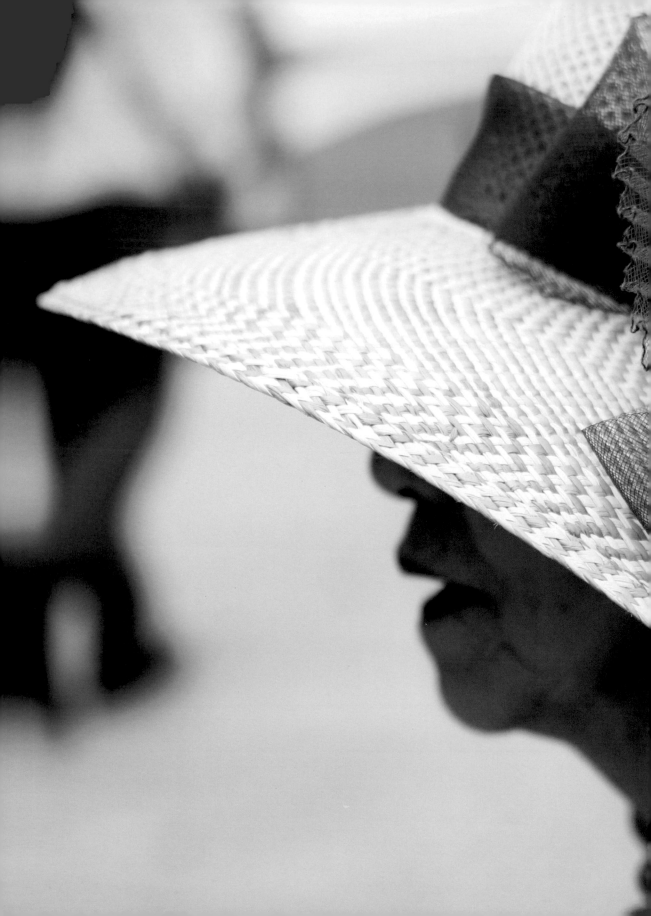

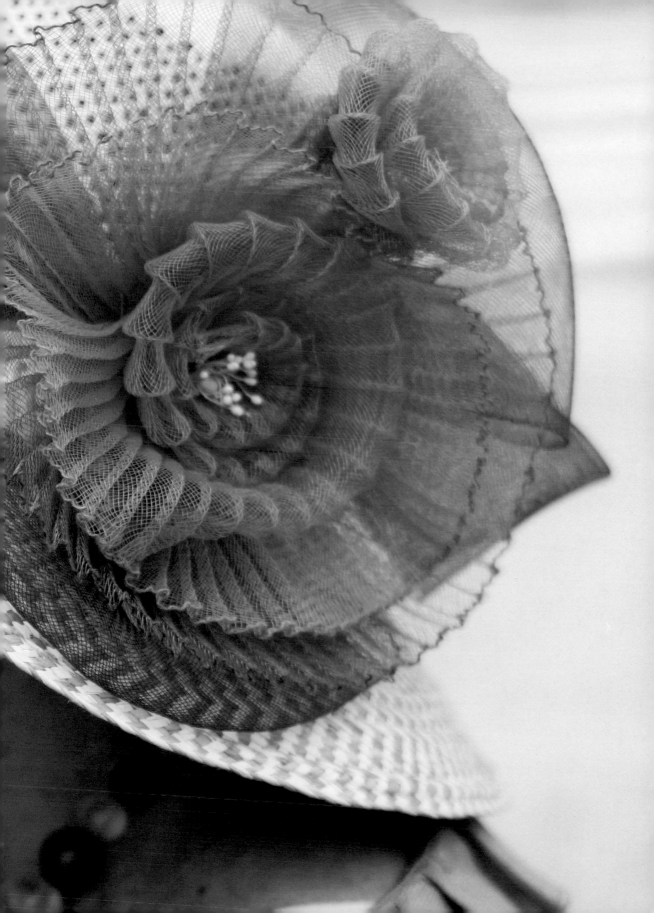

With over 60 years of experience dressing with panache, **Maryann** has grown to embrace her personal style. She knows what looks good on her: a mix of vintage and designer that somehow always comes off as extremely modern and perfectly chic. For Maryann, choosing what to wear is an organic process, and each outfit is an opportunity to create something spectacular.

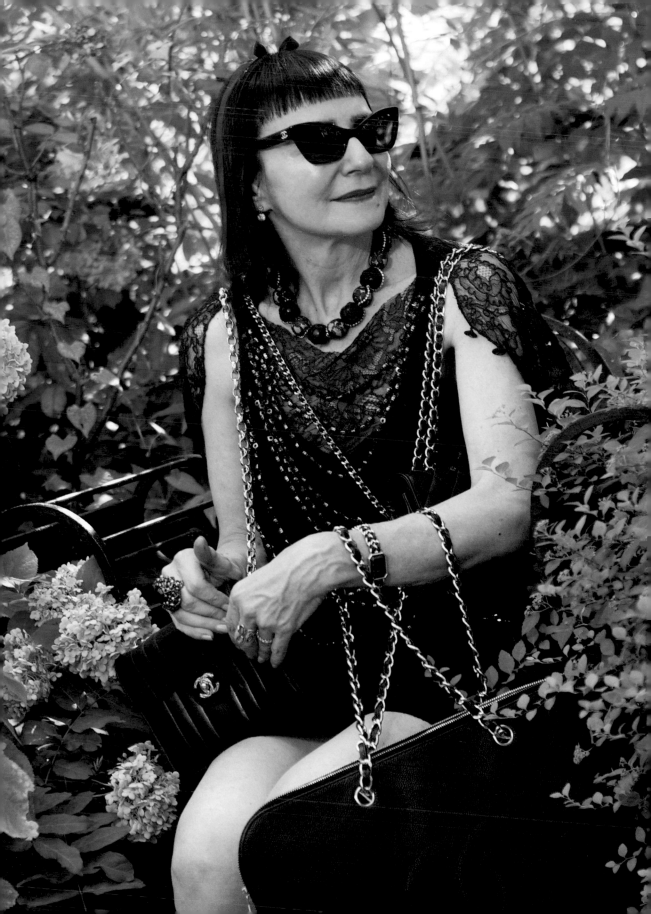

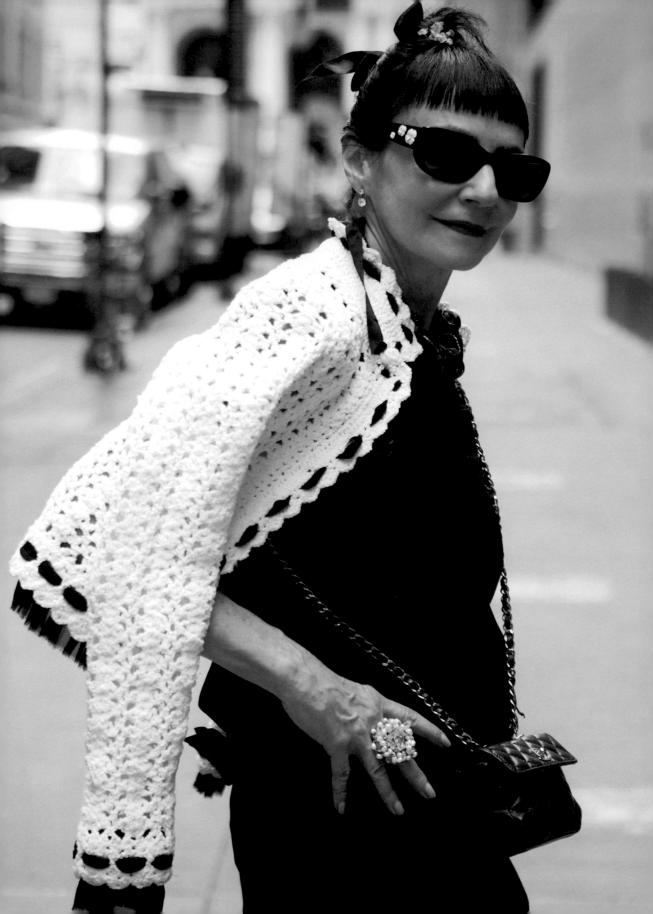

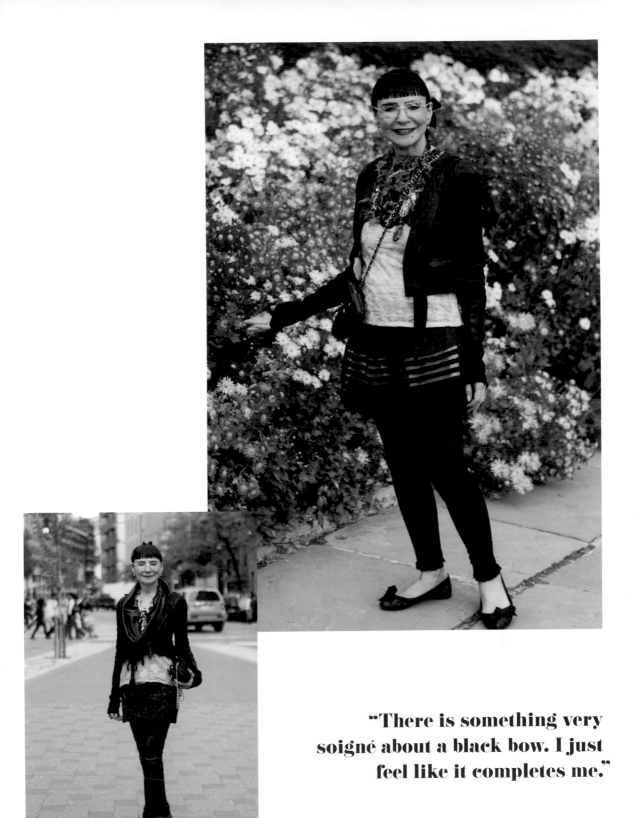

"There is something very
soigné about a black bow. I just
feel like it completes me."

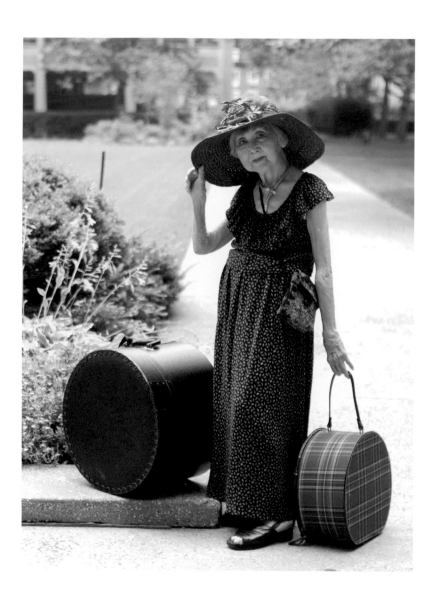

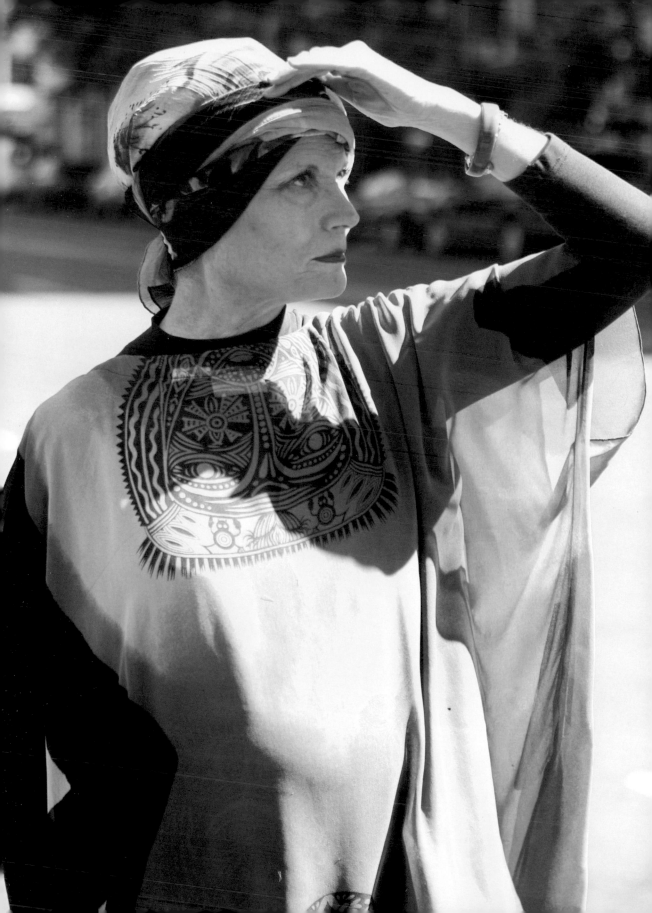

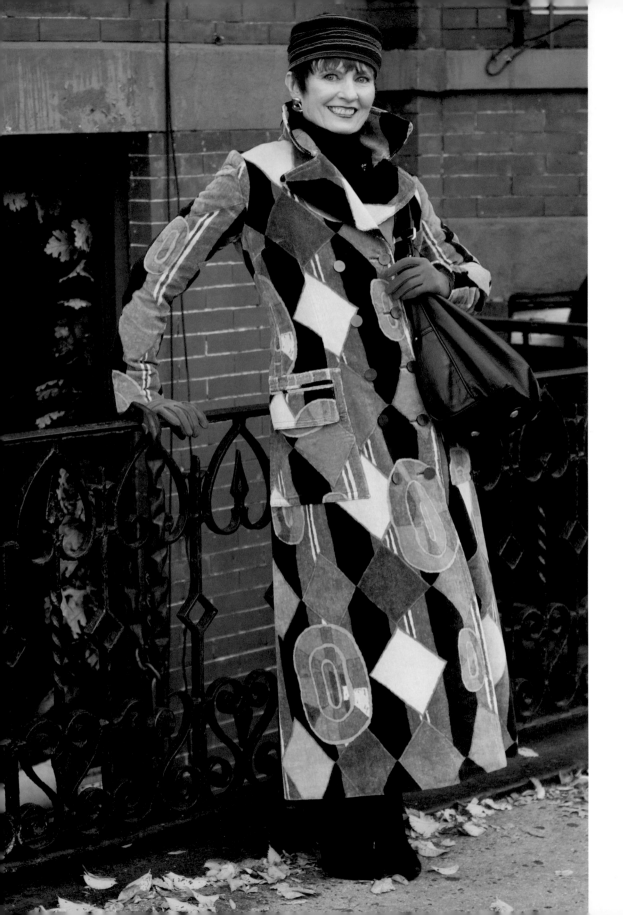

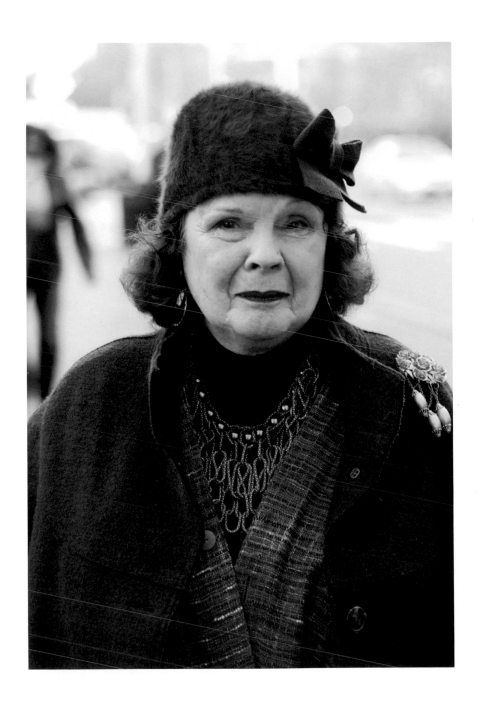

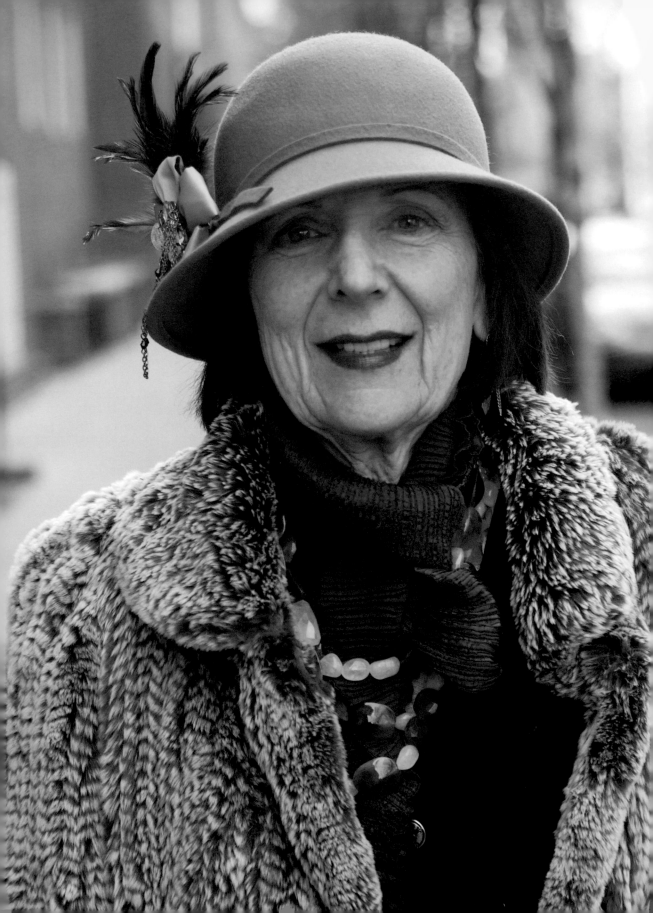

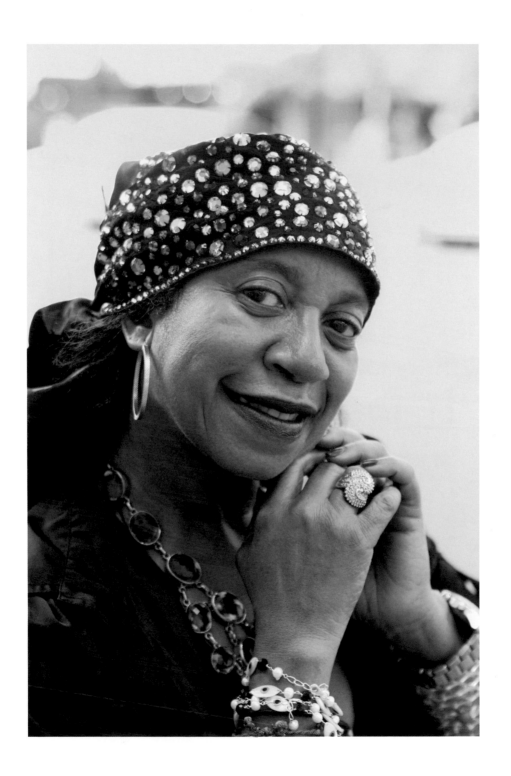

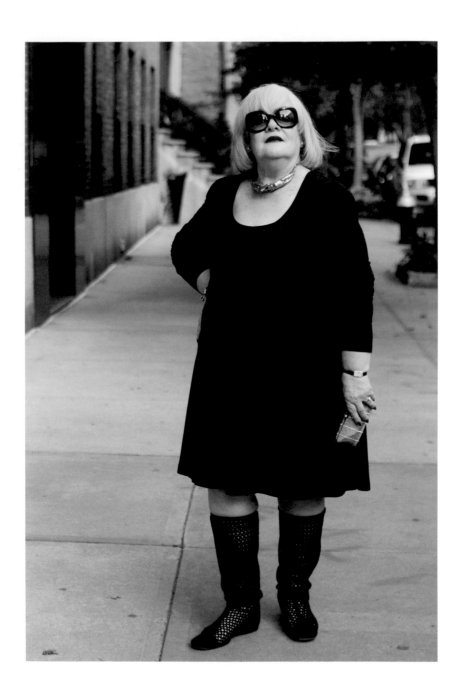

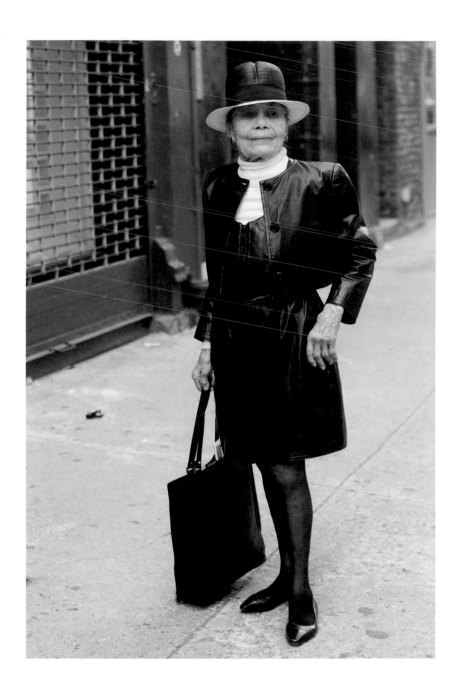

When I first met 80-year-old **Jacquie Tajah Murdock** on a busy New York street, she was smartly dressed in an elegant, blue Chanel jacket. After I took her photograph, she remarked, "Fashion is an art—especially high fashion." Jacquie began dancing at the Apollo Theater and Savoy Ballroom in Harlem in the 1940s. Her graceful poses and jazzy wardrobe are a reflection of a life filled with music and harmony.

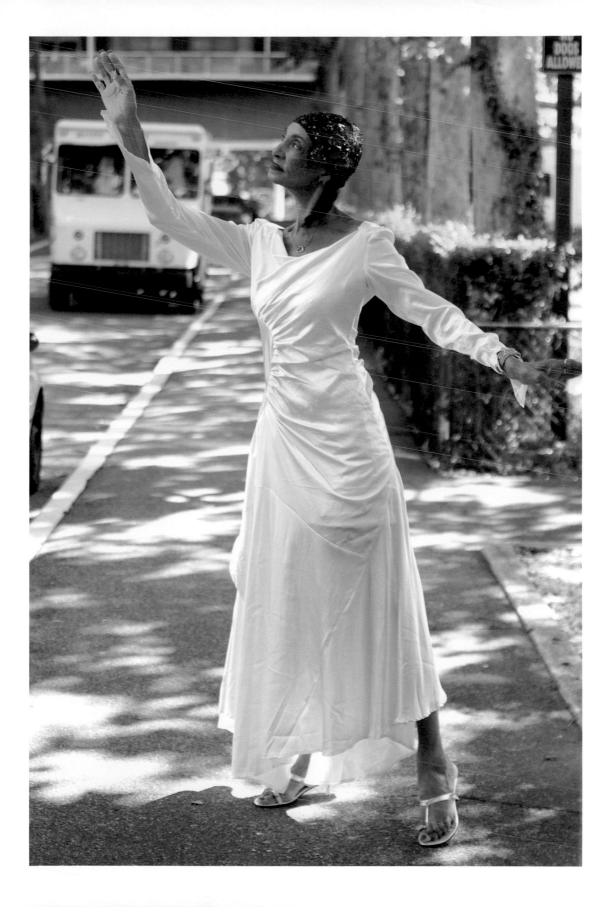

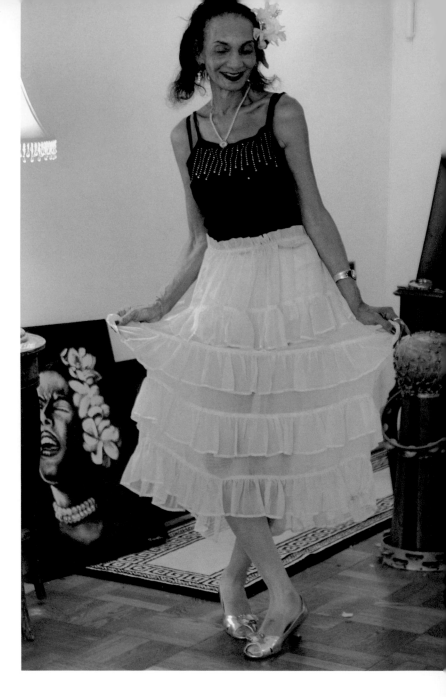

"I thought I'd be an old lady with a cane who keeps on dancing, and it looks like this has come true."

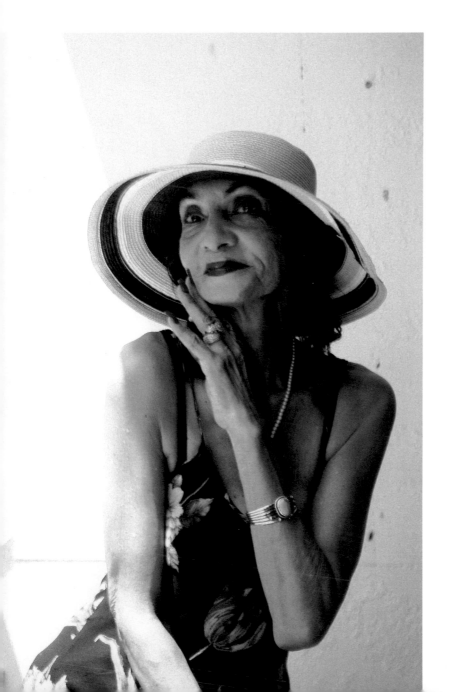

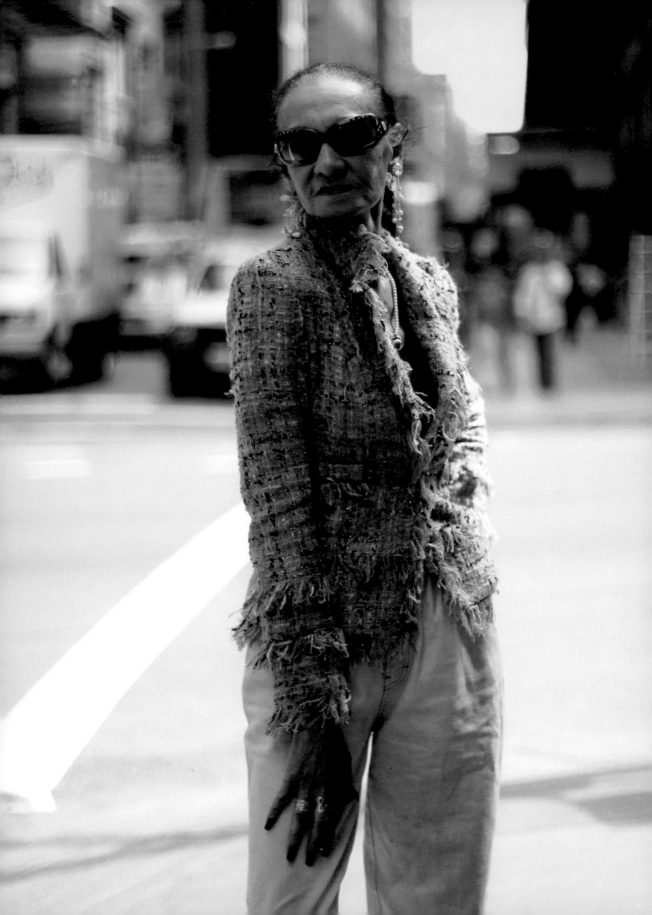

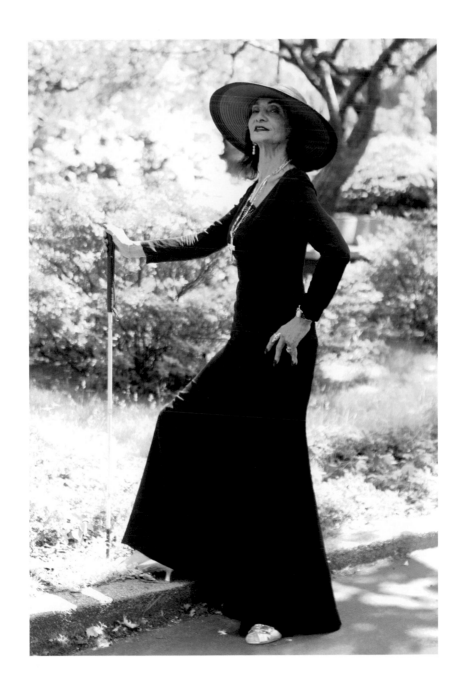

"Someone told me that I would even
look good in a potato sack. Style is
all about how you carry yourself.
I love being active, and I think that is
what keeps you young."

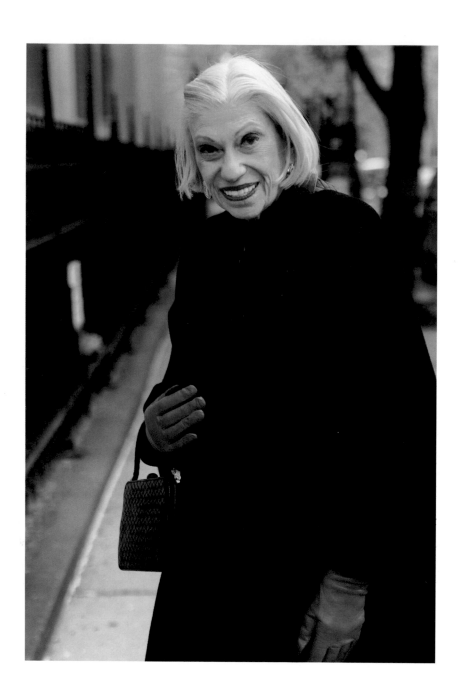

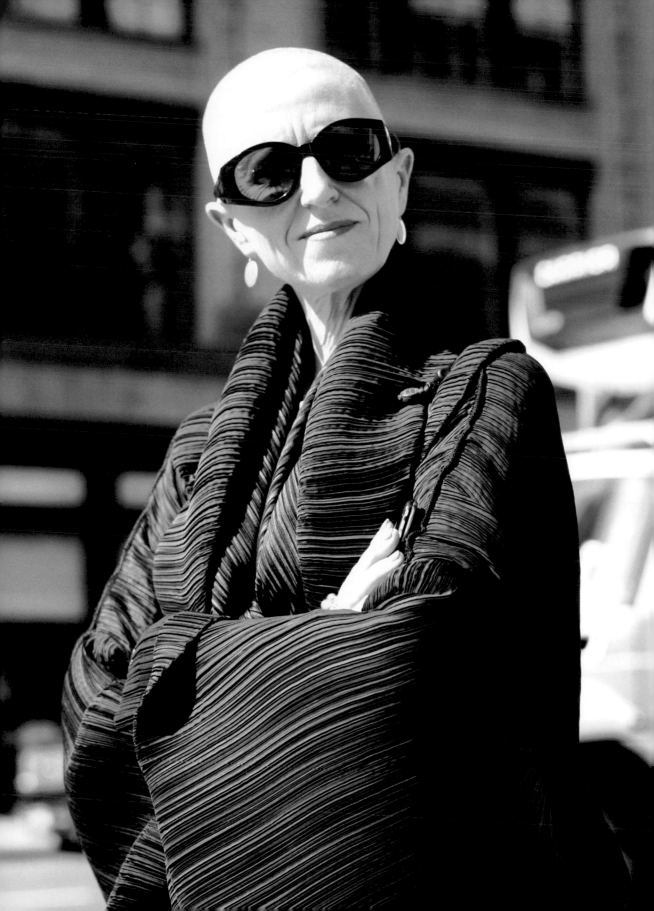

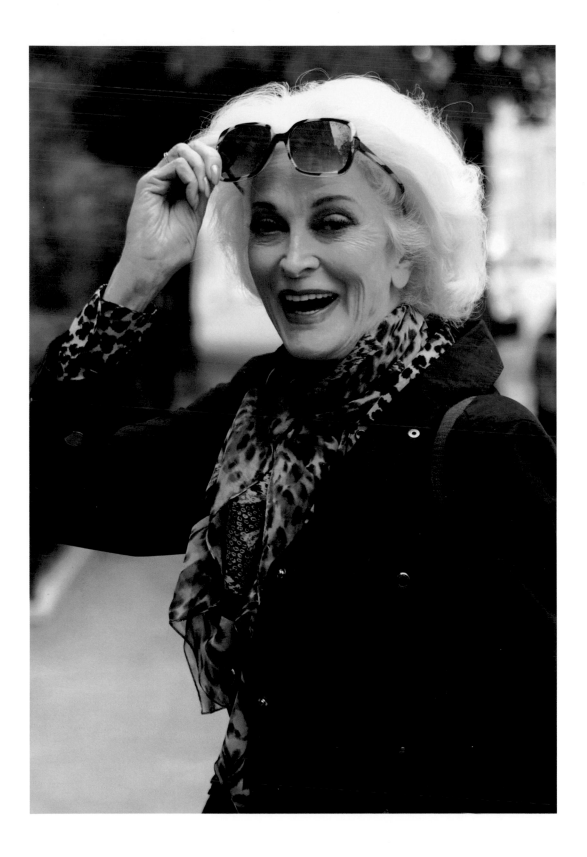

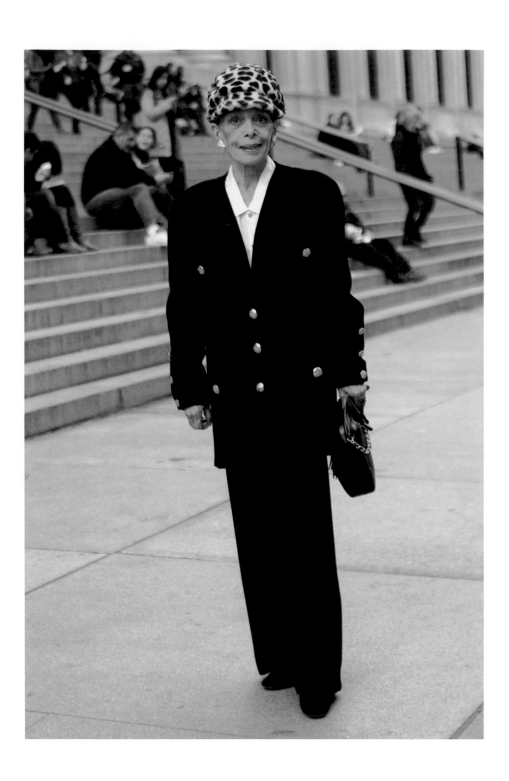

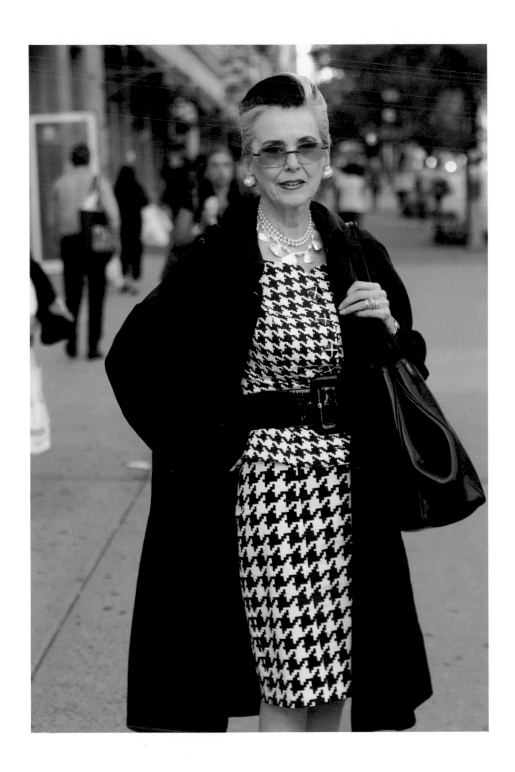

## The Idiosyncratic Fashionistas,

are style partners in crime. Regulars at fashion events all over New York City, they are immediately recognizable for their singular style. Jean and Valerie believe that fashion should be fun at any age. Their unique and often whimsical sartorial choices are a product of lives imbued with humor.

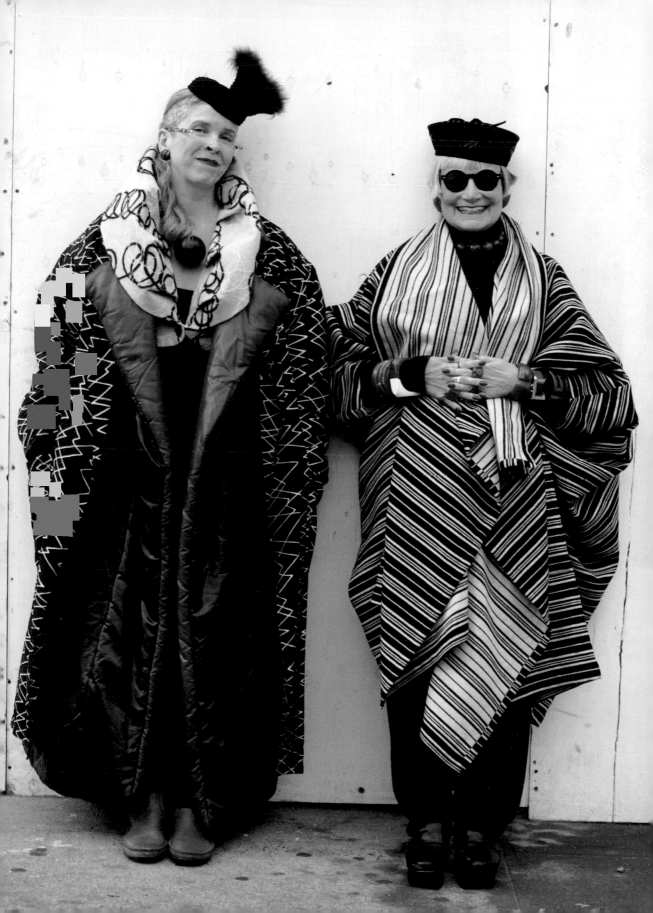

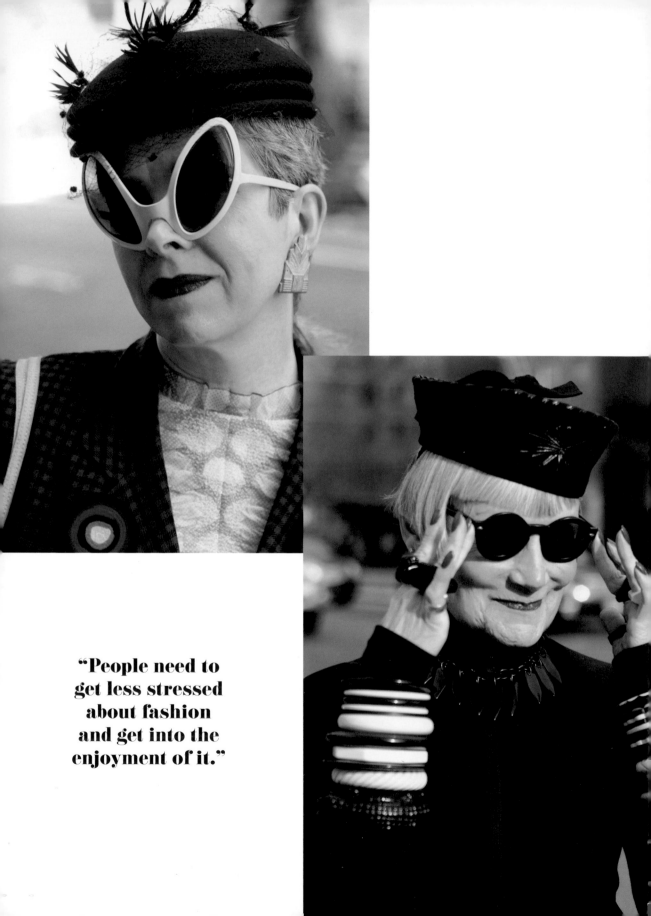

"People need to
get less stressed
about fashion
and get into the
enjoyment of it."

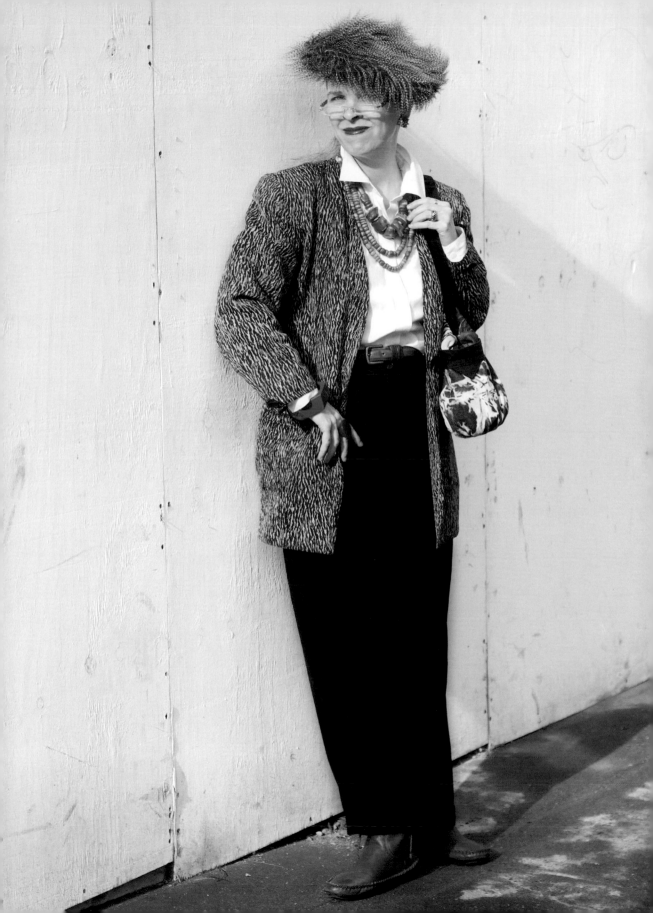

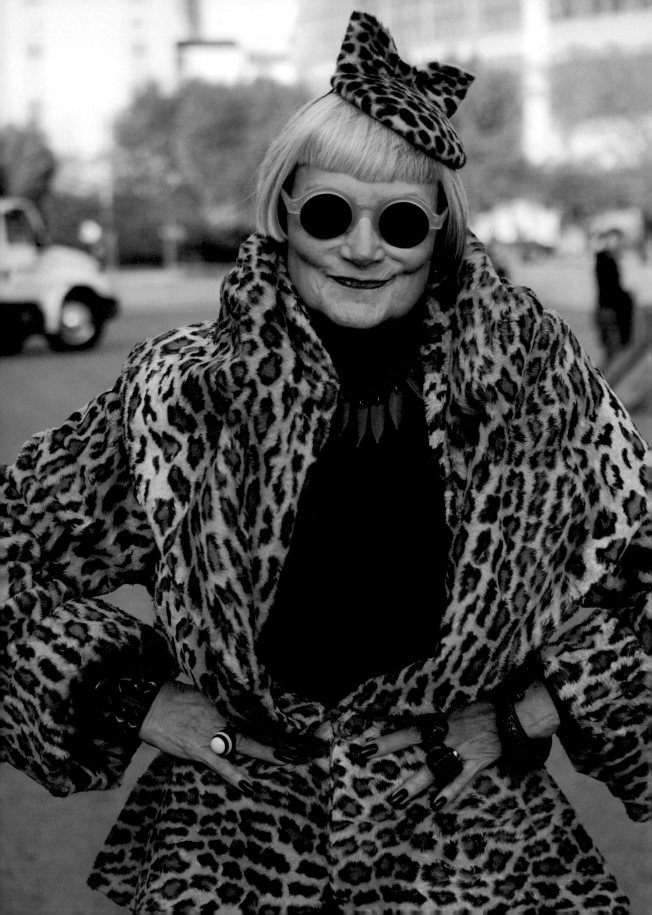

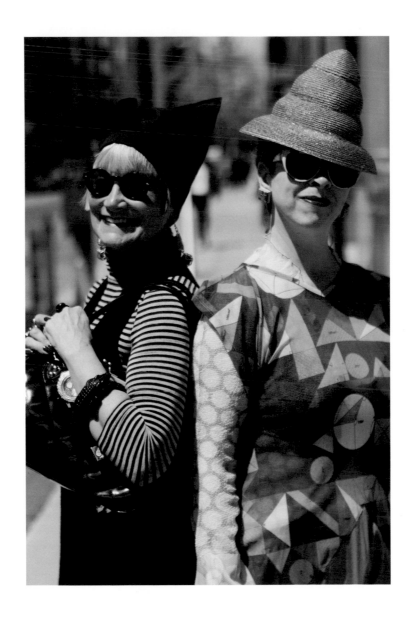

**"Young woman, you're gonna be an old woman someday. Don't worry about it, don't sweat it. Don't worry about getting older. Every era it builds character."**

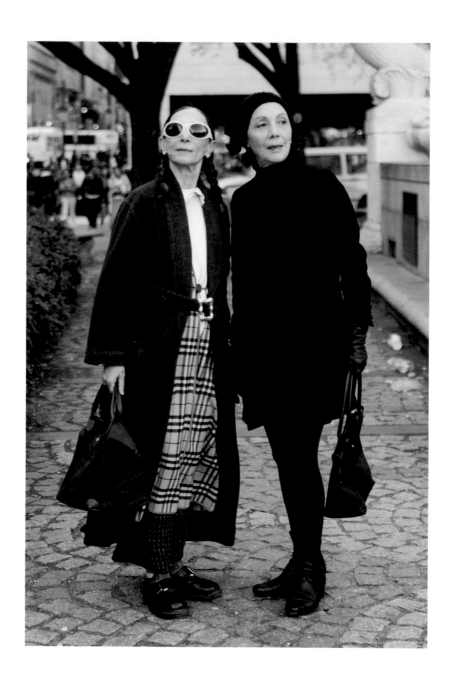

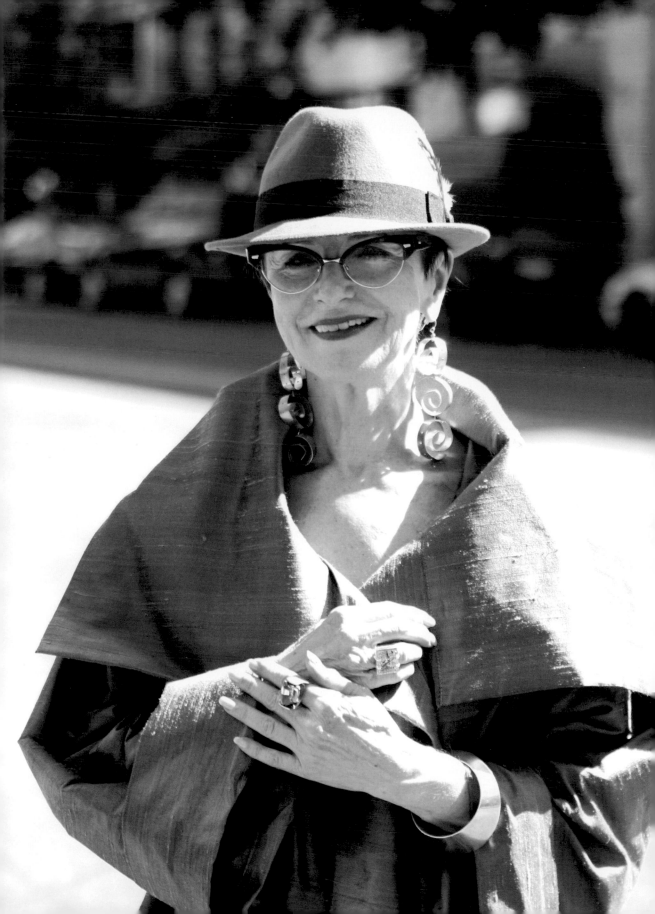

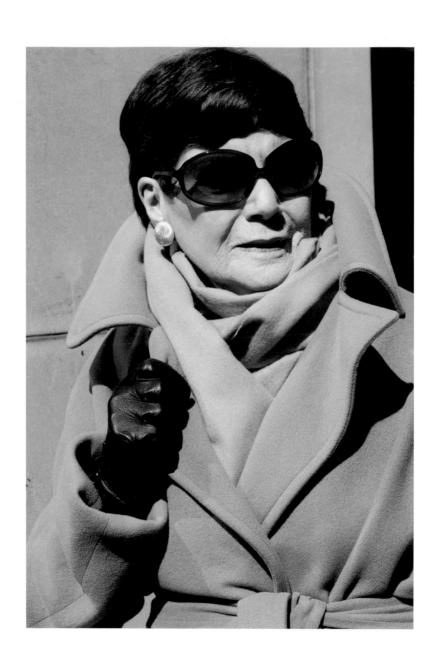

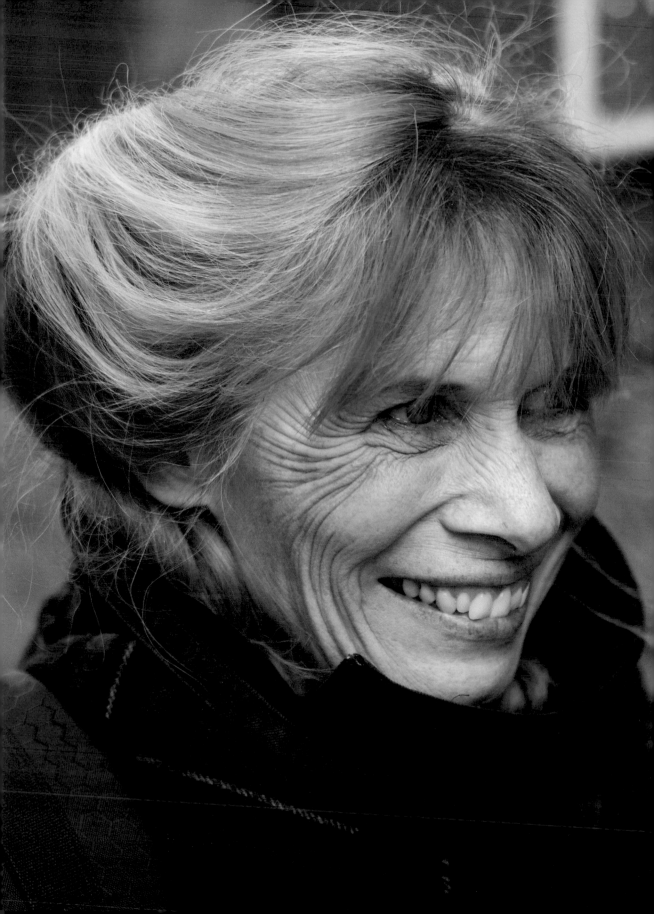

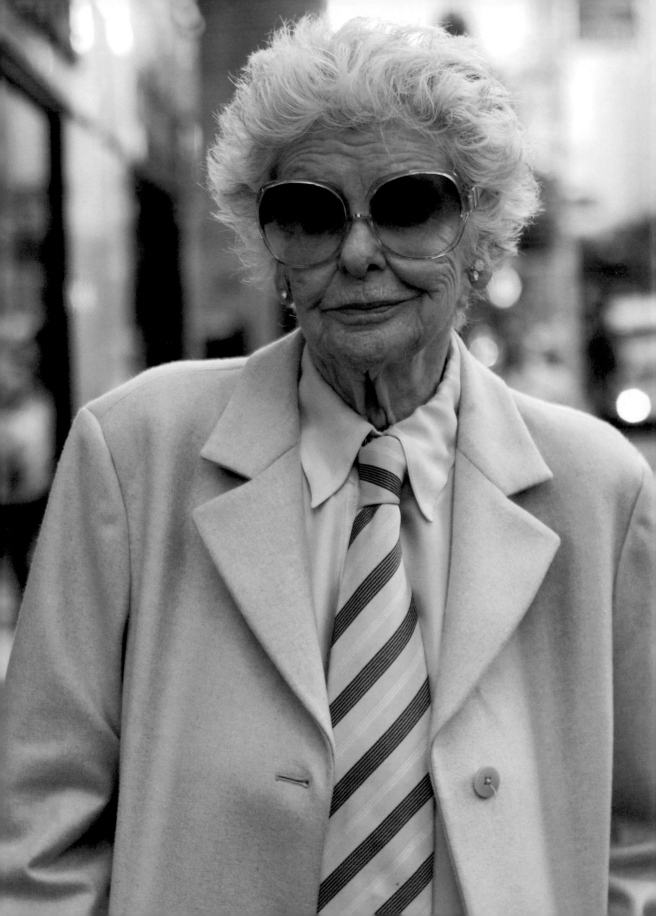

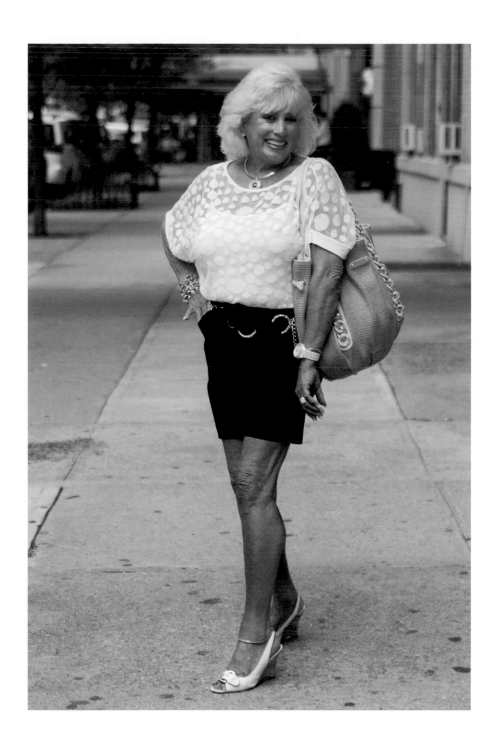

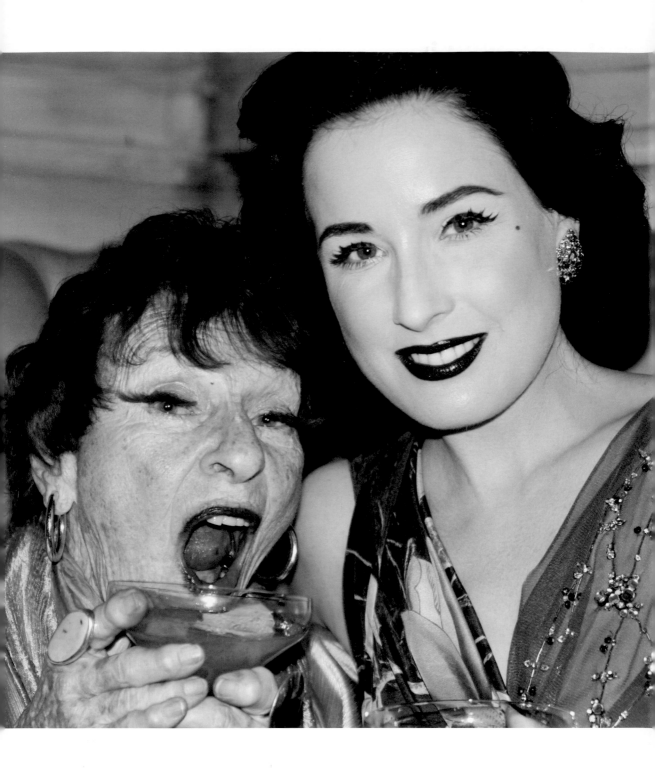

# Dita Von Teese interviews Ilona Royce Smithkin

**Ilona Royce Smithkin:** Dita, I wanted to tell you how delighted I was to meet you, you're really a very exceptional person and I was just so enchanted by you.

**Dita Von Teese**: I feel the same way about you, there is so much monotony going on in mainstream media that I really just look for people like you who are individuals and that are self-reliant for their glamour and style.

**D:** When and how did you start performing your cabaret act, and why did you start performing later in life?

**I:** That was about nine or ten years ago—I was in a nightclub in which they had an open mic. And I was with a friend from Berlin who had never heard me sing. I said, "I'll sing something special for you." So I went over to the piano and performed. And Zoe Lewis, who was on the piano, asked if I would perform in her nightclub act, so that's how we started our relationship. Then the Provincetown Art Association and Museum needed a fund-raiser and we volunteered to do it. That's how my Eyelash Cabaret started—it's about an hour and a half and it's every August, and I do Marlene Dietrich and Édith Piaf songs and some American songs and I tell funny stories. That's it.

**D:** When was the first time you performed? Did you perform when you were younger, or did you wait until later in life?

**I:** No, I never did, but I always loved the theater. I loved theater and backstage and all kinds of things that had to do with make-believe and fairy tales.

**D:** What was your profession when you were younger?

**I:** Well, I'm an artist. I do portraits and landscapes and nudes and I love my work. I have been privileged to do portraits of people in the limelight—people like Ayn Rand, Tennessee Williams, Bobby Short, Senator Kennedy's children. I hope one day I can paint you!

**D:** What do you think is your key to remaining vital and creative?

**I:** Well, Dita, it's when you can see beauty in everything, when you can be open to people, when you don't have to think about "me, me, me"—that is the moment when you can really live and enjoy other people, enjoy a tree, enjoy the streets, anything that you do or touch or see. It's a matter of concept, you know—that you are open to it. You know, everybody in my older life now seems twice as nice looking, twice as exciting and twice as interesting. Even the flowers look prettier.

**D:** Ilona, do you follow fashion at all?

**I:** No, I make my own. I mean, I look at it and I am always amazed at it and I've always been interested in it, but from an outsider's point of view. I have been doing a lot of changing of things like taking a skirt that I didn't wear anymore but loved the material, turned it upside down, and made a blouse out of it. Or I took a cover of an old umbrella, cut it out, and made a rain cape out of it. Or with jewelry. I play with all kinds of things. I call it "creative dressing."

**D:** Yes, I think that's more important—real style icons don't really follow fashion, they just watch it, admire it, and get inspired by it, but

aren't slaves to it. I think you and I have that in common, Ilona—I go to shows, and look at magazines, and I see the way that fashion fluctuates, but I never really try to keep up with it…we have a very distinctive idea of how we want to look, and that is really what every fashion icon is truly about.

**I:** Dita, I wanted to let you know, the gown you wore when I met you was so lovely and elegant, it was both understated and overstated. It was shocking in its simplicity and beauty. It was detailed. The best way I can describe it would be, "elegant."

**D:** Oh, thank you. I like the word "elegance," because it really means something not about looking wealthy or having expensive things—it's about a carriage—the way you walk, the way you stand, the way you speak.

**I:** Absolutely—style has nothing to do with money. You can take paper and make a dress out of it. It has to do with what looks good. If a drape comes natural, you can do all kinds of things if you're inventive. It depends on how you feel about your body. If you have something nice, show it off! If you've got it, flaunt it!

**D:** I started dressing in vintage clothes because I couldn't afford designer clothes—and hey, it worked in my favor in the end.

**I:** Dita, you could put on a sackcloth and look good in it.

**D:** [Laughs] I like the way clothes make me feel, like they change the way you walk, the way you carry yourself. You can be whoever you want with just a change of clothes.

**I:** Well, that's true. They can make you feel good, or make you feel awkward if you've got the wrong thing on.

**D:** Now, I'm an eccentric dresser, and I know you are too—so I wanted to ask if you were always dressing this way when you were younger, or did it take time before you were confident that you could wear whatever you liked?

**I:** I always had the idea. I couldn't always do it because I was brought up very conservatively by my parents who didn't want me to stand out, but I always had a craving for something extraordinary, something colorful, something special, something different…and when I dressed up on my own in ways I couldn't on the street, I would do very crazy things—I would pile things up, and drape them around, and I had a great time with that [laughs]… But only later in my life, Dita, did I come into my own, that I really became who I am now.

**D:** Yeah, you know—it's hard sometimes when you're young, because you're influenced by what everyone else says you should look like, and I've found there have been times in my life when it's been hard because someone would tell me they didn't like what I was wearing or that I was too attention-getting, so I can relate to that.

**I:** Yes, yes.

**D:** Do you have friends that dress like you?

**I:** Never, no, no. My friends always thought I was a little bit way off, because I always did something different. I still remember I had a boyfriend who used to say, "You always have to have an extra sausage! You always have to do something different. Why can't you do what everybody else can do?" And I felt very humbled by it, because at that time, I didn't know who I was, what I had to offer, and I just took somebody else's word for it. But now, of course, you know—it's so different. It's not that I don't care about other opinions, but I know what is beautiful, I know what is nice, I know what's too much, I know what's too little. And it's not a matter of how I appear, or the impression I give, it's

a matter of enjoying it, and creating a painting. When you get dressed, you create something.

**D:** You make a work of art. The Marchesa Casati said, "I want to be a living work of art."

Is there something you would like to say to young girls who are afraid of being different, because there are a lot of young girls who would say, you know, "I would love to look like that, but I'm too afraid that someone would make fun of me"?

**I:** Well, to them I would say, look in the mirror and see, and find your own beauty. Look how wonderful your eyes are—and they can see! Look at your ears, they can hear. Look at your nose, it can smell. Look at your mouth, it eats, it can whistle, can sing, it can kiss. You have so many beautiful things—use them! Be aware of what you have, never mind what somebody else has. You have so many wonderful, special things. Use them.

**D:** Is there someone whose style you've always admired, or anyone that's influenced you?

**I:** When I was a young girl, the person I most admired was Marlene Dietrich. You are young, and I don't know if you remember her clothes, but she had clothes which were just so beautiful. She had a knack for dressing very, very beautifully.

**D:** Yes, and she had lots of different looks, from the menswear to glamour. And she was such a smart lady, and would dress herself instead of having other people dress her. She was a genius, I think.

**I:** Yeah, you know some people have it inside of themselves. You have to find out what is most you, and then you take it from there. I think any young woman or young girl should try a lot of things and see what makes them feel most comfortable. It's very important that you're feeling comfortable in your clothes.

**D:** You have to know what's right for you and what isn't. I love clothes from the 20s, but I can't wear them because I have my curves, and…

**I:** But you can be happy—everyone would want your curves, kid. Be happy with the curves—to hell with the fashion!

**D:** What's the most beautiful thing you've ever seen?

**I:** Now that is a difficult question. Because at my stage, at 91 years old, wherever I look I see something which to me seems extraordinary. Maybe because I have only a short time here. Maybe because I rediscover the world. Maybe because I rediscover everything which I've ever learned. But for me, to pick one single thing, would be difficult.

**D:** Well, that's the perfect answer.

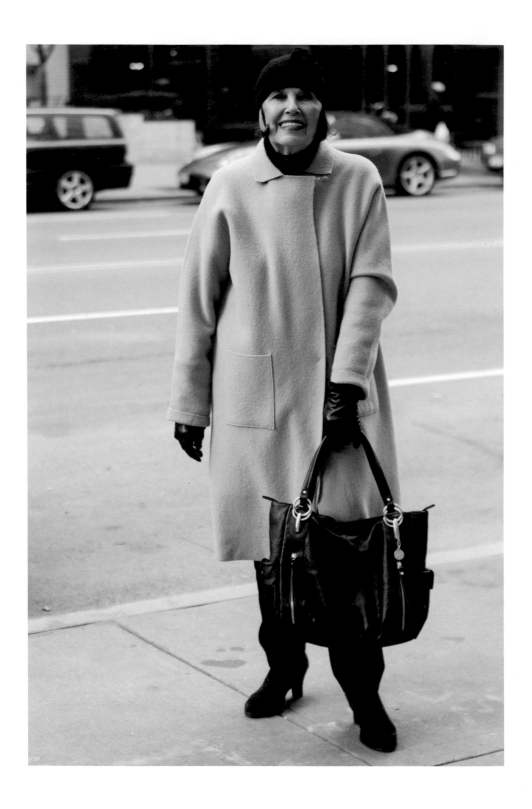

## Dedicated To

The Advanced Style Ladies and my amazing grandmothers Bluma Levine and Helen Cohen.

## Thanks To

Carol Markel

Briana Rognlin

Dita Von Teese

Mayaan Zilberman

## My beloved mother Frances Cohen

and my wonderful editor, Will Luckman, at powerHouse Books, without whose guidance this book wouldn't have been possible.

*Advanced Style*

Published in the United States by powerHouse Books,
a division of powerHouse Cultural Entertainment, Inc.
37 Main Street, Brooklyn, NY 11201-1021
telephone 212.604.9074, fax 212.366.5247
e-mail: advancedstyle@powerhousebooks.com
website: www.powerhousebooks.com

www.AdvancedStyle.blogspot.com

First edition, 2012

Library of Congress Control Number: 2011946232

Hardcover ISBN 978-1-57687-592-6

Printing in China through Asia Pacific Offset Ltd.

Book design by Rodrigo Corral Design

A complete catalog of powerHouse Books and Limited Edi-
tions is available upon request; please call, write, or visit our
website.

10 9 8